REAL-LIFE HEROINE

The home dug into the banks of Plum Creek, swapped for and lost again . . . the crops carefully nurtured, then destroyed by grasshoppers . . . the raging blizzard of 1880 . . . the cabins made warm with love and with music from Pa's honey-brown fiddle—these and other stories from a life rich with memories will be read and read again, never to be forgotten.

"The *Little House* books by Laura Ingalls Wilder have been read and loved by millions of people for more than two generations. This first biography . . . is an affection-ate and definitive piece of work that captures the pioneer spirit of the Ingalls family and maintains the same sim-plicity with which Mrs. Wilder wrote."

The Nashville Banner

"This book can only confirm our respect for the woman and her courage and make her books more popular for generations to come."

Boston Herald Advertiser

DONALD ZOCHERT

LAURA

The Life Of
LAURA INGALLS
WILDER

AVON BOOKS ◈ NEW YORK

AVON BOOKS
A division of
The Hearst Corporation
1350 Avenue of the Americas
New York, New York 10019

First Avon Books Printing: May 1977

AVON BOOKS TRADEMARK REG. U.S. PAT. OFF. AND IN OTHER COUNTRIES, MARCA REGISTRADA.

Printed in Canada.

UNV 25 24 23

For Nancy

When the fiddle had stopped singing Laura called out softly, "What are days of auld lang syne, Pa?"

"They are the days of a long time ago, Laura," Pa said. "Go to sleep, now."

But Laura lay awake a little while, listening to Pa's fiddle softly playing and to the lonely sound of the wind in the Big Woods. She looked at Pa sitting on the bench by the hearth, the firelight gleaming on the honey-brown fiddle. She looked at Ma, gently rocking and knitting.

She thought to herself, "This is now."

She was glad that the cosy house, and Pa and Ma and the firelight and the music, were now. They could not be forgotten, she thought, because now is now. It can never be a long time ago.

—Little House in the Big Woods
Laura Ingalls Wilder

Contents

Preface

For two generations of readers, now nearly three, Laura Ingalls Wilder has been justifiably beloved for the grace, the charm, the courage, and the strength of love and affection that shine through her *Little House* books. She is inevitably American, inimitably the pioneer girl.

Her appeal is not to children alone, although from the very beginning they took her to their hearts and asked her again and again for more of her delightful stories. But even those who have left behind the fields of childhood can find in her stories, and indeed in her life, rich reminders of the self-sufficient spirit. They can read the rewards of a family life built on sharing and respect and concern for one another, and they can appreciate—in a way they could not as children —the sense of bittersweet and loneliness and growing up that lies beneath the surface of these books, and from which the happiest memories bloom like miracles.

If historians had hearts, they too could study her with profit, and perhaps some day will, for her stories touch so genuinely upon the pioneering spirit; they swell with hope. It has been said, with a certain irony, that more people have learned of the frontier in America through the writings of Laura Ingalls Wilder than ever heard of Frederick Jackson Turner, the great historian of the frontier. Yet it is not for her history but for her stories, and for her character as it stands within and behind them, that she is not merely remembered but cherished.

Her life spanned ninety years, her books less than a fourth of that. In this incredible reach of time, wonders were common—the invention of the telephone, the radio, the automobile, the motion picture, the airplane, the television, the transistor, the computer, the taming of nuclear energy—

but none so wonderful as the stuff of life upon which she turned the bright lens of memory and imagination. In the year Laura Ingalls Wilder died, American military advisors were already in Viet Nam; artificial satellites whirred and whispered around the earth. So close do we stand to the Little House in the Big Woods, to the vast world of pioneer America, to the sound of a fiddle drifting across the distant prairie.

I've tried in this book to tell the story of Laura Ingalls Wilder with honesty and affection. My search has been for her traces, for the things she touched, the places she passed, the life she actually lived. It has carried me into places both familiar and obscure—courthouse basements, archives, libraries. It's taken me through manuscripts already faint with age, through volume after volume of newspapers now stiff and dead, and into all the bright particular places where Laura's life was spent. It would have been convenient, perhaps, to dress this account in the vestments of scholarship and float it forth on a sea of footnotes; instead I have tried to follow Laura's advice—simplify!—and to tell her story as fully and clearly as possible.

Beneath the happy golden years the *Little House* books tell about was a reality even more diverse than the one she recreated, but I have tried as well to sound the years in which the books are silent. My own hope is that these pages reflect the dimensions of her life and of her character, and that they will encourage an even greater appreciation of her stories, which hold such hope and everlasting magic.

In this enterprise many hands have helped me. I am indebted in numerous ways to Irene V. Lichty, curator of the Laura Ingalls Wilder Home and Museum in Mansfield, Missouri, but most especially for the privilege of consulting and using material from Laura's autobiographical memoir of her life, still in manuscript and, like all of her writing, done edge-to-edge in pencil on inexpensive lined school tablets. This is of immense importance in setting out the authentic details of Laura's life, and I have depended heavily upon it; it was written without artifice or thought of publication, and it has not previously been made available.

Margaret Clement of Independence, Kansas, was most generous in sharing her information on the residence of the Ingalls family in Indian Territory, a subject in which she has long held a special interest, and she played a major role in

determining details of the family's residence in Missouri before they moved on to Indian Territory.

William Anderson of Davison, Michigan, who has spent many years in devoted attention to the career and remembrance of Laura Ingalls Wilder, tolerated my constant inquiries with a patient spirit, directed me to source material I might not otherwise have found, shared information, and granted me permission to quote from some of the material he has published.

I am grateful to Roger Lea MacBride of Charlottesville, Virginia, the heir of Rose Wilder Lane, for permission to quote material from those manuscripts of Laura's now in the Detroit Public Library. For permission to quote other material I am indebted to Clifton H. Johnson, Executive Director, Archives of the American Home Missionary Society, Amistad Research Center; *The Christian Science Monitor;* and Cordell Tindall, Editor, *Missouri Ruralist.* The frontispiece is from *Little House in the Big Woods,* text copyright 1932 by Laura Ingalls Wilder, copyright renewed 1959 by Roger Lea MacBride, and is reprinted by permission of Harper & Row, Publishers, Inc.

I benefited from the knowledge and enthusiasm of David DeCou of Burr Oak, Iowa. Ruby Shields of the Minnesota Historical Society in Saint Paul directed me to manuscript collections which proved most useful; Roger Barr of the same institution also responded to my many queries and assisted in my research with efficiency and friendship. My observations about Laura's work were sharpened and improved by my correspondence with Rosa Ann Moore of the Department of English, University of Tennessee at Chattanooga, whose perceptive textual study of Laura Ingalls Wilder's writing is the most impressive I have seen. Without the assistance of Terri Golembiewski of Chicago, this book would have been another year in the making.

I also acknowledge with appreciation the several kindnesses of Michele Aldrich of Washington, D.C.; Lola M. Flack of Lincoln, Nebraska; Harold and Della Gordon of Walnut Grove, Minnesota; Leroy Helgeson of Redwood Falls, Minnesota; Elizabeth Jahnke of Pepin, Wisconsin; Emma Langlois of Durand, Wisconsin; Gina Mares and the staff of the Undergraduate Library at the University of Missouri in Columbia; Vera McCaskell of DeSmet, South Dakota; Doris O'Brien of Independence, Kansas; and Neta

V. Seal of Mansfield, Missouri, who not only shared with me her experiences of Mrs. Wilder but sang for me a song which Laura often sang, "O Waltz Me Around, O Willie."

None of these people are responsible for any errors in fact or interpretation that may appear on the following pages. I trust there are few, but such as there are I claim.

Donald Zochert

1

The Big Woods

For Laura, this is where it all began—in the Big Woods of Wisconsin.

In winter, snow flew through the long night. By morning's light it gleamed and crackled in giant drifts against the walls of Pa's house. In spring the flowers came bright and bountiful. Then the little clearing in the Big Woods rang with the sound of Pa's axe and the barking of a brindle bulldog named Jack. Summer and fall followed, each in its slow turn. These were the seasons of Laura's childhood.

But for Ma and Pa Ingalls there were other places, other seasons, other times. For them the Big Woods was but a way station on a long and restless journey west. It was a journey that began far away and long ago, in their own childhoods and their own growing-up in auld lang syne.

Far away from the Big Woods of Wisconsin, the gentle hills of New York State rose up bare and white beneath the blue winter sky. The Erie Canal had frozen over long before. Teams of straining mules and rough shouting boatmen turned to sleds to get their cargo to its destination. Never had traffic stopped so early in the season.

Each night the mercury fell to thirty-five and even forty degrees below zero. Animals kept to their burrows and dens. Children peered through frost-sparkled windows until their noses turned red with cold. When men left their little cabins to chop wood for the stove or to care for the cattle, words hung before their faces. They hummed snowstorms and whistled strings of cirrus clouds. Their beards turned frosty white.

It was a cold time. The year was turning. An old year was dying, a new year was about to be born.

Between the two was a moment—a very quiet moment—when men stood silent in their work and thought ahead to what the year would bring. Already pioneers had reached the distant Willamette. Texas struggled to be free. Cyrus Hall McCormick had patented his miraculous reaping machine, and a painter by the name of Samuel Morse would soon invent the telegraph. Then singing wires would be strung from pole to pole, linking cities, sections, even distant nations. Great days indeed were coming.

To the scattered farmers and settlers of western New York State it seemed as if the air itself were ringing out the old and ringing in the new—so cold was it and so brittle, like a glass bell.

But within a week the mercury bounced up in the glass. Snow began to fall. Hour after hour, deeper and ever deeper, the snow fell, from one end of the state to the other. One settler observed the wind "blows pretty smartly." Another remarked, "Dreadful snow all day."

Dreadful snow! In the country, trees bent beneath its weight and snapped in two like rifle shots. In villages and towns, roofs collapsed. Brick walls bulged outward. When the snow finally stopped it lay three feet deep upon the ground. In some places to the east it was two feet deeper, and ever after it was called "The Big Snow."

Old-timers remembered it for years and years, but no one remembered it more clearly than Lansford Ingalls, a farmer who lived in Allegany County with his wife and his young son Peter. On the very day the storm was over, the 10th of January in 1836, another son was born to Lansford's wife. This new baby, blue-eyed and bawling, was named Charles Philip Ingalls. One day he would be Laura's Pa.

From both his father and his mother, Charles Ingalls had Yankee blood and a hard sense of discipline. Although Lansford had been born in Canada, his roots reached back to New Hampshire, his wife's to Vermont. But Lansford gave his son another gift as well, a gift of spirit. His own mother came from a French family several generations back, and he passed on to Pa not only his sturdy Yankee character but the carefree and romantic air of the Canadian French.

Lansford's wife, whose name was Laura, was eighteen when they were married. She was a school teacher, and he often teased her about being a Quaker, although that may just have been a joke between them.

Together, in another time and in another place, Lansford and Laura Colby Ingalls would be the Grandpa and Grandma of the Big Woods. Indeed, Pa's mother was the Dancing Grandma of sugaring-off time—and how she could jig! It was after her that Laura Ingalls Wilder was named.

The place where Pa was born was called Cuba Township. Lying just north of the Pennsylvania line, it was a place for lumbering more than farming, for grazing cattle more than growing crops. The soil was thin and poor, and in some places there were pools of petroleum.

But a deep pine forest grew on the hills and ridges and clung to the dizzy ravines. Even as a boy, Pa had his own Big Woods in which to roam free.

In these woods he pretended to be a mighty hunter, on the watch for prowling bears and lurking wolves and screaming panthers, and wary of shadows that fell upon his path. It was here, when he was only seven or eight years old, that Pa had an adventure which made his hair stand straight on end. This was the story of "The Voice in the Woods," a story Laura loved to hear when she was a little girl, sitting safely on Pa's knee with her head snug against his shoulder.

In Pa's family, Peter was the oldest. On Valentine's Day in the year before Pa himself was born, Grandma had another baby, but it died and she sadly wrote in the family Bible: "Our Babe." So Pa was the third born, and the second to live. But he was no longer the baby in the family when he heard the voice in the woods. By then he had two little sisters—Lydia and Polly Melona—and a new baby brother all his own.

Grandpa Ingalls watched with restless eyes as his family grew around him. Like the country, it was growing larger. Like his neighbors, Grandpa turned his eyes toward the west.

Every year thousands of families from the eastern states left the friendly hills and farms of home. They sold off all the things they couldn't carry, and they crowded into canal boats and lake steamers. Some packed all their possessions into wagons and started west on foot, walking beside the teams toward a new beginning. They all hoped for room to stretch, for better and for richer land, for more opportunity.

"Westward the course of Empire takes its way!" they all said, and into this westering stream Grandpa Ingalls took his growing family. With baby Lansford James in Grandma's

arms, Grandpa set off for the prairies of Illinois, where a lawyer named Lincoln told stories around courthouse stoves. Peter and Pa and Lydia and Polly Melona trailed along behind.

Other men named Ingalls had gone before them. At the very place Grandpa chose to settle, there were a Jasper Ingalls and a John Ingalls and a James Ingalls and a George Ingalls. When Grandpa arrived, it was like old home week on the prairie.

The last two Ingallses—George and James—were most likely Grandpa's brothers. When they were boys themselves, Grandpa and his brothers stole from the house one Sabbath afternoon to try their brand-new sled. They ran straight into trouble in the shape of a slick black pig, and they got a good hard whipping for it. Pa told Laura that story many times so she would know just how hard it was to be good in the olden days.

In Illinois, Grandpa Ingalls settled his family on the prairie, about forty miles west of a boom town called Chicago. Local folks called it Skunk City. But there was nothing skunky about the prairie.

To Pa and Peter it must have seemed a magic place. Nearby was Otter Creek, small enough for a boy to leap over. Not far away was the Fox River, winding down from Wisconsin through woods of oak and elm and hickory. On one side of the river, where the trees grew thick together, the settlers even called them "The Big Woods." But of course they were not the Big Woods of Laura's time.

Beneath these trees and out along the edges of the bright prairie, wild raspberries and gooseberries grew in red profusion. There were strawberries and wild blackberries as well, and hazelnuts and hickory nuts and butternuts and walnuts— and wild red squirrels, scolding from the overhanging limbs.

Best of all, however, was the prairie itself. The land went on and on, always stretching west as far as Pa could see. For every season there were flowers floating on a sea of grass— hyacinth and indigo and shooting stars, cinquefoil and paintbrush. The grasses of the prairie were called giant bluestem. They grew twice as high as Grandpa. They hid a man on horseback. For a boy like Pa or Peter, they crowded out the sky. The boys had to shinny up a tree or stand tiptoe in the springy branches of a hazel bush to see where the land went. And the land went on and on.

Of all the places there were on this earth, Pa loved prairies the best. He lived many years in the virgin woods. He lived many years in town. But he spent his happiest, most care-free days on the prairies, from Kansas to Dakota, and it was as a boy in Illinois that he first came to know them.

Pa's new home was close to Chicago and closer still to the river town of Elgin, but settlers had opened up the land only ten years before. For a long time people had said that if a prairie won't grow trees it won't grow crops, it won't grow corn, it won't grow anything. They were wrong, of course.

The people who broke this prairie sod were mostly from New England, and they bore old New England names: Pardon Tabor, Champion Turner, Dependence Nichols. Pa's own closest neighbors were farmer George McKee and his family, a carpenter named Isaac Fisk (perhaps he taught Pa how to use the square and saw), and a lady mysteriously named Margaret Moon. They were all pioneers.

In the fall of 1850, when the census-taker came to Kane County on the prairie of Illinois, he found George and James Ingalls and the other Ingalls families in Plato Township. But he counted Grandpa Ingalls in Campton Township, just to the south.

Grandpa was 38 years old that year. Even though his brothers had big farms nearby, Grandpa did not own any land at all. He listed his profession as a laborer, not a farmer, but he probably worked land that belonged to George or James.

Grandma Ingalls told the census-taker she was only one year older than Grandpa, although her Bible record shows that she was two years older than he was. Grandma Ingalls' name went down on the census-taker's list as Lura, not Laura, but perhaps that was not bad spelling. Perhaps that was the way she pronounced her name.

The other members of the family were also listed in the census. Peter Ingalls was said to be nineteen years old. Like his father, he was listed as a laborer, and like his mother, he was given the wrong age. He was only seventeen. Pa was put down as fourteen—which was right, for a change. Lydia was twelve, Polly Melona was ten, and Lansford James, whom everyone simply called James, was seven. Now there were two new faces in the family, little Lura—or Laura—who was five, and baby Hiram, who was only two. Both had been

born since Grandpa and Grandma came out to the prairie from New York.

The census-taker took more than names. There was also a place on his form where he could mark down whether or not a child had attended school during the previous year. Hiram and Laura were too young, of course. But after James' name, the census-taker wrote the word "Yes." After Polly's name he wrote "Yes." After Lydia's name he wrote "Yes."

And after Pa's name he wrote "No." Even though Pa was only fourteen, he was already working to help the family.

The years passed quickly out on the prairie. Just as before, when he saw the country build up around him, Grandpa Ingalls got restless. Fences crisscrossed the prairie where once the grass had waved like an ocean to the very edge of the sky. The high prairie grass itself fell before the shining blades of John Deere's steel plows. At night in the winter, when the prairies were scrubbed white and clean with snow and the fences disappeared beneath drifts, the lonely whistle of the railroad train carried across the fields.

It said, "People are coming! Towns are growing! Times are changing!" And once again Grandpa knew it was time to be moving on.

This time Pa was almost a man. This time he and Peter helped Grandpa lead the way. Off the glistening prairies they went, and up along the winding banks of the Fox River. A faint trail took them northward, toward the dark and snowy woods of Wisconsin.

They moved slowly. They were looking for a home.

Through all the years Pa was chasing cows in the hills of New York State and growing up on the sunny prairies of eastern Illinois, a little girl was growing up in another part of pioneer America. She would know hard times and she would know good times; she would know sweet music from a honey-brown fiddle. Her name was Caroline Lake Quiner. One day she would be Laura's Ma.

When Laura came to write *The Little House in the Big Woods,* one of the things she wrote about was the beautiful delaine dress which Ma wore to the party at Grandpa's during sugaring-off time. It was dark green, Laura wrote, with a pattern that looked like strawberries. A dressmaker had made it especially for Ma in the East, where Ma came from. But the East where Ma came from was—West!

Ma was born in a hectic December in Milwaukee County, Wisconsin. Her big brother Henry Quiner celebrated his own birthday only five days earlier, and then Christmas Eve was less than a week away. But hustle and bustle were nothing new to the Quiners. They were a family of Connecticut Yankees, and they had as much "movin' about" in their blood as the Ingallses ever did.

Laura never knew her Grandma Quiner—or her Grandpa Quiner, who died long before Laura was born. But Ma surely must have told her all about them.

Grandma Quiner's name was Charlotte W. Tucker before she married Henry N. Quiner. They were married in New Haven, Connecticut, in the spring of 1831, and their first child was born a year later. They named her Martha, but like many children in pioneer days, she died when she was still a small girl. Grandma and Grandpa Quiner moved west to Ohio, where first Joseph and then Henry Quiner were born. They moved on to Indiana, where another baby girl was born. Remembering the daughter they had lost, they named the baby Martha. And once again they moved.

This time their wandering took them around the tip of Lake Michigan and up into Wisconsin Territory, just beyond the pioneer village of Milwaukee. Only a few years before, there had been but a handful of settlers on the site of this new village, trading with roving bands of Indians. But now the place was growing by leaps and bounds.

Every summer thousands of immigrants came up the lakes from Buffalo and other eastern cities and streamed down the gangplanks of wobbly lake steamers here at Milwaukee. Streets were going in; houses and stores and even hotels were being built; bridges were being thrown across rivers and creeks. When the Quiners arrived, they pushed right through the muddy streets and headed out of town. They had not come for town life. They wandered out through groves and forests past patches of prairie to the very western edge of the county, and there they settled, in what was called Brookfield Township.

It was good country. The soil was rich and unbroken. The first settler had put up a cabin there only three years earlier, in the fall of 1836, and Laura's Ma may well have been the first child born in this sparsely settled section. The old county histories give that honor to a boy named Solomon

Wales, who was born "about 1840." But Ma was born on December 12th, in 1839.

Soon two more children were added to the family. These were Eliza Ann, who was born when Ma was two and a half, and young Tom, who was born when Ma was almost five.

Even though Ma once told Laura that she had been "very fashionable" before she married Pa, times were far from easy when she was a little girl growing up in Wisconsin. The family was large and crops were uncertain. The times grew harder. When Ma was about seven, her father died, and Grandma Quiner was left to care for her large family alone. Although they were still young, Joseph and Henry became the men of the family overnight. Years later, Ma told Laura that friendly Indians had given them food during that first long winter after their father died.

Grandma Quiner tried very hard to make a go of it on the old place. But before long the spirit of "movin' on" took hold of her again. She purchased some government land across the county line in Jefferson County, and moved her family there. For Ma, who was then nine years old, it was the first move in a lifetime of moving on.

Part of their new farm was low and marshy and not much use at all, but more than half was deeply wooded. The Oconomowoc River drifted lazily through the winter woods, along the northern edge of the property. A territorial road ran just south of the farm—in one direction to the little village of Concord, two miles away, and in the other direction to the village of Oconomowoc, about twice as far.

Beyond Concord the road turned up toward the Rock River and Watertown, the largest town around. Watertown boasted of lawyers, clothing stores, banks, iron works, homeopaths, dealers in elephant oil, piano teachers, and newspapers, and it was soon to have a genuine Daguerrean Gallery guaranteeing "first-class likenesses."

It is unlikely that Ma had much time to visit Watertown, despite its attractions. She was a girl without a father, and without a father there was plenty of work to be done.

She had to help take care of Eliza Ann and little Tom. She had to help her mother and her sister Martha cook and put up food for the long Wisconsin winter. She had to help with the sewing, of which there was no end—and how she did hate to sew! Still, she did it because she knew it had to be done. Ma learned very early that there were some things that

just had to be done, if not with a smile at least without a complaint.

But when the chores were over, there was always time to play. Ma and Martha could take the smaller children down to the riverside and wade in the shallow water. They could walk barefoot in the mud until their feet had turned into balls of earth and they could hardly move. In the winter they could slide out upon the icy Oconomowoc and glide into the far bank. They could skate down their own icy highway, past the drifting snow and beneath the bare clattering branches of the trees.

When Ma was ten years old, Grandma Quiner married a farmer from Connecticut. His name was Frederick Holbrook. He was much younger than Grandma, and he made a good stepfather for Ma and the other children. Of course it was not exactly like having their own father, but he was much better than no father at all.

Mr. Holbrook bought another forty acres of government land across the river from Grandma's farm, and a small strip of land to the south, between Grandma's farm and the territorial road. They put the farms together, and quiet times settled upon the Quiners at last.

The Quiner family was used to hustle and bustle and hectic Decembers. They were not used to quiet times. But for Ma, these were indeed quiet years which followed Grandma's marriage to Mr. Holbrook. They were school years and growing-up years. Day followed day in an orderly parade.

It was during these years that Ma wrote a little school composition on the subject of "home." She told of her own home, and how she loved it, and she put down a thought that she carried close to her heart forever.

How sweet and endearing is the name of home! What music in that sacred sound!

It is there we can have the society of our beloved parents, brothers, and sisters; and how delightful it is after the avocations of the day to assemble around the bright, blazing fire variously employed: perhaps one with a book, to read aloud some interesting story, for the benefit and amusement of us all.

Although the wind is whistling without and blowing the snow, in every direction, making drifts as high as

the fences; yet we heed it not. But we oftentimes think
of and pity those who have no comfortable home, to
secure them from the inclemency of the weather.

Who could wish to leave home and wander forth in
the world to meet its tempests and its storms? Without
a mother's watchful care and a sister's tender love?
Not one.

They would very likely meet with some warm
friends, and some that would try to make it pleasant
for them, and appear as much like home as possible,
for which they would be very grateful. Yet after all it
would not be like home.

Then give me a place at home, a seat at my father's
fireside, where all is so happy and free.

*Who would wish to wander forth in the world, to meet its
tempests and its storms?* The answer to that was coming up
the frozen road from Illinois—the clop-clop-clop of horses,
the creak of weary wagons past the Quiner farm, the shouts
of new neighbors in the frosty air. Their name? Ingalls!

And in their number was a boy named Charles, who
played the fiddle and had a very special twinkle in his eye.

No one knows what chance or luck brought Grandpa and
Grandma Ingalls to Jefferson County in Wisconsin. But one
thing is certain. They found a whole colony of Ingallses
there before them. There were Edwin Ingalls and Ebenezer
Ingalls, there were Albert Ingalls and Abigail Ingalls, Ed-
mund and Milo Ingalls. There was even a Charles Ingalls.
There were certainly more than enough Ingallses in the
world to go around.

Best of all, Grandpa found a nice piece of high land out
along the Oconomowoc River, only a few rods beyond the
farms of the Quiners and Mr. Holbrook. Grandpa and
Grandma Ingalls paid for their eighty acres of land on the
very last day of 1853. Grandpa took $300 from his purse
and the land was theirs—perhaps the first place they ever
owned for themselves.

There were deep woods on the land, and Grandpa liked
that. He put up a little frame house right in the middle of
them. Pa and Peter had to pitch in, of course, but they could
still steal time in the January of a new year to strap on their

skates and go racing up the frozen river to the neighboring farm. After all, that's where the fun was.

At first Ma wasn't around very much, for in that same month Grandma Quiner had her last child, a girl. Mr. Holbrook insisted that she be named after Grandma, so she was. Her name was Charlotte, but everyone called her Lottie. One day she would grow up and pay a visit to the Little House in the Big Woods, and to two little girls who wanted to know whose hair was the prettiest.

So for Ma there were even more chores than usual. But it didn't take long for all of the Quiners and all of the Ingallses to get to know each other—and very well indeed. Pa and Henry Quiner became especially good friends, and the reason soon was clear. Pa had his eye on Henry's sister Caroline, and Henry had his eye on Pa's sister Polly. Before too many years had passed, the minister had plenty of work to do.

When spring came in 1856, Ma went before Henry M. Rouse, the superintendent of schools in Concord Township, and took her teacher's examination. Mr. Rouse found her "qualified in regard to moral character, learning and ability to teach a common school in this town." She was just three months past her sixteenth birthday.

That same year Ma's older brother Joseph became the first in his family to marry. On Christmas Day he took a town girl, Nancy Frank, as his bride. The ceremony was held at the bride's house in Concord, and Henry Quiner was a witness. Laura never knew her Uncle Joseph: five Christmases later, to the day—when the Civil War was raging—Joseph signed up with the Wisconsin Infantry. He was sent to Tennessee, and died in a skirmish at Pittsburg Landing.

But what Joseph started in the marrying line, his brothers and sisters were quick to finish. It didn't take long for Henry Quiner to propose to Polly Ingalls. They were married just after Valentine's Day in 1859 by William Allen, a justice of the peace. And they had their first home on the little strip of land between Grandma Quiner's farm and the territorial road.

Ma and Pa were the next to court, but little has been left us of those happy days. In Laura's own books we have only the barest of hints. Ma's hair was long and beautiful. Pa's hair went every which way and all at once, even when he

slicked it down with bear's grease. Ma's waist was so small that Pa could fit his hands around it before they were married.

But there is one other clue that we might count on for a glimpse of these times before Ma and Pa were married. Ma was never pretty in the way that Laura was pretty. Her figure may have been very delicate; her character was surely steadfast. But as with most of us, her face was merely plain. She squinted a little, and her face did not have the grace and lift and easy lines that Laura's did. When Laura's own daughter began to write books, one of the books she wrote was based upon the stories she had heard so many times from Laura, and perhaps even from Ma. And in this book, Rose Wilder Lane wrote that Ma was always a little bit surprised that so gay and handsome a man as Pa had picked her for his wife.

But with Caroline Quiner, beauty was certainly more than skin-deep. Pa could see in her a good helpmate, to share the long, hard days of his life. He could see her steadfast heart. She would follow where he went, and would bear misfortune and privation to make a life together. She would be a good mother. No matter how humble the circumstances of their life, she would bring to her children a taste of finer things, good manners, and a conscience.

Pa could see all this. On those long-ago days still to come, when she would read aloud to him as he worked over his traps or his bullet mold, Pa would know it was true. Every time she made do and baked a pie as good as a miracle, he would know what kind of a woman she was. He would look into her eyes and wait for her smile.

Charles Ingalls and Caroline Quiner were married at nearby Concord on the first day of February in 1860, by Reverend James W. Lyman. Ma's older sister Martha and Pa's older brother Peter were the witnesses.

Peter Ingalls was the last to marry, and for his bride he picked Ma's younger sister Eliza Ann. They were married in Watertown on the fifth of June, 1861, by Justice of the Peace Bernhard Miller.

Now there were a Ma and Pa, an Uncle Henry and an Aunt Polly, an Uncle Peter and an Aunt Eliza. All that was needed was a Laura—and the adventures of the *Little House* books could begin!

These would seem like happy days for everyone. For Grandpa and Grandma Ingalls, especially, they should have

been happy golden days. But they weren't. Hard times had turned their dreams to dust.

It was an old story on the frontier, wherever men without money tried to make their living on the virgin land, wherever men who had money hungered and thirsted for more. It was a story of property and promises, money and mortgages. For Grandpa Ingalls it all began on a spring day in 1857, when he signed his name to a little slip of paper colored as blue as the spring sky.

Grandpa needed money. Perhaps he needed it for crops, or for horses, or for the start of a new house. Perhaps it was for more land, or for a machine to help on the farm. Whatever the reason was, he made a deal with a rich man from the East. Grandpa borrowed $500, and he signed the paper.

- The paper said Grandpa would pay the money back within three years. If he didn't, the rich man from the East could go to court and take all of Grandpa's land away from him. And that is just what happened.

Try as he might, Grandpa could not pay the money back. He paid most of it back, but he couldn't raise the rest. So at the end of the three years the rich man went to court—and the judge decided that there would be an auction of all of Grandpa's land on the last day of January 1861, at the Planter's Hotel in Watertown.

So all the while Grandpa's children were getting married, full of hope, the sheriff was knocking on Grandpa's door. And in that cold January, Grandpa's dreams went up for sale to the highest bidder. The rich man bought them.

But Grandpa Ingalls was not the sort of man to let hard times get him down. He had seen hard times before, and so had Grandma. Land or no land, there was still plenty of work to be done. Why, a person could just count noses to see the truth in that. Even though the older children had grown up and married, Lydia remained at home. So did Docia—they had called her Laura when she was a baby back in Illinois, but her full name was Laura Ladocia, and now everyone called her Docia. Hiram and James were big strapping boys, almost men, and three new faces had been added to the family since they'd come to Wisconsin—George, Ruby, and little Lafayette.

Grandma and Grandpa may not have had a house, but they had a houseful. There were plenty of things to be done.

Besides, things were getting close again. More and more
people were coming into the country. There just wasn't the
kind of elbow room a man liked to have around him. Why
not move on—to a new place, for different times and different
seasons?

They asked Ma and Pa. Well, Ma and Pa liked the idea.
They asked Uncle Henry and Aunt Polly. They liked the
idea, too. They asked Uncle Peter and his bride Eliza. Let's
go! they said. So they did. And where they went was the Big
Woods.

The Big Woods of Wisconsin—Laura's own Big Woods—
was no land of make-believe. When she herself was grown
up, Laura's daughter confessed with a sigh that she had
never quite "lost my very-little-girl feeling that the Big
Woods was somewhere in fairy land or at least what was the
same region, my mother's When I Was A Little Girl time."
But the Big Woods was no imagined realm of childhood.

It was a real place, dark and deep. It was a place of silence
and solitude, broken now and then by the scream of a
wildcat, or the slow ghostly fluttering of a snowy owl. The
high trees held the mysterious silence like webs in their
branches, and it was to the edge of these woods that the
pioneers came to make their homes—to cut timber for
cabins, to raise families free in the wilderness. In Pepin
County, where Ma and Pa and all the Ingallses went, the
woods were not pine and fir but hardwood: oak and ash,
elm and maple, butternut and birch. They covered the west-
ern half of Pepin County, and they stretched as far north
as a man could walk. To the east was natural meadow, and
farther east yet was prairieland filled with oak openings and
hay marshes and tamarack bogs.

When the wagons of the Ingalls family creaked and
groaned across the washboard hills of Pepin County, there
were only two good-sized villages in the entire section. One
was the town of Durand, on the Chippewa River. This was
the county seat. The other was the village of Pepin, huddled
on the shore of the Mississippi where the river widened to
form Lake Pepin.

It was toward Pepin that the wagons carried Ma and Pa,
Henry and Polly, Peter and Eliza, Grandpa and Grandma,
and all the rest of the family. And what did they find there?
Anyone might have guessed—they found other Ingallses. No

matter where Grandpa and Grandma went, other Ingallses seemed to have gone ahead. It wouldn't be long before Pa would change that. *He* would be the pathfinder.

But for now there were other Ingallses. Louisa Ingalls had come up from Iowa Territory ten years before to teach in a little one-room school in the village of Pepin. She had twenty scholars, and she bought land in Pepin Township and stayed on. So did a lady named Sarah Ingalls. And on the Roaring River, a little to the east of Pepin, a man named Isaac Ingalls had built the very first watermill in the township. He didn't have an Ingalls for a partner, but his partner had a fine name for a miller: Melville Mills.

One descendant of the family, Gertrude Yanish, whose mother was Laura's cousin, heard from her own mother the story of the Ingalls family's arrival in Pepin County. "The Ingallses arrived in the Pepin area with all their possessions tightly packed in a covered wagon," she related. "The family slept and ate near the wagon, until a small log house was built to shelter them. It was a slow job. Neighbors took turns helping each other to construct their cabins before winter set in, as it was too cold to camp out.

"The house was built of logs, with one end curtained off for a bedroom. Here they cooked, ate, and enjoyed the simple means of entertainment. Some evenings they sat around the hearth, popping corn and listening to Laura's father play his violin. At night the children retired to a small room on the second floor.

"A window in the east end let in the morning sunshine. There was also a small shed built at the entrance of the cabin, where an extra supply of wood was kept for protection against unexpected winter blizzards."

Of course, the children Gertrude Yanish spoke of weren't Laura and Mary. They would have been George, Ruby, and Lafayette, because Laura and Mary weren't born yet. It was from this cabin, Mrs. Yanish remarks, that Pa and Uncle Peter and no doubt Uncle Henry swam across Lake Pepin, to work as harvest hands in the Minnesota Territory during the summertime.

Pa hadn't come all the way to the Big Woods to crowd into one cabin, however. He and Uncle Henry spent many days looking in the woods around Pepin for places of their own. There were plenty of places to pick from, but they wanted just the right place. It must be deep enough in the

Big Woods so that the wild animals hadn't already been frightened by guns or by the sound of men's voices or by the mournful call of the steamboats that smoked up and down the Mississippi and the Chippewa rivers. But it must be close enough to the little village of Pepin so that Pa could walk there and back in a single day, if he walked hard and watched carefully for stumps in the road.

One day they found exactly what they were looking for—a little piece of land on high ground, protected from spring freshets when the heavy snows of winter melted off. Nearby in the Big Woods were clearings where the forest opened to the smiling sun. Here Pa and Uncle Henry could sow oats and hay in season. On every side, creeks fell off from the high land and ran cool and clear through the Big Woods, Elk Creek and Pine Creek and Lost Creek and Bogus Creek. Not too far away there was even a Plum Creek, although it was not the Plum Creek of Laura's stories. Bogus Creek dried up in the summertime, when the black flies hummed at sunset and rain didn't fall for days, and that's why it was called Bogus Creek. Lost Creek was even smaller, but it was the best creek, because down along the creek bed and under a high bluff, the faint wagon road ran toward Lake Pepin.

Pa and Uncle Henry were very good friends, close in age and in mind. Uncle Henry could boast that he was older than Pa, but everybody knew it was by less than a month. They liked to do things together, and together they bought this piece of high land they had found in the Big Woods.

Buying land was always a tricky business. Men had come into this part of the Big Woods seven or eight years before and made their claims—Jake Cupps and Dillon Hyde, Felix Craft and Josiah Sawyer, Stephen Scales and David White. But the land changed hands so quickly that it was sometimes hard to tell who owned what.

Charles Nunn owned the land Pa and Uncle Henry wanted to buy. He had been born in England and was a druggist; he lived in the little town of Reed's Landing across Lake Pepin, on the Minnesota side. Pa and Uncle Henry made Mr. Nunn an offer: they would put together $335 and pay him that much for his land in the Big Woods. Mr. Nunn agreed. On September 22, 1863, he and his wife Abbie signed the bill of sale.

The very next day Pa and Uncle Henry sold it back. What they did was take out a mortgage. Mr. Nunn paid

them back $300, and once again he became owner of the land, although Pa and Uncle Henry could live on it. If they paid him back $300 by a certain time, and paid taxes on the land, the land would be theirs.

Mr. Nunn then turned around and sold the mortgage to a land speculator named Harvey D. Kellogg. So now Mr. Kellogg owned the land that Mr. Nunn had bought from Pa and Uncle Henry after Pa and Uncle Henry had bought it from Mr. Nunn. Buying land was always a tricky business.

Government surveyors with their chains and compasses had marked these eighty acres down as Section 27, Township 15, Range 24. But Pa and Ma, who took the southern half of the land, marked it down as home. Uncle Henry and Aunt Polly settled on the north half of the land, right next door. They too called it home.

Uncle Henry and Pa helped each other build snug cabins in the Big Woods. They always traded work—at butchering time, at harvest time, whenever one man needed the help of another. That was the pioneer way. One man alone in the wilderness found terrible hardships before him. Two men together, or three working together, could do much more.

Pa's cabin wasn't fancy, but it was well made. There were shutters on the windows and flowers in the dooryard. In front of the little house, Pa cut down the trees to make a larger yard, but he left two trees standing. These were mighty oaks, the grandfathers of the Big Woods, and in summer they made a green roof over the yard. In fall their leaves turned as bright and red as fire.

Wild game was still plentiful in the Big Woods, and so was work. There was no end of work for Ma and Pa, making their first little homestead together.

Every once in a while Pa would disappear down the road along Lost Creek toward Lake Pepin, and not return until night had fallen. Ma would be alone in the Big Woods then, working busily in the house or stepping outside to look down the road toward Lost Creek. Then, beneath the blue stars, Pa would come whistling home to the little house with a load of whitefish from the sparkling waters of Lake Pepin. Every once in a longer while, he would go into town to trade.

But most of the time he stayed in the Big Woods—hunting, trapping, farming, just as pioneers did all over America. He could say, as his own father said, that there was plenty

of work to be done. And when the work was done, the sound
of a honey-brown fiddle sang from the little house in the Big
Woods, happy songs and sad songs and songs of auld lang
syne drifting through the dark trees and clearings.

Even before Pa and Uncle Henry built their little houses,
Uncle Henry and Aunt Polly had their first baby. Her name
was Louisa—not pronounced like Louisa May Alcott, but
like Lou-EYE-sa. One day she would be Laura's cousin.
Two years after this, Aunt Polly had a little boy, Charles.
He would be Laura's cousin Charlie, the same one Pa
thought was spoiled. Two years after that, Uncle Henry and
Aunt Polly had another boy, and named him Albert.

In that same year Ma and Pa had their first child. She was
Mary Amelia Ingalls, and she was born in the Big Woods
on Tuesday, January 10, 1865, near the very end of the
Civil War. Like Ma and Pa, Mary was a winter baby, and
for the best of surprises her birthday was the same as Pa's.

It was in this very month that Pa's two brothers, Hiram
and James, ran away to the Civil War. They went to Saint
Paul and joined the 1st Regiment of Heavy Artillery in the
Minnesota Volunteers. The war was nearly over and Sher-
man was ready to march to the sea, but Hiram and James
wanted to get in on it. Grandpa Ingalls ran after them, be-
cause he said James was too young to go to war. James was
nineteen. But he wouldn't go home with Grandpa, so he
went away to war and Grandpa went home alone. He still
had George at home, though, so things wouldn't be dull.

The snows melted. The giant oaks in front of Pa's little
house in the Big Woods leafed out, turned red, grew bare
with the approach of another winter. Acorns rained on the
wooden roof. Winter came and went again. Twice the
seasons made their steady circle in the Big Woods. And then,
on February 7, 1867, Laura herself was born. Her birthday
was on a Thursday, and her full name was Laura Elizabeth
Ingalls.

It was a cold time. The ice in Lake Pepin was a full twenty-
seven inches thick. Soon gales and blowing storms would
sweep the Big Woods. What the French boatmen along the
river called "poudreires"—blizzards—would whistle through
the woods with the heaviest snows of the season. For now,
the bare branches of the February trees clacked and clat-

tered before the rising wind. And inside the little house, Ma and Pa and Mary looked after a baby named Laura.

The world into which Laura was born was a world just recovered from the Civil War. Hiram and James were home, safe. Abraham Lincoln was two years dead. It was the very year that the United States purchased all of Alaska from Russia. And what Samuel Morse had started back around the time that Pa was born, a visionary industrialist named Cyrus Fields was carrying to great lengths. Only a few months before, he had successfully laid his great Atlantic cable linking the old world and the new by telegraph.

But there were worlds within worlds. Laura knew nothing of great events far away. Her world lay in the Big Woods, in the little house, in Ma's lap and snuggled up against Pa's hard shoulder.

A new generation was being born in the Big Woods, and Laura was part of it. The last generation had surged across the Alleghenies and streamed down the lakes and rivers to the west. It had made towns and built churches and opened roads to distant places. But Laura's generation would do even more. It would carry the breaking wave of people even farther west. It would build railroads, and then automobiles, and then airplanes. It would invent modern times and carry America into a new century. It would open new territories.

And to Laura fell the most special task of all. She would open new territories of the heart.

Laura was no sooner born than Pa began to talk about moving on. It was not that he didn't like the Big Woods. He did. But his eye roved westward. His thoughts turned toward the prairies that lay untouched beneath a high blue sky, toward land that went on and on as far as boy or man could see. Pa was a pioneer of the clear view. His heart was restless.

Already the newspapers were boasting of the wide lands waiting in the West. They carried advertisements to catch the eyes of men like Pa, like this one taken out by the Union Pacific Railroad:

KANSAS FARMS!
Neosho Valley Lands.
1,300,000 Acres for Sale
to
Actual Settlers.

The Neosho Valley, the railroad said, was the "richest, finest, and most inviting valley for settlement in the West. One-third of the labor required at the East in the culture of farms will inspire here double the amount of crops. For orchards, grape culture, and small fruit in general, it is un-equaled."

Just think—more than a million acres of land! It made Pa's heart beat fast just to think about it.

Pa and Uncle Henry had always done things together. But would Uncle Henry and Aunt Polly want to leave their home in the Big Woods, to make a perilous journey west? Would they want to try a new life somewhere else? Those were questions to consider.

In November, before Laura was even one year old, Pa and Uncle Henry divided their land in the Big Woods and sold the halves to one another. That way each man could be responsible for his own land. If one wanted to go, he could. If one wanted to stay, he could do that too. And they would have all winter to think about it.

Once again, winter came. The snow flew, and from the little house came the merry traveling songs of a fiddle. The snow piled up in great glistening drifts, and from the little house the songs grew faster—happy, traveling songs. In February, Laura had her birthday. The bow jumped across the strings of the fiddle, faster and faster. The songs tumbled on, footloose songs, songs of fancy free. And then suddenly it was spring.

In the clearing, the great oaks leafed out, green and fresh. In the little house, Pa carefully put away his fiddle. But the twinkle stayed in his eye. They would go!

It wouldn't have to be Kansas. But it would be some-where else. It would be across the great river and out upon the prairies. It would be moving on, it would be free, and Uncle Henry and Aunt Polly would come along.

Late in April, Pa and Uncle Henry sold their land in the Big Woods. The man who bought it was Gustaf Rejnhalt Gustafson, and he promised to pay them for it a little at a time. On the second day of May, Pa went across the river to Lake City in Minnesota to pay off what he still owed Mr. Kellogg, the land speculator. Then for a few weeks, Ma and Pa and Uncle Henry and Aunt Polly stayed with Grandpa and Grandma Ingalls in the Big Woods.

The weather grew warm. The roads dried out. Great summery clouds began to drift in over the woods. The wind lifted and blew from the west, from out upon the distant prairies. Then one day the wagons were loaded. Pa and Ma and Mary and Laura were in one. Uncle Henry and Aunt Polly, cousin Charlie and Louisa, and Albert and baby Charlotte were in the other. A brindle bulldog named Jack trotted in little circles, ready to be off.

Slowly the wagons began to move, out of the bluffs and down toward the blue sparkling water of the Mississippi. Behind them, the woods dropped back. The little house was nowhere to be seen. But from the front of Grandpa's house the family waved goodbye—Grandma and Grandpa and Uncle Peter and Aunt Eliza and all the rest, until at last the wagons disappeared.

For Ma and Pa, the Big Woods of Wisconsin was but a way station on a long journey west. For them there had been other places, other seasons, other times.

But for Laura, this is where it had all begun. In winter, snow flew through the long night. By morning's light it gleamed and crackled in giant drifts against the walls of Pa's log house. In spring, the flowers were bright and bountiful. Then the little clearing in the Big Woods rang with the sound of Pa's axe and the barking of the brindle bulldog named Jack. Summer and fall followed, each in its slow turn.

These were the very first seasons of Laura's childhood. Now she left them all behind. It was goodbye! goodbye! But a whole lifetime lay ahead.

2

The Prairie

Laura was still too little to remember. She was only a year and a half old. But beneath the burning midsummer sun the wagon rocked gently, like a lullaby.

The road went south over the rounded river hills. It went south through the sudden cold shadows of the bluffs and down the steep, rock-filled ravines which led out upon the gentle road to the west, away from the river. Groves of trees shimmered in the distance. Already the grass was tipped with gold.

Along the road, birds rose startled into the bright air as the wagons passed. When the wagons were gone, they settled slowly back to earth.

The wagon rocked—back and forth, back and forth. Mary could sit in the bed of the wagon and look out over the low backboard watching Aunt Polly and Uncle Henry close behind, the white cover of their wagon billowing in the breeze. The hooves of the horses made a sleepy pattern on the brown wagon road.

Laura couldn't see over the backboard if she sat in the wagon bed. She had to stand up and hold tightly to the smooth wooden backboard with her fingers. What she saw was a circle of woods and hills falling farther and farther behind. She heard the snort of the horses. She felt the lullaby of the wagon, and she felt sleepy. She didn't know where Pa was taking them.

But Pa knew where he was going. He was coming down from the river hills and through the rolling fields of Iowa and south, always south, on the warm and dusty roads of summer. He was going to Missouri.

His rifle was near at hand. So were his hatchet and his powder horn and his patch box and his bullet pouch. But

his pistol was packed away. So was his fiddle, placed carefully in its box and buried in blankets so it wouldn't be broken by the jolting wagon or by a little girl on wobbly legs.

At the edge of the woods in far-off Missouri, Pa would be able to hunt game. He'd build a house on the prairie. And when night came and the stars flew up into the darkness of the sky like fireflies, he would fiddle a song from his honey-brown fiddle. He would make a home in the West for Ma and Mary and Laura.

Pa had bought land in Missouri, sight unseen, while he was still in the Big Woods of Wisconsin. So had Uncle Henry. The man they bought from was named Adamantine Johnson. He was a merchant and a landowner and a banker and a tobacco shipper all rolled into one. Although he wasn't much older than Pa, he was already a wealthy man. Like Pa, he had many brothers and sisters, but they didn't have common names like Peter or George or James. Adamantine Johnson had one sister named Italy and another sister named Sicily and a brother to boot, named Nova Zembla after the islands in Russia. He himself was married to a lady named Pocahontas, who claimed to be descended from the Indian maiden who had saved Captain John Smith.

During the Civil War, Adamantine Johnson had gone to Saint Louis from his home in Chariton County, Missouri, and opened a dry goods store. But after the war, business was bad and he decided to go home again, which he did in 1868. Because he needed money, he decided to sell some of his land in Chariton County. In the spring of that year, Adamantine Johnson seems to have sent his agent up the Mississippi River all the way to Wisconsin and Minnesota, beating the bushes and boasting about Missouri lands. He may even have come along himself.

Pa and Uncle Henry each bought eighty acres of land from Adamantine Johnson's agent, on May 28, 1868. They each promised to pay $900, and they each signed promissory notes, just as Grandpa Ingalls had done so long ago in Jefferson County.

It is possible, of course, that Pa and Uncle Henry made the long journey down to Missouri in the spring to look over the land, as soon as the ice broke up on the river. But this seems unlikely, as all of the documents were written and signed in the Big Woods. Pa and Uncle Henry and Adamantine Johnson's agent appeared before a notary public in the

Big Woods in the first week of July to make everything legal.
And it was after the papers began that the long journey
began.

Now the wagon rocked like a lullaby. They crossed creeks
and hills. They moved slowly across small prairies and
through deep woods, always following the road south. At
night they gathered around a cheery campfire for supper.
The girls played in the grass while Ma and Aunt Polly fried
salt pork in a little iron spider and brewed strong hot coffee
and baked little cakes. Sometimes they even had pancakes
and bacon and molasses.

In these times, when darkness fell across their way, Pa
and Uncle Henry sat and talked about the times that lay
ahead. They would never get to Missouri in time to plant
crops. The best they could hope to do would be to clear
their new land and turn some furrows. Crops could go in
next spring. But what of the winter? How far would it be to
town? Was there work anywhere for a willing man? Pa could
carpenter, and Uncle Henry could probably do the same.
How would they ever pay back the $900 each of them
owed, so the land could really be theirs? Only time and work
and hope could give answers to these questions, not the
night that fell around them.

Day after day the wagons rolled southward. They angled
across Iowa, drifting always to the west. They rolled through
all of July, and inched into August, searching out groves to
camp in and shelter from the hot noon sun.

Soon they were in Missouri, but still they went on and on
until they found the upper reaches of Yellow Creek. Per-
haps they passed the village of Rothville, where the first
store had just been opened. Two miles past town, on a tribu-
tary of Yellow Creek, Pa pulled back on the reins. The
wagons stopped. They were home.

The prairie stretched out before them, golden brown.
Most of the township was prairie and only about a third was
timber—mostly in scattered groves and in long lines of trees
that followed the banks of the many creeks. The house
would go by the trees, close to the creek. The prairies would
be plowed. There was work to be done, and done right away,
before the winds turned from the north and the snow flew.
This was a new beginning.

But Ma could not help looking around her and seeing
that there was nothing here but prairie, nothing but prairie

and trees. There were no roads, no houses, no neighbors, no schools. She could not help thinking, *Who would wish to wander forth in the world, to meet its tempests and its storms?* Pa was shouting, "Let's get to work!"

Winter came with its storms and tempests. Because Laura was too little to remember, it was a silent winter for her books. She left no record of it, of the house or the fireplace or the music in the night. In February she celebrated her second birthday; then came spring and the work of sowing crops. Summer followed. These too are silent seasons. But as the days of summer turned, two things seem to have happened.

For one, the man who bought the little house in the Big Woods from Pa did not keep up his payments for the land as he was supposed to do. No doubt there were good reasons. In the years that followed the Civil War, a depression swept the country. Money was scarce. But money was as scarce for Pa as it could ever be for Mr. Gustafson, who lived in a country settled up. Pa needed the money that had been promised, and there was no way for him to get it from so far away.

So on August 6, 1869, Pa drew up a power of attorney to give Grandpa Ingalls the authority to act for him in the Big Woods. Now Grandpa could make his way through the woods to the little house that Pa had built, to tell Mr. Gustafson: Either you pay for what you bought or we will take the land back and sell it to someone else.

But an even more important thing happened in that hazy Missouri summer. Both Pa and Uncle Henry decided that they wouldn't stay. Perhaps their first small crop had been lost, destroyed by drought or grasshoppers or the hot winds that swept out of the prairies to the southwest. Perhaps there was no work to be had anywhere, not even for a willing man. Perhaps, for Pa, Missouri wasn't far enough west after all.

Uncle Henry and Aunt Polly talked quietly together, alone. They had gone far enough; they wouldn't go farther west. They would return with the cousins the way they had come a year earlier, back to the familiar scenes of the Big Woods.

But Pa wanted the prairies. His fiddle sang of far-away places. Now that he was cut loose and on his own, he didn't

want to go back home. Westward was Kansas and Indian Territory, and even the Indians were moving farther west, toward the setting sun.

Their lands would soon be free lands, open to settlement. A man could homestead there. He wouldn't have to bother with bills of sale and payments and mortgages and power of attorney. All he had to do was make a claim and put his heart and his work into it, and in five years it would be his, simply for the labor.

So once again the wagons were packed, and there were goodbyes. In the fireplace, the coals of the last fire burned red. They crusted over. They flared for a moment like thoughts unsaid, and Ma watched them, and then they died out. Night came.

The wagons started by the early light of morning. One went north from this little unremembered house on the Missouri prairie, north toward home. The other went south.

On September 1, 1869, Pa and Ma were in the town of Keytesville, Missouri, the county seat of Chariton. There the clerk of the Circuit Court certified the power of attorney Pa wanted to send back to the Big Woods. If they weren't already on their way west, they soon would be. The season was late. As in the song, their way lay across the wide Missouri.

The wagon moved slowly across the wide prairie. The hills had been hard; the road was long and dry. The wheels turned so slowly you could count the spokes.

A sudden gust of wind bent the prairie grass, like wind on an inland lake. It caught the wagon cover and puffed it out. It brought the driver to his feet, reins in hand. He spoke to the team, but his words were lost on the wind. And the wagon moved on, at the same steady pace.

From a distance it was impossible to tell this wagon from the hundreds of other wagons that had already moved out on the Kansas prairie, except for the brindle bulldog that marched along behind, a soldier of fortune. "Long strings of canvas-covered wagons are continually streaming in upon us," an observer wrote from the town of Girard in eastern Kansas. "I sometimes wonder whether the East will not be entirely depopulated. Vast sections of country are being filled up as if by magic. 'Welcome!' we say. In this beautiful land there is room for all."

Day after day the wagon crawled across the golden

prairie. Mary and Laura sat in the back, peering over the backboard and feedbox at the faint, lonely track of the wheels. Ma sat up in front with Pa, her eyes shielded from the harsh prairie sun. Pa sat next to her with his pipe, holding the reins. The blue tobacco smell drifted back through the wagon.

The prairie was so wide and so empty it seemed as if no one had ever seen it before. At night they camped, and their campfire made a little ring of light in the immense darkness. By day they moved on, ever westward.

Each one thought his or her own thoughts, until one day Pa pulled the team up short. Pet and Patty, the western mustangs, whooshed. Then the silence came back. The wagon had stopped. Laura and Mary scrambled to the front of the wagon and peeked around Ma and Pa. Ahead of them lay the Verdigris River. Beyond it, on the low bluffs, was a little town of hay and log houses. They were near the end of their long journey.

Carefully Pa led the team down to the river. They had crossed many streams and rivers since the day they'd left the Big Woods of Wisconsin. Each one was different. Each had its element of danger.

Not long before, an ox team that belonged to J. N. DeBruler had become unmanageable in crossing the Verdigris at this very spot. His wagon had tipped over, and down the river four kegs of beer and two barrels of bread went bobbing away. As you can imagine, the men with Mr. De-Bruler got wet that day, but they saved the load.

Pa urged the team into the water; he spoke to them softly. And soon they were safely on the other side—another river had been crossed. The wagon groaned up the low bluff, and once again Laura and Mary peered around Pa's shoulders. They were coming to the little town of log and hay houses. It was a brand-new town, and it was called Independence.

A few weeks before, the first business had opened—Wilson and Irwin's grocery and provision store. In front of it was a hand-painted sign that said *Bred and Pize for Saile huar*. There were a few log buildings, including a double log "hotel" known as the Judson House. Most of the houses were made of hay, though, and even the log buildings had hay roofs. The Indians who pranced on their ponies outside of town called this "Haytown," not Independence. The streets and alleys had been laid out with a pocket compass

in August, but they were still in the imagination of the men
who lived here. The town already had a newspaper, the *In-
dependence Pioneer*, but there was no place in town to pub-
lish it. So the newspaper was published in Oswego, an older
town back east across the Verdigris.

In September, while the Ingallses were still making their
way slowly through the hard Missouri hills, the first settlers
of Independence had had a celebration. They drank the beer
and ate the bread that Mr. DeBruler's men had rescued from
the river. They barbecued an ox. And they heard glorious
speeches by E. R. Trask, who ran the newspaper, and L. T.
Stephenson, who ran the double log hotel. Everyone agreed
the prospects for Independence were very bright indeed.
And they were right.

Within a few weeks, three mills were in operation around
the town, turning out lumber for frame houses and build-
ings. New stores went up in a day, like magic. Settlers were
streaming through Independence. Wilson and Irwin could
count on selling plenty of "bred" and plenty of "pize" to
hungry travelers, even if they did spend most of their time
now harvesting hay in the heart of town.

"Immigration still continues to pour in," the *Pioneer*
boasted. "As many as twenty claims have been taken in this
vicinity in one day. At that rate, every quarter will have an
occupant by spring."

That was just what Pa wanted—a claim on the prairie. He
jumped down from the wagon seat and spoke to some
strangers. Laura couldn't hear what they said, but they were
telling Pa how to find the ford south of town, and where to
find good prairie land for a homestead. Pa climbed back
up on the wagon and picked up the reins. The wagon jerked
forward.

Slowly it turned out of town and moved out upon the
wide prairie, beneath the immense blue sky. They came to
a fork in the road, but Pa knew which way to go. He turned
into the hot draw. The wheels squealed and squeaked as Pa
pulled back with all his might on the brake; the wagon shiv-
ered a moment, and then eased down into the bottomland.

Now the prairie was high above them. Laura heard the
sound of rushing water coming from ahead. Except for that
one sound, they were surrounded by a hot and drowsy still-
ness.

The ford was marked by the ruts of wagon wheels that

had gone before them. The crossing was easy, and when they were safely on the other side Pa let Pet and Patty rest for a moment. He looked back into the wagon, and then with a firm voice he gave the team their command.

The wagon strained forward. Creaking and groaning, it inched up the draw. The small sound of the creek grew fainter and fainter. Soon it was only a whisper; then it was gone. Once again the wagon shivered, and then it was back on the high prairie again.

Here the family camped. In the night, the silence was even greater. They were very near the end of another journey; when again they moved, it was to follow the creek road west, along the southern edge of the draw. They didn't go far.

Pa turned the wagon out upon the golden prairie, where even the faint wagon tracks didn't go. Ahead of them lay a low rise. Pa pulled back on the reins and the wagon stopped, swallowed up in stillness. Here was where he would build a little house.

They were close by Walnut Creek, in the very corner of Rutland Township. They had come thirteen miles from Independence. And Pa was whistling.

Pet and Patty grazed on the lush prairie grass, free at last of the straining leather harness that had pulled the wagon all the way from the hills of Missouri out to the wide Kansas prairie. Walnut Creek lay about a quarter of a mile to the north; beyond it were the low bluffs. Far to the east a faint line of green marked the trees that bordered the Verdigris River, ten miles away.

To Ma, this was a wild and lonely place. It seemed to be a hundred miles from anywhere. But Laura and Mary soon discovered that the prairie was alive with a life of its own. Meadowlarks, with bold black gorgets traced across their breasts, skimmed the top of the prairie grass in long, graceful flights. Tiny dickcissels kept their more discreet distance, clinging to waving stalks of grass and pouring out their song into the bright air. Jackrabbits and gophers traced patterns in the grass, and in the afternoon sky the dark figure of a hawk swung slowly back and forth.

In the evening, phoebe birds and mockers dared short sweeps out across the prairie from the safety of the creek bottom. With their jumbled songs, the darkness rose. Night-

hawks swooped overhead, their flashing, white-banded wings fluttering in confusion. They seemed to skid in the sky, feasting on the last flying insects of the season. The scratching song of the grasshoppers, which had sounded like violins tuning up a midday, slowed down now to a steady reminder that if they stopped singing there would be no sound at all. And the prairie went dark.

It was only a momentary mood of the heart that would say they were a hundred miles from anywhere, and a laughing exaggeration to say they were forty miles from Independence. In this silence and beauty, it only seemed so. Back across the Verdigris was the town of Oswego, already making plans for a mail route to run out from Springfield, Missouri. Oswego, although it was a prairie town, boasted all the advantages of civilization: "fancy cassimers," broadcloths, doeskins, jeans, calicoes, apples, bacon, sugar, sewing machines, oysters, lawyers, washing machines, Yankee notions—even a dentist.

Fort Scott was farther away, and the shelves of its stores groaned with the merchandise of a frontier army—cordials, rectifiers, refiners, "celebrated Amazon ague bitters," Havana cigars, chewing tobacco, wine, beer, ale, porter, and crockery. Even Oswego would soon catch up with this treasure chest of staples to boast of its own "Bourbon, Rye, Scotch & Irish Whiskies! Jamaca and Saint Croix Rums!" and "Blayde's Imperial Bitters, warranteed to cure or prevent FEVER & AGUE!"

In Chetopa one could find "the Best Billiard tables in South Eastern Kansas," and in Baxter Springs one could find a wild time. The railroad was already rushing its way toward Baxter Springs, down in the corner of Kansas, and with it were coming sleek-eyed gamblers and "*Nymphs du Pave.*"

"In their haste the people have forgotten to build churches," one visitor reported, "but they have a nice brewery and something over fifty saloons. I was in one of these where I counted twenty tables, all occupied by men playing cards for drinks, which were brought to them by 'polite lady waiters.'" The observer added, "In one corner was a raised platform occupied by a piano and several musicians who kept up a continual din. In another was a healthy looking chap, with a plug hat and diamond studs, dealing faro to as many gamblers as could crowd around the table." This was really the wild, wild West. Had Ma known about Baxter

Springs, she would have thanked her stars she was a hundred miles from anywhere.

Out on the prairie, Pa spent several days hauling timber for his little house. It was hard work. He would empty out the wagon, hitch up the team, and drive off toward the creek bottom, leaving Ma and Laura and Mary alone in the wide circle of sky and silence. Then he would come back up the rise, dump the logs he had cut, and go back for more. Then one day he had enough logs—about fifty of different lengths were usually enough—and he began to build the little house on the prairie.

The discovery of where Laura lived on the Kansas prairie is an interesting story. After all, there was no sign there saying: "This is it. Signed, Charles Ingalls." And he didn't enter his claim in the records of the county courthouse, as he did everywhere else, because he made no claim. This was still Indian Territory. Finding the spot where the little house stood had to be a real piece of detective work, and in this case the ingenious detective was Margaret Clement, a bookseller and former school teacher who lives in Independence, Kansas.

Even before Margaret Clement began to look for the place where the little house had stood, another detective had been at work. This was Garth Williams, the famous illustrator whose drawings add such marvelous charm and reality to the *Little House* books. To prepare himself to illustrate Laura's books, Williams visited as many of the places where she lived as he could, to get the feel of the country and to see with his own eyes what she saw with hers. One day he found himself in Oklahoma, following a dirt road along the Verdigris River.

"As I rounded a bend," he wrote, "I met an elderly man driving a two-horse wagon. I stopped to speak to him and asked if he knew anything of the Ingalls family. He told me that he had arrived in the vicinity when he was a boy and could recall the people who took over the little house on the prairie after the Ingalls family left. The house had now gone but at least I could see where it used to stand."

But it was the wrong little house, and the wrong prairie. For many years it was thought that the little house on the prairie was in Oklahoma, because before it became a state Oklahoma was known as Indian Territory. But people forgot that there was also a small strip of Indian Territory in Kan-

sas. It was a long time before anyone thought to look in the census records to see whether Pa was listed. And there they found him—in Rutland Township, Montgomery County, Kansas. The Ingalls family Bible also shows that Carrie was born in Montgomery County, so this made a very strong case.

But it was only a start. The census only showed what township people lived in; it didn't tell exactly where they lived within the township, and townships are six miles square. So Margaret Clement went to work. She spent long hours searching through the census records. She made a list of every person who lived in Rutland Township. Then she went to the courthouse, and spent many more hours looking for patents or claims. The very first claims, she discovered, were not filed until the summer of 1871. Pa, of course, did not file one.

Next, she made a map. Wherever she found a claim entered in the records, she wrote down on the map the number that had been given to that family in the census. In this way she could trace the path taken by the census taker. The little house on the prairie was the eighty-ninth house on the census taker's list. Margaret Clement was especially anxious to find the claims for the families who were listed just before and just after Pa on the census; that way, even though Pa himself hadn't filed a claim, she'd be able to find out where Pa's house fit into the path taken by the census taker.

She found that all the houses listed from 83 to 92 were in the southeast corner of the township. In the bottom two sections of that corner, all but two quarter-sections had claims filed on them by people who had been listed on the census. Those two quarter-sections had no claims filed at all. The little house on the prairie, Margaret Clement decided, had stood on one of them.

So she went out to look them over, inch by inch. She discovered two things. The people who have owned this land for the past fifty years pointed out that there had never been a well on one of the quarter-sections. But on the other quarter-section there was a beautiful hand-dug well. Then she looked at an old atlas of the county, which was printed only ten years after Pa and Ma left Kansas. On the quarter-section without a well there was no house. But on the quarter-section with a well, there was indeed a house. This was

the little house on the prairie, tucked away down in the corner of Section 36.

And most amazing of all, even today, the description of the land exactly fits the description Laura wrote in *The Little House on the Prairie*—the creek bottom to the north, the bluffs beyond, and far to the east the gray-green line of trees along the Verdigris.

Even Laura didn't know exactly where the little house on the prairie was located, because she was too little to remember. But that doesn't mean she wasn't curious about where it could have been. Many years later, when she had grown up and begun writing the *Little House* books, she went off one day for an automobile ride with her daughter. She didn't say where she was going, or why. But she did say later that they had car trouble in a little Oklahoma town. That little town was exactly forty miles from Independence, and it doesn't take much imagination to guess what she was looking for.

Of course, the little house was only thirteen miles from Independence; it had only seemed like forty miles. And settlers had come into the country so fast in the fall of 1869 that the little house was soon surrounded by neighbors.

These neighbors weren't so close as they would have been in a town or a city. They lived about a mile apart, or half a mile, or sometimes less, and in the new country, especially in Indian Territory, it was good to know that they were there. One of them, a certain wildcat from Tennessee, even helped Pa finish his little house of strong notched logs, Laura wrote.

And that makes another mystery, even more difficult to solve than the first—a mystery that's probably impossible to solve. Who were Laura's neighbors on the prairie? In her book, she mentions the names of only three neighbor families. These were Mr. Edwards, the wildcat from Tennessee, who lived across the creek; Mr. and Mrs. Scott, who, Laura wrote, lived less than three miles away in a hollow on the high prairie; and Dr. Tann, the black doctor. Two bachelors lived six miles beyond the Scotts, but she doesn't give their names.

Yet in the first draft of her book, and in some notes about her life made before the *Little House* books were written, Laura mentions many other families: Mr. Edwards, Mr. Scott, the black doctor—although she doesn't tell us his

name. She mentions two bachelors, John Turner and Mr.
Jones; two other bachelors living up the creek, Dick and
Tom; Mr. Brown; Mr. Stover; Mrs. Robertson; Mr. Thompson, who was a bachelor, who lived across the creek, and
who helped Pa build the little house.

Now that more than a hundred years have passed, only
one of these people can actually be named, and that is the
one Laura did not name—Dr. George A. Tann. Dr. Tann
was exactly the same age as Pa, 33 years old. He was born
in Pennsylvania and he lived with his elderly father and his
mother in a house less than a mile to the north of Laura's,
up along the banks of Walnut Creek. His father was a
farmer, his mother kept house. With them lived a 13-year-
old girl, Mary Berry, who was listed on the census as a
servant.

Dr. Tann was a homeopathic surgeon, practicing a
branch of medicine still used in some places today. In the
old days it was called the "science of littles." A homeopathic doctor carefully studied the symptoms of a patient
who was sick and then selected a remedy that would produce similar symptoms in the patient. Dr. Tann had been
a Union soldier in the Civil War, and he was later a doctor to
the Osage Indians. He settled in Rutland Township in 1869—
the same year Pa did—and he spent the rest of his life there,
building up his practice among "some of the best known
families of the county" and dying in 1909, widely respected.

Of the other families Laura mentions, none can be said
with certainty to be listed on the census or to be among
those who made land claims in the neighborhood. Still, we
might guess at some of them.

Two families named Scott lived nearby. William H. Scott,
a farmer, lived less than two miles from the little house on
the prairie in Fawn Creek Township. This Mr. Scott first appears in the records in the spring of 1873, long after Laura
had left, but it seems very likely that he had come to the
neighborhood in the first rush of emigration. This was probably the Scott family of Laura's book.

But there was another Scott—one who was not in the census and who did not file a land claim, but who definitely
did live near the little house on the prairie in the year Laura
lived there. This was James L. Scott, a surveyor. He had an
office in Independence where he sold claims, but he also had
a house at the head of Onion Creek, on land owned by a

blacksmith named S. B. Simmons, three or four miles from the little house on the prairie.

Mr. Edwards is a puzzle. If ever anyone sounded like him it would be J. H. Edwards, who ran Ed's Saloon and dealt in "liquor and cigars" in far-off Fort Scott. But that would certainly be too far away to be Laura's wildcat from Tennessee.

There are people we know for sure lived on the prairie near Ma and Pa. Laura didn't mention them because she didn't remember them, and she had no chance to look at the census records where their names are recorded. These neighbors included Joseph James from Kentucky, Alexander Johnson from Illinois, and John Rowles from Maryland, and Ed Mason and Robert Gilmore and John Friendly, and even a man whose name sums up the search for Laura's neighbors: Mr. Riddle.

Out on the prairie the nights grew cold, and the prairie light took on a chill white quality. But during the day, summer still clung to the rolling land. Hawks were overhead, making sharp shadows in the grass. Laura and Mary went off together to play in the drowsy air along the creek bottoms. They spied out the fresh tracks of silent deer and watched carefully for snakes. They watched the waters of Walnut Creek bubbling eastward, running into Onion Creek and then the Verdigris and then the Arkansas and then the Mississippi. The days began to grow short, and it was during this time that Jack the brindle bulldog got into a fight with Mr. Scott's dogs and all the neighbors became afraid of Jack.

One day while Pa was off hunting, two Indians came riding slowly down the Indian trail. They looked so fierce that Laura shivered. With Mary, she had played that day near the stable where Jack was chained. "I was two years, the littlest," she said many years later in her memoirs. When the Indians disappeared, her heart pounded. There was only one place they could have gone.

The Indians were Osages, and this was the story of "Indians in the House." Their visit was a reminder that the little house on the prairie was on Indian Territory. Ma wasn't the only woman visited by the Osages. Eliza Wyckoff, a pioneer from Ohio, came to Indian Territory in the same year the Ingallses did, a few months earlier. Eliza settled with

her family in a little grove along the Verdigris, less than ten miles from the little house on the prairie.

One day she was alone in her cabin with her Uncle Enoch and Aunt Nancy. The men had gone off to look over the country. "While they were gone," she recalled, "an Indian came and showed Uncle and Aunt and I how they would come and shoot through the cracks and scalp us and tear down our houses. We were so frightened that when the men came home we wanted to leave."

Another time Eliza was alone—not even Uncle Enoch and Aunt Nancy were there—when six Osage braves came to visit. Her description of the visit suggests that it was very much like Ma's own experience. It occurred at the same time.

One morning when I was alone, six fine looking young Indian braves, dressed in gaily attire, came to our house. They stayed about half an hour, and laughed and talked to each other. I sat in the back part of the house and felt very uncomfortable. I could not understand anything they said and felt very much relieved when they left.

They called on each family in the neighborhood. They were on dress parade. They had new white blankets, blue-striped at one end, light calico shirts, red flannel leggins and mocassins, and a beaded woolen scarf around the waist so they could throw the blanket back when too warm.

They never went from the town without their blanket, even in the hottest weather. They had thimbles and sleigh-bells fastened down the outside of the leggins to jingle when they walked. They wore lovely bead necklaces and beaded garters over their leggins. Some had pink or white mussel shell breast pins. They were always painted in all sorts of stripes and colors.

Some of the Indians had two slits in their ears, one at the lower part and one in the rim. They would have three or four little ear drops in one slit. These were made of tin and washed with brass.

When they were not on "dress parade," the Osage settled for simpler dress—a breechclout to which they fastened a

bowie knife, a looking glass, and a little bag of paint. The breechclout was often made from the skin of a skunk. "Only the smell of Indians affects us," complained Eliza's Uncle Enoch O'Brien, "for they stink as bad as Polecats." Ma would certainly have agreed with that, although Eliza—beyond her fear—found a beauty in these Indian braves.

The domain of the Osage once ran from the Gulf of Mexico to the Missouri River, and from the Mississippi to the Rocky Mountains. But bit by bit it had fallen away in treaties with the whites. When the flood of settlement brought Pa and other men to southeastern Kansas in 1869, the Osage lands had shrunk to what was called the "Diminished Reserve." This was only a small strip of land bordering Indian Territory, and it was held by the Osage only through a war of nerves.

Most of the men who came to this new country were members of that "grand army of pioneers who respecting law and the rights of others have with industry, energy and courage . . . made the wilderness to bloom as a rose." So the Indian agent, Isaac Gibson, called them. But among this grand army he saw many reckless and aggressive men. "Desperadoes," he said they were.

"The question will suggest itself," Agent Gibson observed. "Which of these people are the savages?" The war of nerves was waged on both sides. When the Osage returned to the valley of the Verdigris from their hunts for buffalo, they often found their cabins taken over by settlers. They found their corn patches plowed up by white men, their homes burned down, their timber cut and carried off. Sometimes they were chased by settlers with axes and rifles. For their part, the Osage tried their best to put the scare on the settlers. They stole horses, and took cattle and hogs for food. They burned the hay harvest of the new settlers. They tore down fences and even cabins.

Uncle Enoch O'Brien's unpublished diary of his early days along the Verdigris in 1869 is full of references like this:

Just after dinner eleven Indians come to see us with an interpreter and give us to understand that we could not stay here.

And this:

We found Wyckoff's house tore down, but we can soon
put it up again.

And this:

Our Vigilance committee meets today & once every
month. The law is hang a man if he don't act right.

Uncle Enoch was certainly no desperado. He plowed land
for the Osages, he invited them to dinner, he planted corn
for them, he even let them store corn in his attic while they
went on their hunt so it wouldn't be burned or carried off
by less friendly settlers. Yet even he lived in an air of un-
certainty. "We don't know what a day will bring forth," he
confessed.

Isaac Gibson felt sure that war was coming between the
Indians and the settlers. "The Osages," he warned his su-
periors in Washington, "enroll about forty-four hundred,
are classed among the savages, and could massacre the
inhabitants of this valley in a few hours, and if they should
be driven to do so by spring, I would not be surprised." This
warning was made in January of 1870. By then, many of
the Osage had moved off from the Verdigris and taken up
a new camp on Onion Creek, not far from the little house of
Ma and Pa and Mary and Laura. And in the still night air,
Laura heard the sound of drums.

For the girls, Christmas had passed quietly on the lonely
prairie. The winter was remarkably mild, although some
days were "as cold as Greenland." On those mornings Laura
woke up to find each blade of bone-colored prairie grass
covered with a trim white jacket of frost. But she was still
too little to remember. In February she was three years old.

Ma and Pa went to Independence in February, and the
girls no doubt went with them. With the war of nerves going
on between the Osage and the settlers, it would not have been
wise to leave them home alone, even though Mary was five
years old already and very responsible.

For months Pa had been unable to pay anything to
Adamantine Johnson for the Missouri land he had bought,
and that was what his trip to Independence was about. His
debt had risen all the way to $1,080. But Adamantine John-

son was willing to forget it if Pa would sign the land back over to him. And *that* Pa was very happy to do. He went to Independence to sign the papers.

Ma and Pa and the girls found that the little town was bursting at its seams. "Independence is growing," the newspaper crowed, proudly pointing out that there were now several two-story buildings in town. "Forty frame buildings have been erected in as many days. Since our saw mills have been turning out lumber, the work of building has went on right merrily, and substantial frame buildings have taken the place of booths, tents and hay houses.

"Four months ago, the tall prairie grass waved where today are rows of buildings and scenes of busy life. To one unused to the rapid growth of the west, it would seem as the work of magic. But hundreds of strong arms and willing hands have been, and are still engaged, in the work of transforming these but recently prairie wilds into comfortable homes.

"Since the first of September last, more than one hundred families have settled in this place, and every day witnesses new arrivals."

It would not be surprising to find that Pa's own strong arm and willing hand had played a part in this magical growth of Independence, for he may have found work in town as a carpenter. There is no question at all, however, that Independence was full of "scenes of busy life." There were attorneys in town now, and insurance men, three town doctors, and a dentist. There were a saddle and harness maker, a furniture store, and a boot shop. There were three churches, a barber, a carriage maker, and a nursery where settlers could buy trees to plant on the prairie. There were a blacksmith and Mrs. Hudiberg's millinery store and Brodie's bakery, a sign painter and a grocery and plenty of whisky being sold.

There was even Dunlavy and Maloney's "Verdigris Valley Drug Emporium," where ladies could buy paints, stationery, fancy toys, and a perfume called "Love Among the Roses." Independence was getting very civilized. The newspaper came out once a week, and even out on the prairie, travelers and homesteaders passed along the paper when they were through with it. In it, Ma and Pa could read about the comedies and curiosities of the world far away:

An exchange advertises for "girls for cooking." We prefer ours raw.

To do the thing properly in New York at a wedding, the bride must have eight bridesmaids, and a hundred-dollar poodle besides the one she marries.

The Cincinnati Gazette tells us how a young man was "killed in a bad place." By the way, where is a *good* place to be killed?

Philadelphia gulps down a hundred tons of strawberries daily.

An old lady, asked by the minister what she thought of the doctrine of "total depravity," replied that she thought it was a very good doctrine if men would only live up to it.

Far from the Kansas prairies, the America of 1870 panted after its frivolous pursuits, its diversions and its games. They called it the Gilded Age. On the prairie itself there was a sense of remoteness and peace. The seasons turned, life had its routines. The curiosities were of a different sort.

There was always land to break, and working the land, a man could not help but notice the snakes—copperheads in the wet spots and rattlesnakes out on the high dry prairie. Old Enoch O'Brien off near the Verdigris once killed nineteen copperheads in a matter of weeks. One, he said, was three feet long and "as thick as my arm." June always brought mosquitoes. They were particularly pesky down in the bottoms, but were bad enough out on the prairie as well —"Nearly as big as snow birds & bad to bite," Uncle Enoch grumped. Pa kept piles of grass burning around the little house and the stable at night, trying to keep the mosquitoes away. And always in these pioneer times, wildcats prowled the bottoms after dark—as Pa found out when he went to investigate a cry in the night.

For Laura, the sudden arrival of a herd of Texas longhorns on the prairie west of the little house was a curiosity and a surprise. As they neared the end of their long drive, the cowboys often let the longhorns pause a few days and fatten up on the juicy green grasses of the Verdigris Valley. Then they pushed on to market in Kansas, to the wild frontier towns which the railroad had reached.

On nights when the cattle were close, Laura lay in bed and listened to the soft and mournful songs of the cowhands as they calmed the herd. The music drifted in across the dark prairie, and then she must have felt the spirit of peace that had come to this distant place. Yet there was something else there, something she couldn't name. Something subtle and dangerous shimmered beneath the surface of this prairie summer, like a snake hidden in the grass. The Osage were unhappy.

They had not gone away, as everyone had expected. Every day seemed to bring more fights between Indian and settler. With every turn of the prairie plow, the trouble deepened. With every death, the Indians clung more firmly to their prairie home. New songs came floating through the air across the prairie.

They weren't the lullabies of cowboys. They were eerie songs, songs to make your hair stand on end, and they came from the Indian camps scattered across the valley. "At daybreak every morning," Eliza Wyckoff wrote in her diary, "they made a hideous sing-song noise lasting a half hour, mourning for their dead."

Usually in June the Osage mounted their ponies and rode west into the high prairie, hunting for buffalo. Every year their hunt took them farther from home. Every year they came back with fewer and fewer skins and robes. While they were gone it was quiet in the valley of the Verdigris. But they always came back.

One day while the Indians were gone, Laura didn't feel like playing. Her legs ached and she was cold, even in the hot sunshine by the door of the little house. She was very thirsty. This was the start of the fever and ague, and quick as a wink Ma and Pa and Mary were sick with it too. Fever and ague was one of the most common sicknesses on the frontier. It made you yawn, it made you weak and sleepy, it made you take such a chill that your teeth chattered "like a harp with a thousand strings." And it was so bad in some parts of the country that people were warned away:

> Don't go to Michigan, that land of ills;
> The word means ague, fever and chills.

Even Ma and Pa were unable to move about when fever and ague struck the little house on the prairie. They lay in

bed, chilled to the heart and shaking so badly they couldn't stop. That's when Dr. Tann stopped by the little house and saved them. He gave them bitter quinine to swallow, and then with his big smile and his rolling laugh he was off to the house of another settler. Then fat Mrs. Scott came over to bustle about in the little house and make sure everyone had something to eat.

There seemed to be an epidemic of fever and ague every summer. But it wasn't caused by watermelons, as Mrs. Scott insisted and Pa denied, or by "miasmatic gases" from the creek bottoms and low spots in the prairie, as other settlers said. It was caused by mosquitoes, and today it's called malaria. So Pa was right about the watermelons after all, and the thought of one helped him get well fast. Then off he went to the creek bottoms and came home with a big ripe melon to celebrate.

Pa had a very special reason to celebrate, although Laura didn't know it and Mary didn't either. One day, with a twinkle in his eye, he asked the girls if they'd like to go and visit the Indian camp by the creek bluffs. The Indians were gone on their hunt and there could be no danger. So off they went, leaving Ma alone in the little house and Mrs. Scott on her way over.

It was the third day of August. The ground was hot and the leaves of the sumac were already turning bright red. All afternoon Pa and Laura and Mary poked around the Indian camp, picking up scattered beads and reading the story that was told by the tracks of big moccasins and little moccasins around the campfires of the Osage. Jackrabbits bounced out of their way and squirrels chattered up the trees. Once Pa raised his rifle quickly to his eye and squeezed the trigger. He had a squirrel! Even Pa was having fun.

Then the sun began to drop toward the summery land. It was time to turn for home. Pa swung his little half-pint up onto his shoulders and took hold of Mary's hand, and they began the long walk back across the prairie to the little house.

When they got there, Mrs. Scott stood smiling at the door. She had seen them coming. They stepped into the darkness of the cabin, and there was Ma tucked away in bed—and there with Ma was Pa's reason to celebrate, a tiny baby sister with a face as red as a sumac leaf and hair as black as an

Indian's. They called her Caroline, after Ma, and for dinner everyone had roast squirrel—except Carrie, of course.

Not even two weeks later an assistant U.S. marshal came riding through the township to take the census. His name was Asa Hairgrove, and he put Ma and Pa and Mary and Laura and baby Carrie down as the ninetieth family "numbered in the order of visitation" (although their house was the eighty-ninth house). Pa was listed as a carpenter, not a farmer, and Ma was shown as "keeping house." But Asa Hairgrove spelled their name "Ingles," not Ingalls. Perhaps he didn't actually come to the little house but got his information from Dr. Tann, whose house he had just visited. Or perhaps he never bothered to ask Pa how his name was spelled, because earlier on his census list Asa Hairgrove had found a family who called themselves Ingles.

There was a place on the census schedule to list the value of land held by each settler, but it wasn't filled in. Instead, an ominous note was written across the column: "The reason no value was carried out . . . is that the Lands belong to the Osage Indians and Settlers had no title to said Lands."

The Indians came back. They gathered in little groups down in the bottoms and by the bluffs, barking their songs. They raced this way and that across the prairie on their magnificent ponies. Now, more than ever, they paid surprise visits to the little cabins of the settlers. Now, more than ever, it seemed that war was coming. The cry that came up from the creek bottoms was a war cry.

Pa went out among the Indians all the time as he hunted and trapped along Walnut Creek. They didn't harm him. Ma couldn't help but be afraid, though, when the doorway suddenly darkened and the Osage braves walked in, pointing to this and that and talking to each other in their Indian language.

Two years earlier they had signed a treaty for all their lands. That started the trouble, for it triggered the rush of settlers out upon the Diminished Reserve. But the treaty had never gone into effect. Now the old Indian trails were blocked by farms and plowed fields. Wild animals were scarce, and cattle grazed lazily on the lonely prairie swells. Wagon roads crossed the prairie, and clouds of yellow dust followed horsemen and teamsters wherever they went. For all this, the Osage had received nothing in return.

The time had come for them to decide: fight or run. For a time, it seemed certain they would fight. Then, near summer's end, the Osage were offered a new treaty for their lands. Unlike the old treaty, this one more than doubled the price the government would pay for each acre of Indian land. But the Osage would have to leave. They would have to find a new home in Indian Territory.

They held many councils. The sound of drums grew loud. But in the end they knew they were outnumbered, and they decided to go.

Band by band, the Osage drifted across the golden prairies toward the house of the Indian agency on Drum Creek. Everywhere they looked were farms and white men. Their time on these prairies was over; the dreams of all their generations had come to an end. The Indians had been driven from their prairie home.

Among the proud Osage leaders who gathered at Drum Creek was one whom Laura called Soldat du Chene. It was he who had spoken French to Pa, and had argued against war. His name was French. It meant "oak soldier," and it meant that he was a strong-hearted leader of his people. But it can't be found in any of the records of that time. Generations before, when the French first worked their way up the rivers to the prairies of what one day would be Kansas, there was an Osage chief whose name was Soldat du Chene, but he had been dead for many, many years. Perhaps this was his grandson, or his great-grandson. Perhaps it was actually Augustus Captain, one of the Osage leaders who helped select the lands to which the tribe would move.

It's always interesting to know the real names of people in books, but we'll never know who Soldat du Chene really was. Even Laura didn't know. When she was writing of her days on the Kansas prairie, she asked an expert whether there had been an Indian by that name, and even he couldn't help. We "do not find any record of the story you are looking for about the Osage chief in 1870–71," he told her. But even without knowing his name, we know this about Soldat du Chene: he was strong-hearted and brave, so strong-hearted and brave that he made his voice talk for peace. We know this because of the name Laura gave him.

The Osage accepted the new treaty on a September day before the start of their fall hunt; they had no real choice.

This time they would go forever. This time they would not return.

The ponies nickered and pranced, held back by the Osage braves. The women mounted, and then the braves swung up behind them, and the ponies stood calm in the September air. Then the lines began to move, up from Drum Creek and out across the prairie to the southwest. Everyone watched them go.

Down along the Verdigris, a boy from Indiana was camped with his family. His name was Laban Records, and he was fourteen years old. He had never seen an Indian. But as he fished with his brother at the foot of a high bank along the river, he heard the clump-clump-clump of horses' hooves. He scrambled up the bank to see what was happening. "Within ten feet of the astonished boy was an old Indian mounted on a horse," one of Laban's descendants wrote many years later. "And he was at the head of a jogging cavalcade that extended back as far as the boy could see." These were the Osage, leaving the prairies they called home.

They crossed a ford, finding a good camping place at a bend of the river. Night fell, the Indian women gathered dry wood, and great bonfires leaped and crackled in the darkness. As Laban fell asleep, he heard the slow, steady song of tom-toms.

Eliza Wyckoff had seen the Osage on the move, too. "They had saddle-trees with sheepskin over them to ride on," she recalled, "and sacks made of rawhide that would hold a bushel or more. They would fill these sacks and strap them on lengthwise, two on a side and one on top, or put three on, and the squaw ride on top and drive the pony that had five on." The ponies looked like covered wagons.

Day after day the Indians rode out, until one day they rode up from the creek bottoms west of the Verdigris along the old Indian trail—the braves with proud, still faces, the women with their bundles and babies. They rode silently by a little house on the prairie with glass windows, and a man and a woman watched them, and a girl named Laura and a girl named Mary, and a little baby named Carrie, until at last they were gone and there was nothing left but the silent, empty prairie and the dust along the old trail where they had passed.

The Indians did not come back.

❋ ❋ ❋

Fall passed quickly, and then winter. At night, from the little house on the prairie, came the faint dry sound of coughing. The Ingalls family—all except baby Carrie—had whooping cough. There were many folk cures for the whooping cough: eat the skin of a snake, drink white ant tea, hang a bag of live ground-bugs around the neck of the person who is sick. But no doubt Dr. Tann came over to take care of them, and these remedies were not needed.

And then one day a neighbor came up to the little house carrying a letter from Independence. Laura tells about it in an early draft of these long-ago times. The letter was for Pa, and as he opened it Ma stood by with a frown. "Don't look so sober, Caroline," Pa laughed. The letter was from the man who had bought Pa's house in the Big Woods. He wanted Pa to come home and take back his house and farm.

"Says he don't want to finish paying for it because he wants to go west," Pa said. "So we'll take back the land and let him go. That makes everything easy." Ma was not so sure. A whole year was gone, she sighed. But Pa could already feel the jiggle of the wagon and the fresh wind in his hair. He told Ma that they had all the time there was.

So the wagon was packed, the doorlatch of the little house was hung out for whomever might need it, and once again it was goodbye. Other settlers were going out, too, and many rode with them as far as Independence. But then each went his separate way.

Pa's way was east, back the way he had come, and out upon the prairies beyond the town his voice rang loud and clear:

> Row the boat lightly, love, over the sea;
> Daily and nightly I'll wander with thee.

Ma was lost in her own thoughts: *Who would wish to leave home and wander forth in the world to meet its tempests and storms? Without a mother's watchful care and a sister's tender love? Not one.*

They were going home.

3

Back to the Big Woods

The road ahead was long and hard. It stretched across
creeks and rivers from the green prairies of Kansas into the
blue Missouri hills. It wound up narrow ravines and out upon
the flat Iowa farmland, where fences already divided the land
into civilized squares. It led north and east for hundreds of
miles, against the tide of emigration, toward the rounded
river hills of the upper Mississippi.

But to Ma and Pa, the road didn't seem too hard or too
long. It was the road that would take them home.

The little mustangs, Pet and Patty, pulled the wagon
slowly across the prairie. Good old Jack trotted in the wagon
track. In a flash he would dart off, and the girls would hear
him barking deep in the prairie grass. In the distance a bird
would leap into the air, and Jack would come jogging back.
Jack always came back.

Baby Carrie was so little that Ma kept her up in front
most of the time, rocking her to the lullaby of the wagon. Pa
sat with his feet propped up on a sack of corn, in front of the
little cupboard with food and dishes, that he had placed
carefully beneath the wagon seat. Rarely did they meet
another wagon. When they did, it was going west, and Ma
and Pa raised their hands or nodded to them, wishing them
luck.

Laura was at last big enough to sit on the thin bed of
ticking and blankets in the back of the wagon with Mary, to
smell the sweet smell of fresh straw and peer over the back-
board at the lonely wagon tracks behind them. This time
there was no Uncle Henry close behind, there were no other
horses making a sleepy pattern with their hooves on the
prairie road. This time they were alone. They were solitary
voyagers on an ocean of prairie.

The girls watched for spring storms coming up on the western wind. When the dark clouds piled up like pudding in the sky, they warned Pa, and the wagon stopped. Pa would hop down from the wagon seat, drop the canvas top over the open sides of the wagon, and tie it down. He would lower the flap over the back, and Ma would place Carrie gently down on the floor of the wagon and step carefully back into the dark cave. And then the rains would come.

The rains came slapping at the canvas with a steady stinging sound that sounded like the sky was tearing. Thunder rolled far off across the empty prairie. Laura and Mary and Ma and Carrie sat in the dark wagon like mice in their nest. As long as they didn't brush up against the canvas they could stay cozy and dry. A half-circle of light from the very front of the wagon showed Pa's dark shape hunched over the reins: water streamed off the brim of his hat, and under his breath all he could say was "Great Gehosophat!"

The storms came often, catching up with the little wagon and passing by with a boom and a bang. The creeks grew higher, the streams ran faster and faster.

It was then, when they had left the Kansas prairies and crossed into Missouri, that they came to a stream in which the water surged wildly from bank to bank and branches of trees surged by in dizzy circles. Pa stopped and searched for the ford. He looked carefully at the far bank for the tell-tale cuts of wagon tracks. Then he decided to cross.

The wagon shuddered, swayed, then floated free. That was the time Pa jumped off the footboard and plunged into the stream to help the team. All Laura could see was Pa's head in the water and Ma holding the reins. It was a close call, but they were safe. They were still together, and they were going home

The wagon moved on, into the Missouri hills. After they had crossed the ford, they came to a little log house in the woods. It was empty, just as the little house on the prairie was empty now. But Pa soon had a blazing fire going in the big stone fireplace, and its cheerful glow made the empty house seem almost like home.

Pa was short of money and they were short of food. It was too early in the season to live off the land and too hard to hunt in the muddy fields and wet woods. So they decided to stay in this empty little house for a while, and Pa went

to work for the man who owned it, to earn enough money
to continue their journey.

Every day Pa went off alone to work. Every day Ma and
the girls were alone in the little cabin. It was like home and
it wasn't like home. It was like home because Ma was there,
and Mary and Carrie, and there was work to do. But still it
was just an empty little cabin in the woods, and they knew
they wouldn't stay there very long. It was just a resting place
between here and there on the long road home.

In that house one windy day, Ma sat quietly with the girls.
Pa was gone, and the fire burned merrily in the big stone
fireplace. Ma heard a crackling sound she hadn't heard be-
fore. She looked around quickly and then peered up the
flue: the chimney was on fire! In and out of the little house
she flew, with Laura right after, to fight the fire high in the
chimney. Ma poured a pail of cold water on the fire in the
hearth and soon the fire was out.

But danger seemed to be following them. It made Ma
more anxious than ever to be back in the Big Woods.

Pa agreed; perhaps he had worked long enough in Mis-
souri. They could buy provisions with the money he had
earned and be on their way again. One thing was certain,
though. Pet and Patty, the little mustangs, could never make
the long trip. They were simply too small to pull the heavy
wagon all the many miles yet to go, through the Missouri
hills and across the Iowa farmland and up to the high bluffs
and rounded river hills around Lake Pepin. So Pa swapped
Pet and Patty for a team of bigger horses. He carefully
packed all of their things in the wagon that had been put
into the little empty house to make it seem more like home.

Then, once again, Ma and Pa and Laura and Mary and
Baby Carrie were on their long way home.

On this long road over the weeks that followed, some-
thing interesting happened to Laura. She began to remem-
ber. She was four years old and her eyes saw everything:
spring flowers of white and red on the leafy floor of the
woods where the wagon passed, trees casting green shadows,
the bright blue sky overhead. She heard sounds: the creak-
ing tick of the wagon wheels, the whoosh and snort of the
hungry horses as they nosed into the feed box, the soft voice
of her father's singing, "Daily and nightly I'll wander with
thee. . . ." She smelled the smells of the wet woods and the
sun-warmed meadow, and the close, dusty smell of corn

and oats in the back of the wagon. All of these things she
saw and heard and smelled and remembered.

The deep mine of her memory began to fill—with words
and images, with the scents and sounds and sights of pioneer
America, with remembrances of tears and laughter, of bon-
fires and fiddle music. It built up bit by bit—a sound, a feel-
ing, a hope that came true—until her memory was as full and
rich as the pantry of a farmer's wife in good times. Each
thing in it brought a remembrance of other things. A sound
recalled a place, a place recalled a laugh and the angle of
the sun, the angle of the sun recalled a hayfield and the
sense of being lost, and found.

Years later Laura would work this rich mine of memory
and write the loveliest stories of all of what it was like to be
a pioneer girl in America. She told a friend then that she
remembered everything in her books except the stories of
her life on the prairies of Kansas, in Indian Territory.
Those were Pa's stories and Ma's stories and Mary's stories,
because they had been old enough to remember.

But now, as the little wagon with its white canvas top
moved slowly northward toward the river, the things that
happened fell for the first time within the province of her
own memory. They began to be Laura's stories.

It was the month of May. It was springtime along the
shores of Lake Pepin, and the long journey was nearly over.

Across the river the wagon rumbled through the little
town of Pepin, past the stores with their false fronts, past
the rows of houses, out to the dirt wagon road along Lost
Creek, turning north to the distant hills. Pa sat on the edge
of the wagon seat. Ma had Carrie on her lap. It had been
three long years since they left the Big Woods of Wisconsin
—they could hardly wait.

The road followed the west branch of Lost Creek up
between the bluffs. On the level places, Pa let the team rest.
But then they attacked the steep ascent again. The wagon
tipped back, Laura and Mary wedged themselves against
the backboard, the horses wheezed and whinnied. And at
last they reached the top of the bluff.

The team trotted swiftly past Barry Corner and up
around the curve toward the little house in the Big Woods.
And then there it was—the little house, with the two great
oaks in the clearing, the friendly shuttered windows, the
chimney Pa and Uncle Henry had built with their own

hands. For Pa and for Ma and for Mary, this little house was home. Of all the little houses in the entire world, this alone was home. Laura tried hard to remember, but she'd been little more than a year old when they'd left this little house, and she couldn't remember it.

Gust Gustafson and his family still lived in the little house; they hadn't yet gone west. So Pa stopped and told him they had come home, and then he drove the team up the road to Uncle Henry's house and its yard of big stumps.

There Uncle Henry and Aunt Polly and the cousins tumbled out of the house like it was the last day of school. They hadn't seen each other since that day in Missouri when one wagon had headed north toward home and the other had rolled on toward Indian Territory. All the other aunts and uncles and cousins would have been there too, if they had only known what day Pa would be driving his wagon up the steep bluffs on the Lost Creek road. But they had no way of knowing how long it would take to make the journey from the far-off prairies of Kansas.

Uncle Henry's family gave them so big a welcome that even Laura knew she was home. "We lived with them until the people who were in our house moved away," she said in her memoir.

The neighborhood had changed little in the three years they'd been gone. The wagon road that wound through the Big Woods past the little house was more traveled now, but it was no highway. There were still silences in the great woods. In the thin red light of evening, deer still nosed cautiously into the clearing near the house, and at night bears crashed through the underbrush. Some of the neighbors had moved on to other places; some new people had moved into the Big Woods. And some of the people who had been there before were still there now—the Huleatts, for instance, and the Petersons, and other families Ma and Pa had known as neighbors.

Before long, Gust Gustafson moved out of the little house and went west, and Ma and Pa and the girls moved back in. It was a cozy house, this first of Laura's little houses that was now the third. She remembered that it had three rooms, although she later described only two—a large main room with a front and a back door, and a little bedroom with shuttered windows. The windows in the big room were made of glass, just like the windows Pa had bought for the

little house on the prairie. Ma considered glass windows a
signature of civilization—and, after all, they did keep the
bugs out.

Upstairs was a large attic where the girls could sleep
when there was company, or could play on a rainy day,
and around the house itself was a zig-zag split-rail fence
that kept the curious animals of the Big Woods at a safe
distance. Many years later, when Ma and Pa had moved
west again, the little house was used as a corncrib. Eventu-
ally it began to crumble away, and its logs and shingles and
door frames were put to other uses—warming some farmer
and his family, perhaps, through the long Wisconsin winter.
Today no trace remains of the little house in the Big Woods,
except in the golden memory of Laura's books.

When the family was settled in the little house again, Pa
took one of the horses and rode off over the hills to the
county seat at Durand. There he visited the office of the
county clerk and revoked the power of attorney he'd signed
in Missouri. Pa was home again, and he no longer needed
Grandpa Ingalls to look after his interests in the Big Woods.
Even today, Pa's signature can be seen at the courthouse in
Durand:

Charles P. Ingalls

No sooner were the Ingallses settled in again than Ma
did something she'd been thinking about for a long time—
she sent Mary off to school. Just as Ma insisted that the girls
not speak at the table unless spoken to, and that they always
remember their manners, and that Laura wear her bonnet
on her head and not around her neck, so she insisted that
the girls have a chance to go to school. This wasn't only
because Ma herself had been a schoolteacher. She knew
that the girls' fortunes in life depended on what they did as
well as on chance, and that they could do more and make
their own chances if they'd been to school. Moving about
as Pa liked to do could be hard on children, even if they
liked it. They could grow up wild. And Ma didn't want her
girls to grow up wild.

So one bright day in May, Cousin Louisa stopped by the

little house with little Lottie, and Mary walked off with them down the wagon road to school. Suddenly Laura felt very alone. Carrie was still too little to play with. She couldn't play dolls, she couldn't run races, she couldn't climb a fence, she couldn't even walk yet. Why, she couldn't do anything—she still spent most of the time in the little house under Ma's watchful eye.

To Laura, with Mary gone off to school, the house seemed empty, and the little yard in front of the house seemed deserted. No doubt Ma gave her many things to do to help pass the time, but it certainly wasn't like having Mary there. Every day that summer, Laura waited anxiously for Mary to come up the road from school with the cousins.

The school Mary went to was a district school, and it had a number—No. 3. But everybody called it the Barry Corner School, because it was near Barry Corner. It was a little more than a mile from the little house in the Big Woods to the little log schoolhouse known as Barry Corner School. To get there, Mary walked down the curving wagon road to Barry Corner, just as if she were Pa going off to Pepin, and turned east at the crossroads. The schoolhouse was just up the road a bit, on the north side.

Annie Barry was the teacher, and in this summer term, which lasted from May through July, she had nineteen little scholars to teach besides Mary Ingalls. Louisa Quiner was among them, and so were cousins Charlie and Albert and little Lottie. Clarence Huleatt, who was a year older than Laura, also counted himself a scholar during this term.

Annie Barry was twenty-five years old, and she lived at Barry Corner with her parents. She was born in Allegheny, Pennsylvania, now a part of Pittsburgh, and she came with her family to Pepin on a steamboat when she was only eleven, making the long trip down the Ohio River and up the Mississippi. Her grandfather, Joseph Porter, one of the early settlers in the neighborhood, set up a grist mill on Bogus Creek, which ran down from the bluffs across a little divide from Lost Creek.

Annie got her first certificate as a schoolteacher in 1869, the year the Ingalls family left for Missouri. Lottie Magill taught at Barry Corner School that year, but the next year Annie Barry took over the school, and she taught there until her family moved down from the bluffs to a house on the shore of Lake Pepin. She was a schoolteacher all her life

(she died in 1941), and in later years her former scholars—
then grown up—would drop by to visit her and remind her
of the whippings they had suffered. But this would only
make Annie laugh, and she would tell the story about the
time she was boarding around and teaching school. One
morning, as she was getting dressed in the attic of the home
where she was staying, she heard the little girl of the fam-
ily ask her mother to buy her a spelling book. But the
mother said no, because she didn't think very much of the
teacher—who was Annie herself, of course. "She's been
teaching over a month and hain't licked anybody yet!" the
mother said.

Still, it must have taken discipline to keep a class of back-
woods scholars in order, especially in the summertime, when
the Big Woods were full of fun and the sunshine and the
cool breezes made it almost impossible to sit quietly inside
a schoolhouse studying a book. There is no doubt that Annie
Barry could keep order.

Laura often walked down the road a little way that sum-
mer to meet Mary on her way home from school. Once Ma
even let Laura go to school with Mary and spend the whole
day there as a visitor. On that special day, Mary had to
recite a piece before the entire class, and Laura made a very
special audience. Surely she had listened to Mary practice
her piece over and over in the big room of the little house.

But that was a special day. Laura's world was still
bounded by the crooked fence that went around the house
and past the dark woods that stood back from the clearing.
In the milky light of morning she watched Pa go off to hunt.
The cities of America were growing crowded day by day,
but here in the Big Woods there was still room to roam.
This was Pa's kind of world, and it was Laura's world too.
She felt free. At night in the little house, the air danced
to the music of Pa's lively fiddle. Outside the shuttered win-
dows, the wind sighed through the trees and moaned a
lonely song.

And how Laura waited for those times when they were
all together, when Mary was home from school and Pa was
home from the hunt. Then, on a lucky evening, Pa would
drop down on all fours—his hair woozled up on end—and
come growling after Laura like a mad dog! Then Laura and
Mary would squeal and scream and Ma would look up from
her sewing with a frown and warn Pa not to frighten the chil-

dren. But Pa would look right at Ma with his blue eyes all bright and twinkling and he would growl again, and even Ma had to laugh. And then he would pick up Laura and call her his half-pint of sweet cider half drunk up.

When October came in the Big Woods, Laura herself started school. After all, she was four years old, just like cousin Lottie, and Lottie had gone to school during the summer term. So now when the cousins came by in the morning for Mary, Laura went along too, down the wagon road to Barry Corner and then up the crossroad to the schoolhouse. She didn't write this down in her memoir, but her name is listed among the scholars at Barry Corner School during the long fall and winter term. She didn't attend school for the entire term, however, but stopped just before Christmas. So did Mary, although Mary returned to school for the last two days of the term in February. Perhaps Ma didn't think Laura was big enough to wade through the snowdrifts to school in the wintertime.

Many years later, someone brought Laura a little bouquet of wild sweet william one day, and she remembered back to a place that could only have been the Barry Corner School. "A window had been broken in the schoolhouse at the county crossroads," Laura said, "and the pieces of glass lay scattered where they had fallen. Several little girls going to school for their first term had picked handfuls of Sweet William and were gathered near the window. Someone discovered that the blossoms could be pulled from the stem and, by wetting their faces, could be stuck to the pieces of glass in whatever fashion they were arranged. They dried on the glass and would stay that way for hours and, looked at through the glass, were very pretty.

"I was one of those little girls and though I have forgotten what it was that I tried to learn out of a book that summer, I never have forgotten the beautiful wreaths and stars and other figures we made on the glass with the Sweet Williams.

"The delicate fragrance of their blossoms this morning," Laura said when she wrote this, "made me feel like a little girl again."

As a schoolgirl, Laura's world widened, and she had an opportunity to become better acquainted with her neighbors in the Big Woods. In her own crowd, cousin Louisa Quiner was the oldest. She was already eleven. Cousin Charlie was

nine and his little brother Albert was six, the same age as
Mary Ingalls. Lottie and Laura, of course, were four.

Because she passed Miss Barry's house every day on the
way to school, Laura also learned something about the
teacher's family. James Barry, the teacher's father, had
been born in Ireland, and was almost sixty years old. He
had been a captain in the army—everyone still called him
Captain Barry—but now he was a farmer. The previous
year he had been the Republican candidate for county trea-
surer, but he wasn't elected. Annie Barry and her brother,
James, Junior, were the only children still living at home.
Her sister Amanda had married Sol Fuller, a riverboat
engineer, in the summer that Pa went to Missouri. Another
sister, Elizabeth, had married John McCain, the first settler
in Pepin Township. Young James Barry was only fourteen
years old, and little more than a year after Laura started
school he was found dead in a snowstorm along the rail-
road tracks north of Pepin. Annie Barry's mother, Elizabeth,
rounded out the big family. A young black boy, George
Weeb, who was fourteen and who was born in Tennessee,
lived with the Barrys as a laborer and a servant.

Of all the families in the neighborhood of the little house,
the Huleatts were easily the favorites—not only of Laura and
Mary, but of Pa and Ma as well. Thomas Huleatt and his
wife Jane lived in a house on a little rise about two miles
down Bogus Creek from the Ingallses. It was what landscape
architects used to call "a beautiful situation," with bluffs
rising from either side of the creek bottom. The Huleatts
called their place "Summer Hill," and one time Ma and Pa
and Laura and Mary and many other friends in the neigh-
borhood went there for a grand dance. Three of Thomas
Huleatt's grown sons lived at home—Sam, John, and Arthur—
and so did one daughter, Jane, who was twenty-one.

But another of Mr. Huleatt's sons, Thomas, Junior, lived
even closer to Laura's house. He was twenty-eight years old,
and like his father he had been born in County Tipperary in
Ireland. He was married to a woman from Pennsylvania,
Maria Clarke, in 1865, and they called their place "Oak-
land." It was just over a little hill from Ma and Pa's place,
no more than half a mile away.

Even though they were younger than the Ingallses
(Thomas Huleatt was seven years younger than Pa), Thomas
and Maria Huleatt were special friends of Ma and Pa, and

they often exchanged visits. The Huleatts had two children, Eva and Clarence. Eva was still a very little girl, only a few months older than Carrie. She had black curls and dark flashing eyes, and such good manners for a baby that Laura didn't particularly like her, although Mary, of course, did.

Clarence was five years old. He had red hair and freckles and a hearty laugh, and he wore shoes with copper toes. He liked to climb up on things, which certainly wasn't very good manners—Laura liked him especially. Clarence went to the Barry Corner School too, and when he grew up he became a merchant and an undertaker. Anna Thorn, a teen-aged Norwegian girl, lived with the Huleatts and no doubt helped Mrs. Huleatt take care of little Eva.

The summer the Ingallses came home to the Big Woods was very dry. Week after week went by without a hint of rain, and when a wagon rolled down the road toward Lake Pepin it left a cloud of brown dust in the air as a reminder that it had passed. When Laura went into the woods with Ma or Pa, the underbrush snapped and crackled beneath her feet. Lost Creek dried up. Even Bogus Creek, which was bigger, ran dry—until it was just a little path of round white stones leading down between the bluffs into the distance.

During the heart of the summer, the days were so hot that the sun seemed likely to burn the whole country to a crisp. Even the needles on the evergreens began to turn brown and brittle, and in the hazy air there was a faint scent of smoke. The winds still blew long and hot from the South in October, when Laura and Mary went to school. They shifted to the southwest, and then returned to the south. Flies hummed around the glass windows of the little house, and night brought no relief from the heat or the dryness or the danger.

"Last Sunday evening," wrote the editor of the newspaper at the county seat on the tenth of October, "we counted seven different fires in seven different directions, on the bluffs, in the woods, and on the prairies."

The Sunday evening the editor wrote about was October 8, 1871. On that day in Chicago, far to the south, a cow kicked over a lantern in a stable on DeKoven Street. The flames rushed to a nearby house. Blown before a scorching wind, the fire leaped from house to house and then from block to block, until the next day great tongues of fire leaped the river which divided the city. This was the Great Chicago Fire, and it left much of the city smouldering in black ruins. At the

same time, all the way across the state of Wisconsin from the village of Pepin, fire broke out in a lumbering town called Peshtigo. Nothing could stop the flames of this deadly October, and hundreds of people died in them.

During this time fire broke out in the Big Woods, near Ma and Pa's house. It wasn't so near that they were in danger, but all it would have taken was a sudden shift in the wind. As it was, a stranger came running out of the woods one day into the clearing around the little house, gasping for breath and frightened half to death. He had narrowly missed being caught by the flames.

In pioneer times, danger and violence were never far away —whether caused by man or by nature. Some settlers found the tedium of the days, the monotony of the nights, the hardness of the work, and even the loneliness of the pioneer life too much to bear. Down Lost Creek from the little house, a young man named Barnard, alone for too many days and nights in his cabin, shot himself to death with his rifle. Sometimes there were murders around Pepin, and bodies were found beneath the ice of the frozen Chippewa River.

Where there was no law, or where families were spread out too far to have effective law, there were always lawless men ready to prey upon the innocent. Some men, it seemed, were wolves. In the middle of September in 1871, just before Laura started school, a Swedish immigrant hiked overland on the crossroad from Lake Pepin. He was bound for the village of Arkansaw, on the ridge in the northeastern part of the county. But when he got to Barry Corner, "two genteel scamps" jumped on him, tied a rope around his neck, beat him with a gun and stole his money—$94.25. Word was sent to Dr. Milton B. Axtell in Pepin, and he came up to dress the poor man's wounds.

This happened in broad daylight at three o'clock in the afternoon, not more than a mile from the little house in the Big Woods. And it happened directly on the road which Laura and Mary had to take to Barry Corner School. It's no wonder that Ma preferred "civilization."

Now the moon rose like a ball of white gold above the Big Woods. The winds had stopped. In the mornings, the windows of the little house were etched with delicate tracings of frost. Winter was coming at last.

Pa had already set out a deer lick in the woods, made of

salt. He had raked dry leaves and golden straw into long piles along the foundation of the little house, to keep out the drafts of cold. And he had tuned up his fiddle and rosined his bow. Let winter come!

Never did a concert violinist have such a compliment as Laura paid to Pa in writing of his music: from his common fiddle he wrung an ovation of the heart. Out on the lonely prairie his fiddle had spoken to nightingales in the darkness, and they had answered. Laura, looking up at the stars come closer and closer, thought the stars themselves were singing. In the Big Woods Pa played other songs, and in every little house along the trail of Laura's life he played old songs and new songs, better-days-are-comin' songs and songs that cried out for days of auld lang syne.

Pa's songs were songs of the Horse Marines and Old Dan Tucker, of the Blue Juniata, of fair lands far away. They were songs of firelight and silver threads, of still nights and the beacon light of home. Ma's voice rose with them, sweet and pure, and Pa's voice could snap with fun or be as sweet and pure as Ma's, as the song and the mood demanded.

For many years it was thought that Pa's violin was a rare Amati, named for the family of Italian violin makers whose instruments were justly famous. The best known of these was Nicolò Amati, who himself was the teacher of Antonio Stradivari. But in truth, Pa's violin wasn't an Amati. It had an amber finish like an Amati, and once, it is believed, it had a little sticker on the inside saying it was an Amati. But it wasn't.

It was just a common fiddle, one of thousands of reproductions of Amatis imported into the United States during the last century, probably from Germany. It was only a common fiddle, with delicate silver flowers scrolled on its dark bridge, but it was played by an uncommon man.

When Pa raised his fiddle to his chin and it gleamed and glistened honey-brown in the firelight's faint glow, he was as American as tall Tom Jefferson or Patrick Henry, for they were fiddle players too. From Pa's fiddle poured the tunes and airs that moved a nation west. From it came songs that bound Ma to Pa and both of them to the girls, songs that made the sharp cold of a winter's night come alive with warmth, and songs that made a summer's night so sweet it could never be forgotten, ever. It was Pa's fiddle

that woke in Laura's heart the purest poetry. And it was only a common fiddle.

In the long nights of the Big Woods, Pa played his fiddle and Ma sang, and Laura dreamed. When the songs were over, Pa told stories of long ago and far away. He told about Grandpa and the panther, the voice in the woods, Grandpa's sled. Then it was quiet in the little house in the Big Woods. The fire crackled and burned low. The only sound was the sound of Ma rocking. And then Laura was asleep.

That Christmas—their first Christmas back in the Big Woods for so long—Ma and Pa and the girls went off through the woods to spend the day at Grandpa's. But school was still in session, so they couldn't make a long visit. On the fifth of January, Ma herself went to school just to visit. But when the new term began, only Mary was enrolled, even though Laura had turned five years old.

All that winter it snowed, and then, when the long winter was almost over, it snowed again—a very special kind of snow. It was a sugar snow, Pa said, and it was one of the happiest times of all in Laura's story of life in the Big Woods.

When Laura grew up and began writing the *Little House* books, people found it hard to believe that such a little girl could remember so much about her life in the Big Woods. But Laura remembered, no matter what grown-ups might say. Just how well she remembered was shown by some detective work as interesting as that which showed where the little house on the prairie was located.

The detective this time was Donald Anderson, a historian at the State Historical Society of Wisconsin. One day he was searching through some census reports for a trace of Laura's relatives in the Big Woods of Pepin County. But he could find no trace of them at all. It was as if Grandpa and Grandma and Uncle Peter and Aunt Eliza and Uncle George simply had not existed. How could the census taker have missed them?

Then Mr. Anderson remembered Laura's story about one Christmas in the Big Woods. It was the Christmas when Pa's fiddle sang out with "Money Musk" and "The Devil's Dream" and "My Darling Nellie Gray." It was the Christmas when Laura found a little rag doll in her stocking.

"Uncle Peter and Aunt Eliza and the cousins had to leave right after an early dinner to get home before dark,"

Mr. Anderson recalled. "I wondered whether they couldn't lead us to Grandpa's farm." So he did a bit of figuring.

"Uncle Peter had allowed for about four and a half hours of daylight to get home before dark. Traveling by bobsled, if the going were not too rough, he could probably make ten or twelve miles in that time—perhaps a little more. The census had ruled out a destination in Pepin County, so it seemed that his trail must go northward."

And northward it did go! Checking into the records of Pierce County, just to the north of the little house in the Big Woods, Detective Anderson found the homestead of Grandpa and Grandma Ingalls. It was thirteen miles away from Pa's house—perhaps four and a half hours away by bobsled, if the going were not too rough. And that was pretty good detective work.

Grandma and Grandpa lived in one big house with Pa's sister Ruby, who was still a teenager, and Uncle George, whose merry eyes were as bold and blue as Pa's own. In another house nearby lived Uncle Peter and Aunt Eliza and the cousins, Alice and Ella and Peter and Lansford. Pa's brother Hiram lived with his wife and children in still another house. Hiram was really the wild one in the family. He often went off alone fishing in the woods, way up north, and he once worked on a Mississippi riverboat. It was even said that he'd once killed a man.

Here on Grandpa's place in Rock Elm Township was the very spot the Ingalls family gathered to celebrate sugaring-off time. All the aunts and uncles got together for the dance that Laura wrote about, when Ma wore her beautiful delaine dress. Uncle George danced one dance with Laura, but he saved his best for Grandma, and while Pa played "The Arkansas Traveler" on his furious fiddle, everyone stood back to watch George and Grandma Ingalls jig faster and faster and faster—until finally George threw out his hands and hollered. He was no match for the Dancing Grandma.

Those were good times in the Big Woods. The seasons changed, and another spring and another summer came to the little house in the Big Woods. Ma often crossed the wagon road and went down the hill to visit with Mrs. Peterson, whose husband, Sven, had built a house bigger than Pa's. The Petersons were Swedes, and good friends of Ma and Pa. They had two children—Helen, who was born in Sweden before her parents came to America, and Charles,

who was three years old and who was born in the Big Woods. Perhaps the Petersons named their boy after a good neighbor, Charles Ingalls.

Laura learned how to sew and do embroidery, carefully stitching out a sampler with bright red thread on a strip of gray cloth. That sampler still exists today. She didn't like to sew any more than Ma did, but sewing was one of the accomplishments of a lady and she had to learn it.

Many times Laura and Mary would walk through the Big Woods to Uncle Henry's house and play with the cousins. Laura liked to watch Cousin Charlie hop from stump to stump in the clearing in front of Uncle Henry's house. At home Laura played on the swing Pa had hung in one of the giant oak trees. She ran barefoot. She made leaf hats for her doll, and she had tea parties with Mary in the wide green circle of shade beneath the oaks.

Sometimes Pa would read to them from his book about the wonders of the animal world, and sometimes Laura would sit alone with the big Bible on her lap, looking at the beautifully colored pictures.

One day Pa loaded the entire family into the wagon and they all set off down the wagon road for a visit to Pepin. Usually Pa walked to town; it saved the horses for the farm work. But this was different. This was an adventure.

The village of Pepin sat right on the edge of the river. "The town was passed into a sleep from which it has never awakened," said one visitor to the little village in these days. But to Laura, it was a marvelous place. There were four dry goods stores and grocery stores lined up along the road that followed the river bank. The busiest store was run by Philip Pfaff, who also had a mill outside of town. He was one of the very earliest settlers. But Horace Richards, a merchant who had come to the Big Woods all the way from New York, also ran a busy dry goods store.

Dr. Axtell's office was here, too. Not many years before, he and a Mr. Montgomery had advertised "Drugs, Yankee Notions and Hardware," and perhaps they still ran such a store. There was a hardware store connected to a tin shop, there was a hotel, and there was even a saloon. At the edge of town, A. D. Gray ran a small steam lumber and flour mill.

Across the road and along the sandy shore of Lake Pepin, Laura found a long beach covered with colorful rounded pebbles, like a face with freckles, and that was the best part

of all. While Ma and Pa shopped, Laura and Mary dashed up and down the beach, feeling the lake breeze in their hair and filling up their pockets with pebbles. Laura's trip to Pepin lasted only one day, but it gave her many days of memories.

Laura's years in the Big Woods were drawing to an end. The country was filling up. Pa worked a fine field of wheat, but game was getting harder and harder to find. It was never easy being a hunter on the frontier, but people scared the wild animals away for sure; when Pa set his trap lines in the snowy woods, he often found them empty. Standing in front of the little house, he watched the wagons rolling down the road filled with new families coming in, and dreamed of places far away.

In the spring of 1873, not long after Laura's sixth birthday, Ma and Pa sold half of their land in the Big Woods to Horace Richards, the merchant from Pepin. The winter had been hard, and perhaps they needed the money to keep going. A storm on Christmas Day had sent eight inches of snow flying through the woods, and two weeks later came a wild storm old settlers remembered as one of the worst ever to strike the neighborhood. Perhaps Ma and Pa sold the land to Mr. Richards because they owed him money for things bought on credit at his store.

Whatever the reason, by harvest time in fall they had enough money to buy the land back from Mr. Richards. So it was only as if they'd borrowed the $250 for those several months.

The reason they bought the land back in October, however, is quite clear. Pa was bound to move on. All that fall, Ma and Pa had talked quietly by the fire about where to go and what to do. Laura and Mary and Carrie lay quiet beneath the cold quilts, and when Pa picked up his fiddle the songs he played were about auld lang syne.

At the end of October, Ma and Pa sold all their land in the Big Woods to a man named Andrew Anderson, for the magnificent sum of one thousand dollars. Then they began to pack up all their belongings. The little house began to look sad and empty.

The first snows of the season had already fallen by the time the wagon was loaded and they were ready to leave. The woods were still and white. Pa climbed up on the wagon

seat and spoke softly to the team, and the wagon moved slowly up the road toward the north. They were going to Grandpa's. In the back of the wagon, Laura and Mary watched the little house sink slowly back into the trees. And then it was gone.

They would never see that little house again. Only in Laura's memory would it always stand waiting, with its cheerful windows and the golden flames of its fireplace, with its yard and its giant oaks and its swing and its good neighbors, waiting for a man and a woman and three little girls to come home.

Pa had made the trip to Grandpa's house many times before—for Christmas, for sugaring-off time, for visits—and the horses knew the way. But this was the last time, and the woods were hushed and silent as they passed by.

At Grandpa's house, things happened in a hurry. Ma and Pa and the girls moved right in with Uncle Peter and Aunt Eliza. School began almost as soon as they arrived, and Mary went right off with Alice and Peter, the cousins. Laura had to stay home to play with Ella and Baby Edith, but sometimes Mary would take her along to school, pulling Laura through the woods on her sled. Pa and Uncle Peter spent the long winter evenings talking about moving west. They were going to go together, just as Uncle Henry had gone with Pa to Missouri.

But then, one by one, the children began to ache all over. Ma and Aunt Eliza felt their foreheads. They were burning up with fever. Laura's throat was sore and her stomach felt queasy. Mary felt the same, and so did the cousins. Then one day a brilliant scarlet rash broke out on their chests and spread quickly over their entire bodies. They all had scarlet fever.

Now there was no thought of school. They were all forced to lie in bed for days on end, watching the snow fly outside the window and the darkness come, and then another white day just as dull and boring as before. "We were all going west in the spring," Laura remembered, "and this sickness worried the fathers and mothers for we must drive across the lake before the ice got soft." She did not know that the mothers and fathers were worried about more than going west. Scarlet fever was a dangerous disease. It brought a fever so high that delirium was just a step away, and then

death. But just as the children had fallen sick, one by one they got well again.

One cold morning in February, Ma gently woke Laura and Mary and Carrie. It was time to go. Although the cold light of morning had not yet begun to seep through the woods, Uncle Peter's house was already full of people. Grandma and Grandpa were there, and all the other aunts and uncles. They had come to see Pa and Uncle Peter off.

Pa had the wagon ready. The white canvas covered the top and the sides were drawn down to keep out the cold. The rifle hung from the bows inside. There were kisses all around. Then the wagon started.

They were moving, and this time it really was goodbye. The wagons pitched and rolled over the snow-covered road, leaving two straight tracks behind them, pointing to the past. When they reached Lake Pepin, Pa and Uncle Peter pulled their teams up. They stood high in the wagon seats and looked out over the white distance.

They were in time; the ice would hold. Out across the ice they went—toward a thin line of trees on the other, western side. The hooves of the horses made a hollow sound in Laura's heart.

She twisted around. There was nothing around her but ice and the white sky of winter, and all she could see were the things they'd left behind. The town of Pepin fell farther and farther away; the dark line of the Big Woods drifted back into the distance. The little house was hidden deep within them, surrounded by silence and drifts of gleaming snow. Then there was nothing but ice and sky.

She turned around, and looked through the front of the wagon. Between Ma and Pa, the town of Lake City had suddenly risen from the far shore. Around it were other woods, wisps of smoke, stately trees. Between the trees were great white spaces—empty, open, leading west.

4

Plum Creek

Lake City lay nestled beneath the snow-covered bluffs on the far side of the river. Compared to the sleepy village of Pepin, it was indeed a city: it had night policemen, and dogs were required to have a license. More than three thousand people lived in the neighborhood. There was a library with magazines and newspapers from all over the country, some from as far away as Europe. There were lecture courses. There were dozens of businesses, and great grain warehouses standing like sentinels on the riverfront.

The people of Lake City complained that they were poorly situated for business, but they shipped a lot of grain and they sold a lot of goods.

The railroad had come down from Saint Paul three years before. In the summer, when Lake Pepin shone like a polished blue jewel beneath the flying clouds, Captain O. N. Murray tooted around the lake with a little steamer full of tourists and vacationers, touching at Maiden Rock and Stockholm and Pepin on the Wisconsin shore and Lake City and Frontenac on the Minnesota side. At Frontenac, just up the shore from Lake City, the Lake Side Hotel catered to this trade. Three stories high, with shuttered windows, the hotel was half-hidden from the water by a long row of shimmering trees; its register for these years carries the names of visitors from Chicago and Cleveland.

Lake City had its own hotels, however. If they weren't as famous or as luxurious as those on the Lake Side, they still offered shelter from the biting cold of February. It was toward one of these hotels that Pa and Uncle Peter drove the wagons after they crossed the frozen river.

They stayed only a few days, preparing for their longer journey west. But while they were in the hotel at Lake City,

Laura celebrated her seventh birthday, and Pa gave her a very special present—a little book of verses called the "Flowret." Before he left the Big Woods he had promised Ma that they would find a place in the west where Laura and Mary could go to school. His present to Laura was a token of his promise to Ma.

Before too many days passed, Laura and the cousins climbed back into the wagons. They burrowed beneath the blankets like mice, and Pa and Uncle Peter drove west, into the high hills which stood behind Lake City. They hadn't gone far when they found an empty little house standing alone beneath the bare trees.

The little house stood on the bank of a creek, Laura remembered, "so close to the creek that if we had fallen out of the back window we would have dropped into the water." Here Pa and Uncle Peter decided to camp until the cold went out of the air and it became easier to travel. They built a roaring fire in the fireplace of the little log house, and Laura and Mary and the cousins helped move the bedding inside from the wagons. The creek already ran free, and at night Laura lay snug in her bed listening to its happy sound. Sometimes she and Mary made believe they were in a ship, the sounds of the water were so close.

When at last the weather turned warm and the trees turned a soft green, it was time again to say goodbye. Uncle Peter and Aunt Eliza were not coming all the way west with Ma and Pa. They were going only a short distance west, to a farm Uncle Peter had rented. Pa's eyes were set on even greater distances, out across Minnesota to where the prairies began and the land was deep and rich and black. So one day Pa shook hands with Uncle Peter and Ma gave Aunt Eliza a squeeze and the two wagons went their separate ways.

The air was soft and balmy. Every day birds came floating back from the south. In the evening, when Pa drove the wagon off the road to camp, the birds sang vespers in the trees and bushes all around them. Then shadows rose from the earth, and the little campfire gleamed like a drop of gold on the darkening land.

On one such evening, when supper was over and the air seemed all silvery and cool, Laura heard a strange, lonely call in the distance. The haunting sound seemed to come

from within the gathering folds of darkness itself. Laura
listened and listened, and then she heard the cry again—long
and lonely and haunting.

She turned to Pa and asked him what it could be. Pa's
eyes twinkled and he smiled as he answered: it was the whistle
of a train. Then Laura looked and in the twilight she saw
the engine and the train coming slowly down the railroad
track alongside the road. It was the first train she had ever
seen. She listened, and again she heard its strange lonely
call.

"I thought it was calling me!" Laura exclaimed. Ma
laughed out loud, but Pa knew what Laura meant. He too
had heard a strange and lonely call that said: "Go on! Go
West! Wander, and be free!"

In the morning Pa harnessed up the team, and once more
the little wagon rolled out beneath the blue sky of Minne-
sota. The road went west. "One day, on the road, we over-
took a strange man all alone in a covered wagon," Laura
remembered. "For several days he drove along with us and
camped with us at night. His name was George George.
He was pleasant company and we liked his little dog."

As they drove nearer the town of New Ulm—Pa in his
wagon, George George in his—they came one day to a large
square building. Green grass grew all around the building,
and from the roof flew a great red, white, and blue flag.
Pa explained that this was a beer garden. But George George
needed no explanation. He stopped his wagon and dashed
off across the grass to the beer hall. When he came back,
the foamy glasses were wet and sloshing in his hands. He
asked Laura and Mary if they would like a sip of beer.

Laura certainly wanted to try it, and even Mary decided
she would too. Ma, we can assume, just looked the other
way. Then Laura and Mary each took a sip of George
George's cold beer. Their faces wrinkled up, and they both
decided it was too bitter to really like.

Everyone camped at the beer garden that night, and the
next day they moved out on the road again. "West of New
Ulm," Laura recalled, "we saw some grassy mounds that
Pa said were ruins of houses where Indians had killed the
settlers in an Indian massacre years before." This had been
in the Sioux uprising in the Civil War, a dozen years before.

Now George George no longer traveled with them. Per-
haps he had decided to homestead on the grassy slope of

the beer garden lawn. The railroad tracks dropped off to the south, but the road Pa followed went straight west toward the prairies. They crossed Sleepy Eye Creek and they crossed the Cottonwood River, and one day they came to a stop at a house in the middle of nowhere. The place was flat and grassy and pretty, and the sound of the wind was in the air. Near the house was a creek—Plum Creek.

The house belonged to Elick C. Nelson and his wife, Lena. Mr. Nelson was still a young man, only twenty-six years old, but already he and his wife had a baby daughter and a house of their own, and a stable and a herd of milk cows and a real stake in a growing country. Elick had come to America from Norway when he was twenty-one, living three years in eastern Minnesota and then moving west to the banks of Plum Creek. He was the first settler in the section.

When the wagon reached the house, Pa went in to speak to Mr. Nelson, and when he came back his face had a smile on it. Mr. Nelson had told him of a nearby settler who wanted to sell his place and move west.

Pa climbed back up on the wagon seat and took the reins from Ma. The wagon moved southwest along the creek, following a faint wagon track through the summery grass. Laura and Mary peered from beneath the canvas of the rocking wagon, hoping to catch another glimpse of the creek. But it rippled and whispered along its curly course beneath the edge of the prairie, almost always out of sight.

They had gone only half a mile when they came to a little stable made of sod, standing alone on the prairie. Here the wagon track ended. Pa stopped the wagon. Then Laura could hear the sound of the wind and the sound of the creek, and between those two sounds she could sense the great silence.

They all looked around for the creek, but they couldn't see it. All they could see was the little sod stable behind them, and off on one side the waving branches of the willows. Plum Creek was hidden, sliding around at the foot of the grassy bank on which they stood. They looked for the house, but that too was nowhere to be seen.

This was certainly a strange place, they thought, a little house on the banks of Plum Creek with a house that no one could see and a creek that wasn't there! And that was when Mr. Hanson suddenly appeared, like a gnome in a fairy tale,

with his round red face and his pale eyes. He was the Norwegian settler who itched to go farther west, and of course he knew that Ma and Pa were there. They had nearly driven their wagon onto his roof.

The wagon emptied out. While Ma and Pa looked over the dugout Mr. Hanson had made in the side of the grassy bank, Laura skipped through the knee-high grass and raced down the little path to the edge of Plum Creek. The creek came around a wide curve choked with stumps and branches, talking to itself. It ran full of floating silver bubbles right past the door of the dugout. With a rush, the water swept under a footbridge and vanished beneath the graceful branches of the willows, back toward Mr. Nelson's house.

By the time Laura climbed back up the path to the prairie where the wagon stood, Pa had decided to swap with Mr. Hanson for the dugout. Ma was not so sure. She had never lived in a dugout before. But by the time bedtime came she was laughing about it. Ma knew how to look things in the eye. At least, she said, it would be something new.

Laura was not so sure, either. It would be fun to live like rabbits, no doubt, but somehow she didn't feel like playing, and when Pa made the campfire and Ma cooked supper she didn't feel the least bit hungry. It was the last night out, Pa said, and that made Laura feel even worse.

She didn't want things to change. In the wagon, every day had been different. Every night along the road from the Big Woods had found them in a new place, with new things to see and new things to do. But now that was over. The road had ended in a faint pair of wagon tracks on a grassy bank, near a creek you couldn't see and a house that wasn't there. Tomorrow they would still be here, and tomorrow, and tomorrow.

Laura wanted to drift on and on, but the anchor was down. Tomorrow would begin a new chapter in her life.

That night the stars came in low over the prairie. The wind died down, but the creek still talked to itself below the grassy bank. Behind that sound was the great silence of the prairie—a silence that would have to be filled by the sound of school, by songs, by Pa's happy shout as he came home from the fields.

Laura was sleepy. She heard Ma and Pa talking softly.

This is great wheat country, Pa was saying, but why is Hanson's crop so thin? And then the stars went out.

Plum Creek ran into the Cottonwood River, and the waters of the Cottonwood ran into the Minnesota. The Minnesota ran northeast to Saint Paul, where it joined the Mississippi, and the Mississippi flowed southward past the little village of Pepin and the rounded river hills of Lake City. So from the little house in the Big Woods to the dugout on the banks of Plum Creek was only a matter of degree—a matter of a certain time and a certain distance. But the two places were worlds apart.

Plum Creek lay on the edge of the great western prairies—not the desolate rolling prairie of Dakota, but the flat fertile prairie of Minnesota. Here the soil was rich and black and three feet thick. Here Scotsmen and Swedes, Norwegians and Irishmen and Englishmen and Canadians, had come together to become Americans. The words they spoke sounded different, but their dreams were the same. They hoped to raise families and carve farms from the land, to build villages and churches, to work and to be free, to do with their hands what they had already done with their hearts.

This dream Ma and Pa shared with Elick Nelson the Norwegian and Lafayette Bedal the Canadian and William Steadman the Englishman and Ellen Boyle the widow, who was an Irishwoman, and with Andy Leidenburg the Swede and Thomas Campbell the Scotsman and Julie Corler, who had come from Poland to the prairies of Plum Creek.

When they arrived on the banks of Plum Creek, Pa was thirty-eight years old and Ma was thirty-five. They were strangers in a new land.

Mr. Nelson, Pa's neighbor, had been the first settler in North Hero Township, but other settlers had followed closely on his heels. Byron Knight, a Vermonter who came with his large family from North Hero Island in Lake Champlain, gave the township its name; earlier it had been known as Barton Township. Gustave Sunwall was another early settler, and so was young John Anderson, a nineteen-year-old Swedish boy who had left his family in Illinois to make his way in the West. Sunwall and Anderson had the first store in Walnut Grove, the little village that lay two miles across the prairie from Pa's dugout.

Elias and Lafayette Bedal—Laura remembered their name as Beadle—were also among the early pioneers of the section. Elias Bedal's claim shanty was the first building erected on the town site of Walnut Grove, and Lafayette Bedal was the village's first postmaster and first school-teacher.

The town itself was laid out in the spring of 1874, only a few weeks before the Ingalls family arrived at Plum Creek. The building of homes and stores proceeded rapidly. The Winona-Tracy branch of the old Winona and St. Peter Railroad had been completed through Walnut Grove the previous fall, and eventually turned northwest from Tracy toward Marshall and then out upon the Dakota prairies.

Walnut Grove was laid out south of the tracks—the dug-out was north. There were twenty-four blocks in town, three blocks one way and eight blocks the other. The streets were wide and dusty, and they ended at the prairie where the wild grasses blew and the blue sky bent to touch the land in the distance.

Not all the building lots in town were filled, of course, but it seemed as if each day saw another house or another store being finished. Every time the train came whistling down the track from the east, it stopped at Walnut Grove and workmen jumped down to unload more lumber.

During that first summer on Plum Creek, Pa left the dug-out each morning and walked up the bank, following the faint wagon tracks down the stream toward Mr. Nelson's farm. He worked the harvest with Mr. Nelson, saving money to buy a cow so Ma and the girls could have fresh rich milk and butter. Laura and Mary did the dishes and helped Ma sweep. They watched Carrie so she wouldn't fall into the creek, while Ma worked at making curtains and turning the little dugout with its whitewashed walls into a home. And when the chores were done, Laura herself set out down the path toward the Nelson farm.

Laura liked Mrs. Nelson very much, and she spent so much time at Mrs. Nelson's house that Pa had to laugh. He said Laura talked English like a Swede, which was a nice joke considering that Mrs. Nelson was Norwegian. Laura got to know Mrs. Nelson's little daughter Anna. Mrs. Nelson taught Laura how to milk a cow, and when Pa had finally saved enough money to buy a milk cow Laura surprised Ma with her worldly knowledge.

In the evening everyone was together—Pa and Ma, Laura and Mary, and Baby Carrie, who was already four years old. The door to the dugout stood open as they ate their evening meal. Plum Creek ran happily past the doorway, its surface silvered and smooth in the glistening light. Across the creek, the sun set behind the vast prairie and meadow grasses.

In the hollows of the land, pools of shadow formed— blue and gray and silver. The sky darkened. Pa leaned back and looked from Ma to Laura to Mary to Carrie. His eyes twinkled and he wiggled his fingers. And then he asked for his fiddle.

Sundays came to be very special days as that summer drew to a close. Then Ma would put on her black and white calico dress with its little stand-up collar and its puffs and shirrings behind. Carrie would look like a little angel in her clean white dress and tiny white sunbonnet, and Laura and Mary would stand still while Ma put bright ribbons in their braids. Then Pa would help them each into the wagon, very carefully, and they would drive off across the morning prairie toward Walnut Grove.

They were going to church. The magnet that drew them there was a tall, thin, kindly man with a dark beard and warm blue eyes. Laura remembered him as Reverend Alden. He was a home missionary who hoped to start a church in Walnut Grove.

Edwin H. Alden came from across the Green Mountains in Vermont. He was born in Windsor, a little village in the Connecticut River Valley, on January 14, 1836; this made him exactly four days younger than Pa. He'd gone to Dartmouth College and then to a seminary in Maine, and soon after he became a minister, Reverend Alden enlisted in the service of the American Home Missionary Society.

Many churches sent missionaries overseas. But the Home Missionary Society was started by the Congregational Church to send missionaries out to the American frontier and into pioneer communities, following the edge and tide of settlement and trying mightily to preach and organize churches. And this the home missionaries did, while attending to the duties of their own home churches. It was no easy business.

Reverend Alden's home church lay east across Minnesota, in the village of Waseca. There he lived with his wife, Anna, and a small daughter, and there he was pastor of the Con-

gregational Church. From Waseca, Reverend Alden rode
the railroad west. He preached at New Ulm and at Sleepy
Eye, at Barnston and Walnut Grove, at Saratoga and at
Marshall, where the railroad tracks ended on the wide,
empty prairie. He preached wherever he could gather pio-
neers around him—in schoolhouses, in private homes, even
in railroad depots. It was a hard life, and sometimes Rev-
erend Alden had to take hammer in hand to help build a
small chapel or a church in one of these pioneer communi-
ties. "So far the Lord has prospered us," he once wrote,
"though it has made me many a weary walk and journey,
besides many a day's toil with hammer and saw when
nothing would induce anyone to help me—it was so cold—
besides many a weary night of anxiety."

Brother Alden's account of trying to build a church at
Marshall during the hard winter of 1873, far from his own
home and family, shows something of the hardships he
faced:

The lumber was ordered in October from Winona,
250 miles off. We waited anxiously for the lumber, day
after day, but it did not come. Then we heard that it is
on a side track sixty miles away, will be here in the next
train. Volunteers with teams hurry in from the county
to unload it and haul it to the site. It does not come, and
the men return disappointed. After a few days comes—
only one car; the other two not heard from. We are
anxious. The beautiful October weather is almost gone.
Winter is at hand. The road has more than it can do to
haul material for the seventy miles yet to be built. En-
gines and men are taxed to their utmost. Ninety tons of
iron for each mile of track must come from Chicago;
bridge timber from Winona, 275 miles; ties and piling
from the Big Woods, 150 miles.

Night and day they drag their immense loads, carry-
ing back 35,000 bushels of wheat daily. What if they
cannot bring our lumber at all! We go eastward eighty
miles and find one car. "Can you ship the car for our
church tonight?" "Very doubtful. We are obliged to
leave here several carloads that have been waiting for
days." After dark, in the rain, with a lantern, we see our
car coupled to the westward train and return with a
light heart. How it poured, all that night, the next day

and the next night, a steady torrent! But our lumber arrived.

Shortly it was framed, raised and partly sheathed. A day or two after came the first great snow-storm of the season, to be followed by others unprecedented for severity and numbers in the history of the state. The house, though held with extra braces, could not stand the fearful gale. It was prostrated soon—buried by the drifting snow. What can be done? The road is blockaded, all the trains but one snowed in, the engines dead. One conductor walks twenty-five miles and telegraphs to the Superintendent. He hastens to the rescue with snowplows, car-loads of provisions and several hundred men with shovels. In time they dig their way to Marshall.

We go by the next train. The weather is beautiful and we move rapidly for seventeen miles. The snowplow comes to a drift; the men ply their shovels; the sky is suddenly overcast; the wind rises, mercury falls, and in thirty minutes all must take refuge in the cars. We are "snowed in." The next morning, your missionary vies with the rest in the use of the shovel. We make seven miles a day. The train can go no further; no team can be found; we dare not try forty miles on foot over that desolate waste, so we return with the train—only to be snowed in again and find our way to New Ulm as we can—most of the way on foot. Nothing daunted, we take the next train several days later, reaching Marshall at night after a four days' journey, visit the church site.

A few boards are seen on the foundation. The rest is covered by a deep snow hard enough to bear a loaded team. Can it be dug out and raised again? The carpenter says "Yes." So says a young lawyer, promising to work his subscription all over again. So say others, and I say "Amen!" Soon the spot is thronged with willing volunteers, shovel in hand, and in two days or so we have the building about where it was before the gale, and passed it over to the contractor for completion. Of course the disaster made us great additional expense which we have not the means to meet.

Will not individuals and churches in the East help us?

This was how churches were planted in the West.

Walnut Grove had not yet been organized into a village when Reverend Alden first visited there, talking with "several Christian families and others." His schedule kept him away for months. When he returned, it was to preach in earnest, and to urge the founding of a Congregational Church in the new community.

One Saturday in August, several families from North Hero Township gathered at the home of James Kennedy, on the northern edge of Walnut Grove. Ma and Pa were among them. Brother Alden said a prayer, everybody sang some hymns, and then they talked about whether to build a church. "The brethren and sisters spoke with much feeling as to the need of a church," the early congregational records state. "It was decided unanimously to proceed."

The next day, Ma and Pa and the girls were on their way across the prairie to the Kennedys' house for church. Laura fidgeted through Reverend Alden's long sermon, but then she watched as the "brethren and sisters" were welcomed into membership. They gathered in hope, although fate was not always kind to them.

Amasa Tower was there with his wife, Julie. They became pillars of the little church, Mr. Tower as a deacon and Sunday School superintendent and his wife as a willing co-worker. Mrs. Tower was Laura's own Sunday School teacher, and Laura liked her very much. Ten years later Mr. Tower was struck and killed by lightning on the Dakota prairies, where he had moved with his wife. Mrs. Tower, the church record sadly tells us, then "drowned in a well during an attack of insanity."

But who could know then what the future held? It was a happy Sunday, and many other families joined the congregation on this day—the Ensigns, Shepherd Moses and his wife, the Steadmans, James and Margaret Kennedy, Margaret Owens, Mrs. Charles Webber, and of course Ma and Pa.

Among these founding members of the Union Congregational Church, two were baptized during the service. They were Charles and Caroline Ingalls. From that day forward, Pa especially took an active role in the church, serving as a trustee and in other ways.

Until the new church could be built, meetings were held in the Kennedys' house. Brother Alden wasn't on hand every week to preach, because he had many other duties as a home missionary and at his own home church. There was Sunday

School every week, but the best Sundays for Laura were still church Sundays, when Reverend Alden came and shook Laura and Mary's hand and called them his "country girls," with his eyes smiling.

The Sunday School had a small library, and Ma often took a book home to the dugout to read during the week. She liked to read, and she often read aloud to Pa as he worked. One day Ma brought home a book which had a poem in it. Laura loved it so much she learned it by heart. It went like this:

> Twenty froggies went to school
> Down beside a rushy pool.
> Twenty little coats of green
> Twenty vests all white and clean.
>
> Master Bullfrog grave and stern
> Taught the classes in their turn
> Showed them how to leap and dive
> Taught them how to nobly strive
> Likewise how to dodge the blow
> From the stick which bad boys throw.

Once learned, these twenty froggies were not forgotten. Laura remembered this rhyme sixty years later, and could recite it by heart even then. It was more fun than learning Bible verses.

Ma and Pa had come to Plum Creek too late in the season to think of putting in another crop. And there was no use in trying to improve the dugout, because Pa hoped to build a real house in the spring, in the meadow across the creek. So as the golden days of autumn came, their life turned more and more to the activities of the new church in town.

For many pioneer families, church was more than worship. It gave them a sense of belonging when they were far from their own families and old friends. It made life less tedious and dull. For Ma, church was a symbol that at last they had settled and were making a civilized life. For Pa, even though the congregation sang woefully off-key with the voices of tired, hard-working men, church was rich with hymns and songs of faith. These he carried home in his heart, and when the nights began to turn chill, he sat before the fire in the dugout and played them over and over on his fiddle.

Soon Reverend Alden, Amasa Tower, and John Ensign

were hard at work planning a special celebration to dedicate
the new church building. It would be interesting to know if
Pa helped in the construction of the new church. He was a
fine carpenter, and the church went up quickly on the corner
of Fourth and Washington streets at the edge of town, only
a block west of Lafayette Bedal's house. But if Pa helped
build the church, that fact did not find its way into the
records.

One thing didn't escape the record, however, and that's
the contribution Pa made to help pay for the church bell. His
offering was much more than the three dollars Laura remem-
bered: late in November, as the church neared completion
and the belfry still stood empty, Pa gave Brother Alden
the sum of twenty-six dollars and fifteen cents!

So it was that on a frosty December evening, only five days
before Christmas, Ma and Pa and the girls rode toward town
in a wagon filled with fresh clean hay, and the stars them-
selves seemed to sing, and the darkness rang with the two
clean notes of the church bell Pa helped buy.

That night there were people in church Laura had never
seen before. There were Reverend Cobb from the Home
Missionary Society, and Reverend Jenkins from London,
Reverend Champlain from Sleepy Eye and Reverend Sim-
mons from Marshall—and of course Reverend Alden, with
his bright blue eyes all atwinkle in the lamplight. Reverend
Cobb preached the sermon and Reverend Alden offered the
prayer of dedication, but Laura didn't notice what they said.

Her ears were filled with mighty hymns she couldn't sing,
and the whirl of people all around. Her hand squeezed
Mary's. And she couldn't take her eyes from the Christmas
tree, the first she had ever seen. It was decorated with gay
streamers of paper, and from its thin branches hung wonder-
ful presents that had been sent west with Reverend Alden by
the people of his home church at Waseca. The most won-
derful present of all was a little brown fur cape and shawl.

Once she saw it, Laura could think of nothing else—until
the moment Mrs. Tower walked down the aisle and gave it
to her. Of course she got other presents too. She got a pair
of red mittens and a bag with candy in it and a popcorn ball
and a gleaming china jewel box that she kept all her life,
even though one day it broke.

But it was the fur cape that made Laura feel she'd never
had such a happy Christmas in all her life. Some other little

girl had worn it in the East, but that didn't matter to Laura. Pa's wagon took her through the dark village and out upon the prairie and through the cold night to the dugout, and in her silky fur, Laura was as warm as a little brown bird with red trimmings, just as Reverend Alden had said.

Winter came in earnest in January. The winds blew straight from the northwest, stinging with snow. Plum Creek was frozen now and still; the prairie turned white, drifted with snow. In the mornings Pa would put his shoulder against the door of the little dugout and push with all his might, wedging open a crack until he made space enough to reach around and scoop away the snow with his hand. The sky would clear for a day or two and then another storm would come, worse than the first.

This was blizzard country. There were few trees to break the force of the wind, and the few willows and plum trees along the banks of Plum Creek only brought more snow down from the heavy drifting wind.

"When the cold wind blows, take care of your nose, that it doesn't get froze, and wrap up your toes in warm woolen hose," one newspaper editor wrote.

Another newspaper editor saw this, of course, and he wrote: "The above we suppose was written in prose by someone who knows the effect of cold snows, and the further this goes the longer it grows, each telling what he knows about writing in prose, when it snows and it blows, as it so often does."

And of course yet another newspaper editor saw *this*. His name was Pat, and he wrote: "Pat doesn't propose to favor those who read his prose with what he knows of wind and snows, and frosted toes, and tattered clothes, and all the woes that follow those who won't repose at home and doze when it snows and blows!"

With the coming of spring in 1875, Plum Creek filled from bank to bank with foaming brown water. The drifts of winter melted off. Spring rains added to the meltwater made it a menacing stream—not at all like the peaceful silvery creek of summer and fall. Branches torn from banks upstream hurtled past the little dugout and hammered at the frail footbridge that crossed to the other side, and even a century later, visitors to Plum Creek can see the marks of violence left by the torrents of spring.

Pa and Ma knew the dangers of Plum Creek during these times. They warned Laura to stay clear of the water. Laura knew the dangers too, but she was drawn to them. When she ventured out upon the footbridge and was nearly swept away, like a piece of wood or the branch of an old tree, she was doing more than just disobeying her Pa. Just as she sensed the silence on the prairie, she felt the power of Plum Creek. She felt its independence and its strength in flood and its freedom. She had to tell Ma what she'd done; she had to admit that she nearly drowned, and had to promise to stay away from Plum Creek. Yet she had felt something "stronger than anybody" in the racing waters of the creek, and she had also, for the first time, felt something very strong in herself. She had not screamed, and she had not cried. She was growing up.

Laura was eight years old that February. In the same month Pa was elected a trustee of the Union Congregational Church, replacing Mr. Steadman, who had resigned with some things—as the church record put it—"reflecting upon his standing as a Christian." Mr. Steadman was later welcomed back into the congregation, but it wasn't unusual for people to be "cut off from membership for cause."

Pa worked hard that spring, attending to his new responsibilities in church and sowing with wheat and promises the ground he had already plowed. A good crop, he knew, would bring Ma and the girls some of the things they wanted—and for starters, there would be a new house. One day Pa came home with a wagonload of smooth, straight sawed lumber, and he and Mr. Nelson were soon at work building a wonderful new house on a little rise of the prairie across Plum Creek.

While they worked, a small voice was reading in the dugout. "Every window and shutter at Millbank was closed," the voice said. "Knots of crepe were streaming from the bellknobs, and all around the house there was that deep hush which only the presence of death can inspire." There was a pause here, so that chills could run up and down the spines of the listeners. Then the voice continued: "Indoors there was a kind of twilight gloom pervading the rooms, and the servants spoke in whispers whenever they came near the chamber where the old squire lay in his handsome coffin"—here there was another pause— "waiting the arrival of Roger,

who had been in Saint Louis when his father died, and who was expected home on the night when our story opens."

It was eerie. It was scary. It was delicious, good reading. But Ma just laughed. She laughed and looked at Laura, who was holding a book with a deep green cover in front of her face, and Ma said she knew that Laura wasn't really reading. She was only saying from memory what she had heard Ma read so many times aloud during that long winter.

The book was called *Millbank*, and it was written by the very popular novelist Mary Jane Holmes. It was full of skips of the heart and sudden surprises, of loose boards and maniacs and puzzles and riddles. Why on earth was Roger in Saint Louis? Ma had read the book to Pa over and over, as Pa waxed his boots and worked in the dugout. Laura had been all ears. "But, Magdalen, my silence must have its price, and that price is *yourself!*"

Laura's recitation reminded Ma of how badly she wished the girls could go to school. It doesn't seem likely that Laura and Mary attended classes during their first summer and fall on the banks of Plum Creek, or that Ma would have sent them off alone across the prairie—two miles to town—in the winter, when a storm might blow up without a moment's notice. School had been taught then in the home of young Lafayette Bedal, with Mr. Bedal himself as the teacher.

Not until 1875 was a regular schoolhouse built in Walnut Grove. That was the spring when the Ingallses moved out of the dugout and into the new house Pa had built on the other side of Plum Creek. The new school was located on the prairie at the edge of the village. To get to it, Laura and Mary had to cross Plum Creek, follow the faint trail to town that Pa's wagon had made in the grass, cross the railroad tracks, and walk all the way through the village.

The girls were already familiar with the stores and houses of town, having gone in almost every Sunday to church or Sunday School. They knew the Kennedy house and Mr. Bedal's store and post office. They knew Mr. Owens' store on Main Street, and Mr. Fitch's store, just across from Mr. Owens'. They knew the blacksmith shop and the lumberyard near the railroad tracks, where Pa had bought the smooth straight mill boards for the new house. And they also knew many of the children. So on their first day of school, Laura and Mary were not really strangers.

When she came to write of her life on Plum Creek, Laura

remembered that the teacher's name was Eva Bedal and that she had a face that seemed very sweet and welcome to two country girls going to school there for the first time. But the only Eva Bedal in town was Mr. Bedal's little daughter, and she was only four years old. Perhaps the postmaster's wife, Clementina Bedal, was the teacher.

Laura's favorite friend in school was Nettie Kennedy, who, like her, was eight. Nettie came from one of the biggest families in town, and her parents were James and Margaret Kennedy, in whose house church services were held before the new church was built. Christy Kennedy, whose hair was as bright red as her father's, was already fifteen. She was even too old to be Mary's playmate, and nearly old enough to be teaching school herself. Cassie must have been Catherine Kennedy; she was thirteen. Their brother Daniel was twelve, and another brother, Alexander, was ten. Everyone called Alexander Sandy because of his red hair and his freckles.

The only other child in the entire township who was exactly Laura's age was Howard Ensign. His mother and father were members of the Congregational Church, and were good friends of Ma and Pa. The Steadman boys were also the right age to be going to school. Johnny Steadman was ten, and his brother Reuben was seven. Laura would get to know them both very well. Their parents were both born in England, and had lived in Pennsylvania and Iowa before coming to Walnut Grove.

Of all Laura's schoolmates, there was one she remembered better than anyone else. That was Nellie Owens. Nellie's father ran a general store—something Nellie never let any of the other girls forget. Even though she was only six years old, while Laura was eight, Nellie was pretty as a penny, and she was the leader of all the younger girls until Laura began coming to school. Nellie's brother Willie was a year younger than she was. Both Nellie and Willie had been born in Minnesota in the years since their parents had come to settle.

Nellie wrinkled up her nose at Laura and Mary because they were country girls, although her own family had done its share of wandering too. Mr. Owens, whose name was William, was a New Yorker, and both his parents were Welsh. Mrs. Owens, whose name was Margaret, was born in Canada. Laura didn't mind when Reverend Alden called

her a country girl, but when Nellie Owens did it that was something else again.

Every day, when school was out, Laura and Mary walked slowly back across the prairie from town. Sometimes they ran, their pigtails flying and their books and lunch buckets bouncing on their straps. But they didn't run far. The heat of the prairie summer was upon the land.

At home, Pa proudly surveyed his fields of wheat. The grain was stiff and plump and full of promise in the burning sun. Harvest was only a week away.

Then one day after dinner, the afternoon light turned queer. A silvery shadow passed over the house on the banks of Plum Creek, over the fields, green and gold with wheat ready to be cut. Soon people up and down Plum Creek would be looking through their family Bibles. They would find a line by the prophet Joel:

> Like the noise of chariots on the tops of mountains shall they leap, like the noise of a flame of fire that devoureth the stubble.

The grasshoppers had come.

They came on the wind, flying high against the copper summer sun. Curiously, they drifted backwards, borne only by the frail membranes of their glistening wings. They landed brown and hungry—in Iowa, in Dakota, in Minnesota—devouring crops wherever the wind chanced to drop them.

"Their flight may be likened to an immense snow-storm," wrote one pioneer who watched them come, "extending from the ground to a height at which our visual organs perceive them only as minute, darting scintillations, leaving the imagination to picture them indefinite distances beyond. . . . It is a vast cloud of animated specks, glittering against the sun. On the horizon they often appear as a dust tornado, riding upon the wind like an ominous hail-storm. . . . They circle in myriads around you, beating against everything animate or inanimate; driving into open doorways and windows; heaping around your feet and around your buildings; their jaws constantly at work biting and testing all things in seeking what they can devour."

Those who saw them searched for words to tell about them: snow-storms, dust tornadoes, hail-storms. Behind those common words were ruin and desolation, fields

stripped bare, farms lost, and a close unspeakable sense of horror as the sound of the grasshopper hordes came through the shuttered doors and windows day after day, night after night, never stopping.

At times they fell so fast from the sky that their juices, crushed out on the railroad tracks, caused the silver wheels of trains to spin and spin and not move. They came and they destroyed and they bred and they laid their eggs. Then they died. But another season saw new clouds of destruction against the sun, and the earth hatched the marching hordes.

Farmers were urged to plow and harrow their fields, to crush the grasshopper larvae with rollers smeared with tar, to capture the young before they could fly. Bounties were offered: a dollar a bushel for grasshoppers, fifty cents a gallon for their eggs. In Minnesota the governor called on all settlers in the devastated districts to burn piles of straw and to set fire to the prairie grass. But smoke did little good. As a last resort, farmers should try "scaring them to death" with "loud and discordant noises made by striking tin vessels, and by shrieking and yelling with the voice." This did even less good.

Like most settlers', Pa's battle against the grasshoppers was lost before it began. A year's work was gone, and with it a year's dreams and hopes. Where once the fields had seemed fruitful beyond belief, they were now forlorn. In some places, whole towns emptied out, unable even to sustain hope. At Lamberton, a little village down the tracks from Walnut Grove, every businessman except one felt forced to leave. For Pa and for many others, there was only one thing to be done: they could go east to the counties that had been spared, and work the fruitful harvest there.

It was nothing, Pa said. He took down his fiddle and played "The Campbells Are Coming" and "Life Let Us Cherish" and "Dixie Land." Laura and Mary sat by his side. Ma rocked with Carrie. The next day he was gone.

Pa went east along the railroad tracks, probably only as far as Olmstead County, where the crops had been saved, but perhaps as far as Uncle Peter's rented farm along the Zumbro River. With him went a ragtag army of boys and men, looking for work. Some even went barefoot, like Marion Johnson and his younger brother. Before they left their home in Redwood County, the Johnson boys' father had given them each five cents and told them to seek food and shelter

from farmers along their way; when they reached Rochester in Olmstead County each boy had a dollar and a half. They'd been fed, sheltered, and given small coins by families all along the way.

With Pa gone, Mr. Nelson came down along the banks of Plum Creek to help with chores. He chopped wood. He brought flour and sugar from town. Every Saturday, he looked for a letter from Pa. And when at last a letter came, Ma cried.

She couldn't help but cry. She'd worked from dawn to dusk. She'd thought of games for the girls to play, and been both father and mother, and she'd done it with a secret. The secret was one she shared with Pa before he left, and she knew that somewhere in the wheat fields of the East, Pa was thinking about it too. Ma was going to have another baby.

Several other letters came from Pa, and some with money, but none was as special as the first—for that letter told Ma that Pa was alive and well and would one day be home.

One fine day in the fall, Pa did come home. His purse was filled with money, because he'd made a dollar for each long day he'd worked in the harvest. His heart was filled with happiness, because at last he was back with Ma and the girls. How the fiddle rang out on the banks of Plum Creek that night!

In October everyone climbed into the wagon and Pa headed down the wagon trail toward town. But they weren't going there to visit—they were going there to live. The new baby was due any day, and Pa didn't want Ma to be so far away from help as she was on Plum Creek. So the house was closed up and the things they needed were loaded into the wagon. And Pa and Ma and the girls moved into a little house in town.

The house they moved into stood directly behind the church in Walnut Grove on the edge of the prairie, close to the schoolhouse that still smelled so fresh and clean and new. Almost immediately, Laura and Mary began going to school again.

Living in town was much different from living out on the banks of Plum Creek. Ma and the girls hadn't been to church or Sunday School since Pa went away, because it was too far to go. Now they could see the church from the window of the little house in town, right down the street. Laura and

Mary no longer had a long walk across the prairie to school. Now school was only a block away, and they could go all winter because Ma and Pa didn't have to worry about them being trapped on the prairie by a storm. The stores were closer, too, and when Laura had a penny or two she could skip down to Mr. Fitch's general store and buy candy.

There were people to see every day, and there was news to catch up on. Laura found out that Christy and Cassie Kennedy had joined the church during the summer. The three youngest Kennedy children—Johnny and Edwin and Elizabeth—had been baptized, although Nettie Kennedy and Sandy and Daniel had not. Perhaps they'd been baptized in Canada, where they were born and where they lived before they came to Walnut Grove.

Howard Ensign's big brother and sister also joined the church during the summer. Willard and Anna Ensign were much older than Laura, although Howard was exactly her age. Leonard Moses and his wife were members of the church now, and so was Nellie Owens' father, and so was young Lafayette Bedal. Like Mr. and Mrs. Tower, Lafayette Bedal met a sudden death. Only six years later, when Laura was in far-off Dakota on the shores of Silver Lake, he was killed in a sawmill accident.

Every Sunday the church bell rang out over the little town and people came out of their houses dressed in their finest clothes. They walked down the street past the house Laura lived in and went to services. Reverend Alden's hard work to establish a church at Walnut Grove was bearing fruit, although he himself no longer came. His commission as a home missionary had expired for this district, and now he was building new churches in other places.

The church in Walnut Grove didn't have a minister for a long time. Still the congregation grew, and so did Pa's little family.

Coming home from school one day, Laura and Mary were surprised to find a strange woman making supper. They didn't know who she was, and they wondered where Ma could be. But they soon found her, in bed—with their new baby brother. He was born on November 1, 1875, and Ma and Pa decided to name him Charles Frederick Ingalls. The girls, however, were soon calling him Freddie.

Even with a baby around, the winter seemed long and dreary to Laura. It was a very mild winter, but she had more

work than ever to do, sweeping and cleaning and running errands and helping Pa and Ma. It appears that Pa found work in town that winter, perhaps as a carpenter or as a clerk in one of the stores, because he gradually added to the money he'd earned in the harvest back East.

Laura didn't record her own feelings about this first experience of living in town. But Pa's feelings seemed plain enough. "While the snow and ice were still on the ground and on the creek," as Laura remembered it, Pa moved his family out of the little house in town and back to the house he'd built on the banks of Plum Creek.

The sun moved higher into the sky, and winter's grip began to loosen. From inside the house Laura could hear the steady drip-drip-drip of melting snow, the crack of ice, and soon the roar of the creek in flood. The spring freshet had come.

One day, when Plum Creek roared at its loudest, danger came to the little house like an uninvited guest. Laura told about it many years later in her memoir. Ma had suddenly become desperately sick, and Pa's thin face was a mask of worry. He couldn't leave her, because she was in pain, and he could do nothing to help her. She needed a doctor. He turned to Laura and told her to run up to Mr. Nelson's house. Mr. Nelson would ride to town and telegraph for the doctor to come, Pa said. But he had forgotten one thing: the brown, foamy fingers of Plum Creek sweeping dangerously against the footbridge Laura would have to cross.

Laura was frightened, but she knew she had to go. Pa had said so. She slipped from the house and raced down the path toward the creek. And there she stopped. The creek roared around the curving bank and battered the fragile bridge. Some of the water, yellow and shiny, slid smoothly over the top of the log stepping boards. At both ends of the bridge, flood-waters swirled and circled in treacherous pools.

The bridge was an island! Laura's eyes grew wider; she looked at it for a moment and stepped carefully into the nearest pool. It was the only way to reach the bridge, the only way to save Ma. She knew the power of Plum Creek, and she braced herself against it. The water tugged at her and pushed against her, trying to knock her down. But she held steady, and took another step forward. And then she heard a man's voice floating in the air above the roar of

Plum Creek. Laura looked up and saw Mr. Nelson standing on the high bank near the empty dugout.

He was waving his arms like a windmill, and his faint voice was saying, "Go back! Go back! You'll drown!" Laura stopped. The creek tugged at her, and she cried across to Mr. Nelson. Her voice wasn't as big as his, but it was higher. It carried across the roar of the creek, and Mr. Nelson waved his arms to let her know he understood. Then he turned and disappeared, and Laura was alone with the terrible roaring in her ears.

Then Laura herself turned, and balancing carefully, she stepped back out of the swirling waters. She raced up the path to the house, and when she burst through the door, Pa looked at her with a startled, quizzical look. He saw her muddy legs and wet dress and her white face. And then he remembered about the creek. When Laura chattered out what had happened, Pa could only say one thing: "By Jinks!"

While Laura had been gone, Ma had grown quieter; the pain seemed to ease. Mr. Nelson, meanwhile, was already on his horse and racing madly down the muddy wagon trail toward town. The next day the doctor came; if indeed he had been forty miles away, as Laura said, then he'd been at New Ulm, and he'd come by train. A woman came with him to help. Pa rowed them across the creek in a little boat he used for fishing and they hurried into the house to look after Ma.

The doctor came twice more after that, and gradually Ma got better and better until one day she was well again.

The creek went down and the land began to dry out. Pa took one of the horses and forded it. He rode into town to get some seed wheat, because last year's crop had been lost. When he came home he put the team to work plowing a small patch of ground, and then he sowed the wheat. The size of Pa's wheat field this spring matched Pa's hopes—he knew that if the grasshopper eggs hatched, he would again have no crop.

For Laura, Sundays still brought something special that spring. "The little white daisies with their hearts of gold grew thickly along the path where we walked to Sunday school," she remembered. "Father and sister and I used to walk the two and a half miles every Sunday morning. The horses had worked hard all week and must rest this one day

and Mother would rather stay at home with baby brother so with Father and Sister Mary I walked to the church through the beauties of the sunny spring Sundays.

"I have forgotten what I was taught on those days also. I was only a little girl, you know. But I can still plainly see the grass and the trees and the path winding ahead, flecked with sunshine and shadow and the beautiful golden-hearted daisies scattered all along the way."

During the spring and early summer, Laura and Mary again walked across the prairie to town every day to attend school. Laura felt happy to see Nettie Kennedy and her friends again, and even Nellie Owens. Sometimes Ma gave the girls permission to go to the Owens store after school and play with Nellie for a little while. But that didn't work out very well. It wasn't much fun to look at the prettiest toys in the world and not even be able to touch them.

Across the dusty street from Mr. Owens' store, however, was the store of Mr. and Mrs. Fitch. John R. Fitch was a young man from New York, about the same age as Mr. Bedal, and his wife, Josephine, was even younger. She was just out of her teens.

Laura thought that John and Josephine Fitch were both very nice. They had a baby girl who was going on two years old; baby Ada was much too young for Laura or Mary to play with, but still Mrs. Fitch often invited the girls to come by the store after school and visit. This they did often. And Mr. Fitch often gave them little pieces of candy to eat on their long walk home across the prairie.

In her memoir of these days. Laura told about a beautiful high-back comb Mr. Fitch had for sale in his store. When Laura and Mary saw it they thought it would be a perfect surprise for Ma, because Ma didn't have anything like it.

They asked Mr. Fitch how much it cost. When he told them fifty cents, their hearts sank. Laura and Mary had only ten cents each. But Mr. Fitch said he would hold the comb for them until they could save up fifty cents. Little by little, Laura and Mary added to their secret purse. Pa often gave them a penny or two for doing a chore well, but they were careful not to tell Pa what they were saving for because they wanted him to be surprised too. It seemed to take forever just to add a few pennies to what they had.

One day after school they stopped by Mr. Fitch's store to look at the comb. They couldn't buy it, of course, be-

cause they had saved only forty cents, and that was at home.
But they wanted to admire the comb anyway. Mr. Fitch saw
them, and asked them how much they'd saved. Laura and
Mary admitted they were stuck at forty. When Mr. Fitch
heard that, he took down the comb and wrapped it carefully
in paper and handed it to them. They could bring their forty
cents after school the next day, he said, and forget about the
extra dime.

They raced across the prairie with the precious package.
Their eyes were merry with excitement while Ma carefully
unwrapped the paper. Ma was so happy with her present
that her eyes began to glisten, and Pa was happy, too, to
think that his girls could be so kind-hearted. It was only a
little gift and there was no special occasion, but it was a
symbol of the love Ma and Pa and the girls felt for each
other.

With the coming of summer, Pa's little patch of wheat was
washed with a faint green. The wheat sprouts were coming
up. But at the same time, the grasshoppers hatched. The
ground squirmed with grasshoppers, as they marched and ate
and tried their wings. They ate everything.

Pa watched them sadly, but he didn't fight them. He knew
what was going to happen, and he was helpless to stop it.
The first hot winds off the prairies to the west brought more
grasshoppers, drifting across Dakota and Minnesota. The
air filled with the sound of angry buzzing, and Pa knew that
his days on Plum Creek were over. With the small wheat
crop devoured even before it had grown, there would be
nothing to live on.

In the prairie evenings Pa sat with Ma on the doorstep of
the little house. In silence they watched the sun move slowly
toward the dark edge of the western prairie. That was where
Pa's heart was—west with the setting sun and the wide spaces
and the high silences. But now to the west were grasshoppers,
devouring dreams and lives as well as crops.

Near the little house, shadows rose in the hollows of the
prairie. They made pools of darkness. Where the land and
the sky came together in a sharp black edge, the sun came to
rest for a moment, dull and red. And then the air itself turned
dark. On the doorstep of the little house beside Plum Creek,
Pa sat with Ma and talked quietly of where they had been
and where they would go.

* * *

Pa spent his days in town. More people than ever were leaving. There was no money, and they couldn't bear another season of grasshoppers. Pa walked up and down Main Street. He went into the stores, with his hands in his pockets. He saw Mr. Steadman and they talked for a long time. Mr. Steadman was going to leave. He was going to wait until fall, but he was going East.

Pa walked down by the railroad tracks. He looked for a long way down the silver tracks, first west, then east. He didn't know what he was looking for. He was just looking. Then one day, at Mr. Bedal's store and post office, Pa found a letter. It was from Uncle Peter, in eastern Minnesota. Uncle Peter said that they should come to join him and Aunt Eliza; there were no grasshoppers in eastern Minnesota. Bring Ma and the girls, Uncle Peter said. Laura and Mary and Carrie could play with the cousins, and Pa could work in the fields, which were already heavy with grain.

Pa didn't say anything. He folded the letter and put it in his pocket. On July 6 he paid his property taxes for the previous year: $2.76. On the next day the Land Office at New Ulm marked down in the record books that Pa had paid for his homestead claim. Three days later he sold his house and land on Plum Creek. The Ingallses were going East.

Abraham Keller and his wife Margaret bought Pa's land. They were anxious to move in. Grasshoppers or not, they wanted to try their hand at prairie life. But there was still time for Laura and Mary to run into town and say goodbye to all their friends. Nettie Kennedy said that her father had talked about leaving too, but she didn't know whether he would. Ma and Pa said goodbye to the friends they'd made in church.

And then one day the canvas wagon cover was rolled up. The horses pawed the ground; the wagon began to move. The year was 1876, the centennial year. The telephone had just been invented. Far out across the western prairies, an Indian named Sitting Bull and a soldier named Custer rode toward a rendezvous; only one would ride away. In the factories of the East, workers were on strike. The Molly Maguires were at work by night in the coalfields of Pennsylvania.

The year was 1876, the centennial year, a year of celebration. Politics was a scandal. America was still a mixture of promises made, and promises broken.

On the road east from Walnut Grove, a little wagon moved slowly against the march of empire. It carried more than promises. It carried Ma and Pa and Laura, and Mary and Carrie and the little baby. It carried dreams that would not die.

5

Burr Oak

There was a sadness in the summer air, and a strange foreboding feeling. Ma had been sick. The baby was so little. Except for being together and the prospect of seeing Peter and Eliza, this journey back through Minnesota held no delights for Ma and Pa, and no anticipation. From high in the wagon seat they saw only familiar scenes. They hunted out the old camping places, and every evening the sun sank in glory behind them. The fiddle stayed in its case.

But to Laura, east or west didn't matter. She liked to feel the easy roll of the wagon beneath her; she liked to hear Pa's voice come floating back on the breeze. Every turn of the day and every bend of the wagon road brought new things to see—her mind was eager and her heart leaped up to be going places. She was nine and a half years old. Mary was eleven; she was sweet and nice and she had a fine sense of humor, which she hid under good manners. She was very proper. She was afraid to put a worm on a hook, or take a fish off a hook, but Laura wasn't afraid to do that. Carrie was only six, but she was very much like Laura. After all, she'd been born in Indian Territory.

One afternoon Pa stopped the wagon near a house along the road. He unhitched the horses and the girls ran off to play. They didn't have to run far, because three other little girls came out of the house near where Pa had stopped. All that evening until darkness fell, Laura and Mary and Carrie played "Hide and Go Seek" and "Ring Around the Rosy" and other games. Then their new friends had to go into the house and go to bed. So they said goodbye.

But the man of the house came out and talked to Pa. In the failing light, he pointed to his rows of silent beehives and to the fields of flowers that had been eaten bare by grass-

hoppers. The man nearly cried. There were no flowers for his bees, and no honey. He couldn't stay in this country any longer—he was going west, to Oregon.

For a moment, Pa stood silent. Think of it! Across the prairies and through the mountains, always into the blue distance, all the way to Oregon—a man could be free!

But Pa couldn't think of it. He'd promised to meet Mr. Steadman in the autumn. They would meet in a little town in Iowa, and they would live there and run a hotel that Mr. Steadman was going to buy. It wouldn't be like being a free and independent farmer on the banks of Plum Creek. It wouldn't be like going to Oregon. But then, grasshoppers couldn't possibly eat anything as large as a hotel.

The wagon rolled on and on, day after day, eastward. Ma's arms grew tired holding baby Freddie. Yet Laura remembered that in the mornings of this journey, Ma carefully combed out the girls' hair. Wherever Ma followed Pa, Ma's virtues followed her. Nice girls had their hair combed in the morning, she would say. Pa's eyes just followed the road, on and on. It was a curious thing about Ma and Pa. Ma did follow Pa wherever he went, but Pa never went anywhere that Ma wouldn't follow.

The road led into the rolling hills of Wabasha County, and one day the wagon came to a stop in the yard of a strange house. The door popped open, and there stood Uncle Peter and Aunt Eliza. The journey was suddenly over.

Uncle Peter's farm wasn't very far from the Mississippi River. If Pa had kept on driving a day or two longer he would have reached Lake City; they could have crossed Lake Pepin on the ferry boat, and clopped through the streets of Pepin, and turned up the familiar wagon road along Lost Creek. Back in the bluffs, they would have found the little house in the Big Woods. It would have been only a few hours from there to Grandma and Grandpa's house, and to all the aunts and uncles and cousins who lived around them.

It doesn't seem that Pa went the extra day or two. If he did, perhaps only Ma and Pa went. But Laura didn't recall it, and she didn't write it down in her remembrance of these times.

She did remember Uncle Peter's farm. It was located in the western part of Wabasha County, in Gillford Township, where the river hills that stood behind Lake City finally flattened themselves into gently rolling countryside. The

Zumbro River, shining and clear, ran along the edge of Uncle Peter's pasture.

Curiously enough, no one has ever found exactly where Uncle Peter's farm was in Gillford Township. But if he rented it, as Laura remembered, that's easy to explain. The land would be registered in the name of the man who owned it. Most likely it was close to the village of Zumbro Falls; on the next census, Uncle Peter's family was counted just before the families of Alexander Carley, who was a hotel keeper, and of several other men with town occupations.

Surely it wasn't a large farm, or a particularly prosperous farm. Uncle Peter's name doesn't appear in the *Directory of Farmers* published in 1877, the year after Laura visited. But there's a reason for this too: Uncle Peter worked as a laborer. That was his occupation. Like Pa, he called himself a farmer, but he was a jack-of-all-trades. He often worked in town, or at odd jobs, wherever he could find them. The farm was simply a nice place to live, to keep cows for fresh milk and butter, and to grow crops.

Laura hadn't seen her cousins since that day two years before when they had said farewell in the hills behind Lake City. Everyone had grown. Cousin Peter, who was one of Laura's favorites and who would one day live with Laura and Almanzo, was nine years old now—just as Laura was. Cousin Alice was already fourteen. She was bigger even than Mary, and within a few years she would be a schoolteacher. Cousin Ella was eleven and Cousin Lansford was already six, like Carrie. The baby in Uncle Peter's family was Cousin Edith. She was only four.

Uncle Peter himself was a dark handsome man, and his light-colored eyes danced brightly beneath his heavy eyebrows. Aunt Eliza had a full, round and friendly face that said "Welcome! Welcome" when Pa's wagon pulled up outside her door.

Laura found Uncle Peter's farm a wonderful place to be—even though Ma sometimes wore a worried look and Pa often paced by himself at the door. Laura couldn't know the reason. With two large families living in one house, there was more work than ever to do, and Laura and Mary pitched in to do their share. Every afternoon Laura had a special chore which she enjoyed. She and Cousin Peter and Cousin Ella walked down to the river pasture and brought home the cows.

The river pasture was a wonderfully free place. The river sparkled in the late afternoon sun and ran gaily between banks of summer flowers and cool green trees. The long grass was soft and chill on Laura's feet, and in the distance the cowbells tinkled merrily. Sometimes, Laura remembered, the children would forget themselves in the pleasures of this pasture. They would forage through the thickets, eating the beg red and frosty purple plums, and talk quietly among themselves. Before they knew it, darkness would be upon them. They would suddenly stop and listen, and hear the glad sound of the river gliding past, and, far off, the tink-tink-tink of the cowbells. On those days, Laura and Peter and Ella had to run hard to catch up with the cows and get ahead of them. It just wouldn't do for the cows to bring the children home.

"Bringing home the cows is the childhood memory that oftenest recurs to me," Laura said when she had grown up. "I think it is because the mind of a child is peculiarly attuned to the beauties of nature and the voices of the wildwood and the impression they made was deep.

"I am sure old Mother Nature talked to me in all the languages she knew when, as a child, I loitered along the cow paths forgetful of milking time and stern parents waiting, while I gathered wild flowers, waded in the creek, watched the squirrels hastening to their homes in the tree tops and listened to the sleepy twitterings of the birds.

"Many a time, instead of me finding the cows, they on their journey home unurged found me and took me home with them."

One day Uncle Peter himself came down into the river pasture and herded the cows up into the meadow, where the hay had been cut and stacked. Then Laura and her cousins had to spend most of the day in the meadow with the cows, keeping them away from the fresh neat haystacks and making sure they grazed only in the stubble that had been left by the cutters.

On cold days, or when the rains came, they built little campfires in sheltered places and roasted wild crabapples and pieces of meat and bits of bread they'd carried out with them from the house. Laura told Peter and Ella all about life on the banks of Plum Creek—how they'd lived in a dugout in the ground, how she'd nearly been swept away by the powerful spring freshet, how the grasshoppers had come

glistening against the sun. She told them about school in Walnut Grove, about her friends there, and even about Nellie Owens, all of them far off now on the prairies of western Minnesota. Perhaps she would never see them again.

About the future Laura could not say much. She didn't know what it would be like to live in a hotel full of strangers.

The August days grew hot. The afternoons broke open with heavy sheets of rain, and then cool weather came. Pa no longer went off to work in the harvest fields. The season was changing; it was time to think of moving on. Perhaps the Steadmans were already in Iowa, waiting for Ma and Pa to come and help them run the hotel.

But Pa and Ma weren't thinking of moving on—they were thinking of baby Freddie. He was suddenly very sick.

The doctor came and looked at Freddie, and smiled at Ma and went away. But Freddie didn't get better. The doctor came again. Laura didn't worry, because she'd seen another doctor at Plum Creek help Ma when she was stricken ill during the spring freshet. But Ma worried, and Pa paced in the doorway. Baby Freddie was dying.

"One awful day," Laura remembered, "he straightened out his little body and was dead." The day was Sunday, August 27, and soon afterwards Charles Frederick Ingalls was buried in a child's grave near the town of South Troy, south of Zumbro River. In the family Bible, Ma and Pa wrote down his age: nine months. He hadn't lived to celebrate even one birthday, or to make more than one journey, or to hear with his heart one song from his father's violin.

From the beginning the journey had been sad for Ma and Pa; now it seemed hopeless. Laura had always found bits of happiness and moments to remember wherever the road would go, but now even she felt the press of the hard pioneer life that Ma and Pa already knew. When she grew up, she never wrote of these hard days except on the tablet of her deepest memories. Even then she spared herself their full reconsideration. The journey to Iowa, she said simply, was "cold, miserable."

They had to go. They had promises to keep. The wagon was loaded and the white canvas top was dropped over the sides, and Ma sat silently on the wagon seat next to Pa. There was a wave, a faint goodbye. Uncle Peter and Aunt Eliza stood in the doorway of their little house and looked

after Pa's wagon for a long time, until it was lost among the smoke-colored trees in the distance.

Heavy rains swept their path, and the wagon moved slowly. Each day closed its gray curtains around them, and found them only a little farther on their way. No one spoke. After many days, they finally reached the village of Burr Oak in Iowa. Laura remembered it as small and old and always a little dark.

Burr Oak lay in the low limestone hills of northeastern Iowa. The country was wooded and rolling and seemed somehow lifted up, close to the sky, even though the roll of the land was gentle. A wagon road came down from the Minnesota line only three miles away, dividing the village as it crossed Silver Creek, and ran on south to Decorah and the towns and villages beyond.

In the very early days of Burr Oak twenty years before, this road had been a major highway for the emigrant trains that poured down from the river counties along the Mississippi, in Minnesota and Wisconsin. Two hundred and sometimes three hundred wagons made their way through Burr Oak every day in those times, raising clouds of gray dust and filling the air with shouts. "At night," an old settler recalled, "the houses and yards would be full of people, and one could hear all sorts of bells on the stock that was being driven through by the emigrants, from little sheep bells to cowbells as loud as church bells." Perhaps when Pa had brought his family to Missouri before going on to Indian Territory, he'd used this very road.

Two hotels still stood in the little village as relics and reminders of the great days of emigration, but now the villagers had settled down to days of restless quiet. The seasons moved on, sometimes sparsely. Even here there was talk of Oregon.

Pa's wagon moved slowly down the road from the north. As it turned past Relihan's Grove, with its rich deep shadows and the gnarled oak trees that gave the village its name, Laura peered curiously from beneath the wagon cover. On both sides of the road were houses—many of brick, some of framed lumber, and a few very small old houses of logs. Silver Creek came in from the east. It ran lightly beneath the wagon road and turned south to follow State Street (as it was called) behind the barns and houses that lined it.

When the wagon reached the older part of town, the buildings seemed to crowd more closely together. Laura saw the blacksmith's shop slide by, and the cooper's, and a store with a high false front. On the left was the American House—one of the two hotels—and kitty-corner from it was a livery barn. Up the hill along Spring Street Laura could catch a glimpse of the two-story brick schoolhouse.

The wagon stopped in front of the other hotel. It was called the Burr Oak House, although some people still called it the Masters Hotel, because Mr. Masters had been the last to own it. All along the street, heads turned.

Laura was home.

The Burr Oak House was a frame building of two stories, with a sloping roof and wide open porch that ran the width of the hotel along the street. It was built into the side of a hill—actually the ridge along which State Street ran—so that the land sloped down rather quickly. Laura's practiced eye told her it would make good sledding and sliding when winter came. The stone foundation of the hotel was exposed on every side except the front, and windows were set into it. In back of the hotel the ground was very low; it was here that Silver Creek turned lazily toward the west in a wide basin. In the late afternoon, when the sun had dropped low enough in the sky, its waters became a ribbon of gold.

Both of the hotels in Burr Oak had the same troubled history. They were dependent on travelers, for the most part, at the mercy of forces over which they had no control. Thus they opened, closed, re-opened, and closed again, with a merry-go-round of owners.

The American House had been built in the summer of 1857 by a man named Mr. Haskins. He ran it for a while and sold it to Mr. Saxby, who ran it for a while and sold it to Joseph McLaughlin, who ran it for a while and sold it to J. R. Jones, who ran it for a while and sold it to Elisha Robinson, who ran it for a while, and so on. In the year the Ingallses came to Burr Oak, A. J. Cratsenberg bought the hotel and announced the fact in the newspapers:

THE AMERICAN HOUSE
Burr Oak, Iowa, has been repaired and opened as a hotel to accommodate the traveling public.

A. J. Cratsenberg.
Proprietor.

"Those who are thrown upon the comforts of the 'American' are in safe and comfortable quarters," said a newspaper editor, perhaps because he got his room there free. The American House was the only hotel in Burr Oak to be "puffed" in the newspapers, because it was the only hotel in Burr Oak to advertise in the newspapers.

But the Burr Oak House traced its roots even further back than its neighbor across the street, all the way back to 1851 when a little log hotel was built north of the present building. Time went by, additions were made, and the original log structure fell by the wayside. What was left was the Burr Oak House as Laura knew it.

It had had just as many owners as a dog that won't be trained: Mr. Belding, who built it; John Waggoner, who kept selling it and buying it back; Edwin Blackmarr and Henry Benedict, who enlarged it; Abe Madison, J. R. Jones, John Miller, A. M. Perry, and so on again. John Waggoner had it back for the fourth time in 1873, when he sold it to William J. Masters, and it was Mr. Masters who sold it to William Steadman, Pa's friend from Walnut Grove. The hotel business in Burr Oak was not the best business in the world, as Pa soon found out.

Ma and Pa were welcomed to the Iowa village by Mr. Steadman and his wife, while their boys—Johnny and Reuben —welcome Laura and Mary and Carrie. Laura wasn't sure she wanted to be welcomed by Johnny Steadman, and she knew for a fact she didn't want to live in the same hotel with him. She knew him from Walnut Grove, of course. He was spoiled, and Ma told Laura she must always be kind to him because he was lame. But he often took advantage of her kindness—he pulled her hair and pinched her and broke her playthings. His youngest brother, Tommy, was just as bad; all he did was cry. But Laura had to put up with it. Ma told her to, and the Steadmans were the only familiar faces in Burr Oak.

While Pa moved the family's belongings into the hotel, Laura looked around her new home. By today's standards the Burr Oak House was not very large, but to Laura's eyes it seemed very large indeed.

There were two front doors on the porch; one opened into a barroom and the other into a parlor. Inside, between these two rooms, was a hall with a stairway at one end. Up-

stairs were the bedrooms and downstairs were a dining room, a kitchen, and a little kitchen bedroom. It was in this bedroom, no doubt, that the hotel's hired girl, Amy, slept.

A door led from the dining room directly into the back yard of the hotel, at the foot of the land sloping down from the street. In this wide dish of land Silver Creek twisted and turned, and there were also a little fishpond and a spring with a springhouse, where milk and butter could be kept fresh and cool on even the hottest day.

Only one thing bothered Ma and Pa about this hotel. That was the barroom and the men who hung around it, drinking and swapping stories and singing boisterous songs. One of these men was the beau of Amy, the hired girl. His name was Jim, but everyone called him Hairpin because he was so tall and skinny.

In the hotel Laura found a little round hole that told a story—a story of danger and violence. The hole was in the door that stood between the kitchen and the dining room downstairs, and it had been made by a bullet. When she thought back on these days, Laura wasn't sure whether there were several bullet holes or only one. But one would have been exciting enough. "It was made when the young man of the house, being drunk, shot at his wife who slammed the door between them as she escaped," Laura recalled. "This had happened some years before, but the bullet hole in the door was thrilling to us children."

When Ma and Pa brought the family to Burr Oak, two men were regular boarders at the hotel. One was a slim young man of about twenty-one, whose name was William H. Reed. He was the principal of the schoolhouse on the hill, and he was also a very good amateur actor. The other was B. L. Bisby, one of the richest men in the village.

One day Mr. Bisby decided to teach Laura how to sing. Laura knew how to sing well enough, she thought, but Mr. Bisby was the best paying lodger in the hotel, and he had to be pleased. So he taught Laura the scales and was pleased; Laura used up her playtime every day practicing the scales, up and down and mixed, and was displeased. Laura liked young Mr. Reed very much, but she didn't like Mr. Bisby. Before too long she would have a good laugh on him.

Soon after arriving in Burr Oak, Pa went into business with a man named J. H. Porter, who ran a grinding mill. Pa helped Mr. Porter run the mill, and probably let him have

the use of the horses in return for some of the profits. But
most of his time Pa spent at the hotel with Ma, caring for
such few guests as there were and worrying about the saloon.
Often Pa would sit in the hotel office and play his fiddle,
while folks stopped by to listen or to talk.

The girls were soon busy in school. It wasn't an easy task
to teach school in what the pioneers called "the brave old
days." One of the early teachers at the Burr Oak school was
a Professor Dockum, about whom the boys sang:

> The Devil came flying from north to south
> With Professor Dockum in his mouth,
> And when he found he had a fool,
> He left him here to teach our school.

There had been many other teachers in Burr Oak since
Professor Dockum, of course, and Will Reed was the latest.
Because he was so young and slim, he had as much trouble
with the older boys and bullies as Professor Dockum could
ever have had. In their first term of school in Burr Oak,
Laura and Mary didn't have Mr. Reed for a teacher, because
he taught the upper grades and they were in the lower. But
Laura heard a fine story about him from her friends.

With the harvest over, the big boys who worked in the
fields had returned to school. Some of them were older than
Mr. Reed and many of them were bigger. The biggest and
the oldest was a boy named Mose; he was the ringleader of a
gang that never learned their lessons and was always noisy in
class. And when they weren't in class, the gang of boys sang
a menacing refrain: "Reed won't be here after Christmas!"
They were going to run him out of school.

One morning before Christmas, Mr. Reed sat patiently at
his desk while Mose and his gang paraded noisily into class—
late, as usual. In his hand Mr. Reed had a large flat ruler, and
he slapped it quietly against the palm of his hand as he waited
for the boys to find their seats.

The boys looked and looked and finally found their seats.
Then Mr. Reed called Mose forward. That was just what
Mose wanted. Everyone watched as he swaggered up to
Mr. Reed's desk, ready to fight. Mose waited for Mr. Reed
to stand up, so he could knock him down. But Mr. Reed
didn't wait for anything.

He reached out and grabbed Mose by the collar and

pulled with all his might. At the same time, he stuck out his foot. Suddenly Mose was stretched out across Mr. Reed's knees and Mr. Reed's arm was going up and down with the ruler in his hand. Smack! Smack! Smack! right on Mose's bottom! It looked so funny that everyone in class just laughed out loud—and when Mr. Reed finally let Mose up, the bully walked right out the door, and never came back to school again.

Laura had no such excitement in her own class. Her teacher seems to have been Miss Sarah Donlan, who was engaged for that term to teach the primary grades. Downstairs, where Laura and Mary were, the children learned to sing the multiplication tables to the tune of "Yankee Doodle Dandy."

When they weren't in school, Laura and Mary helped wait on tables and wash dishes at the hotel. On weekends they took care of little Tommy Steadman. He whined and cried so much that the job was terrible, but Mrs. Steadman promised the girls something nice for Christmas if they would watch him. So they tried their best.

Before long the snows came, and the hill that ran alongside the hotel turned smooth and glassy. It was perfect for coasting down, Laura could plainly see. But she had no sled, and neither did Mary. So sometimes Laura borrowed Johnny Steadman's sled without bothering to ask him. Then she took a few fast bellyflops and hurried to put the sled back before Johnny discovered that she'd been using it. Laura thought that this was a nice way to pay Johnny Steadman back for being mean and taking advantage of people's kindness because he was lame. Soon Ma found out about it, however, just as Ma found out about everything, and Laura's sledding days were over.

For Laura, Christmas had always been a special occasion to look forward to. But when Christmas came that year it was sadly disappointing. "Ma was always tired," Laura remembered. "Pa was always busy, and Mrs. Steadman did not give us anything at all for taking care of their disagreeable baby, Tommy." To make matters worse, Laura and Mary and Reuben Steadman all came down with the measles at the same time.

They had to stay in bed in a dark room, and there was nothing to do. While they were sick, Johnny Steadman was up to his old tricks. He often slipped into their rooms and

yanked the pillows out from under their heads and pinched them all for good measure. He thought this was amusing. But in this way Johnny himself caught the measles, and Laura couldn't help feeling a little glad about it.

Wolves came very close to the village of Burr Oak that winter. They were reported on the wagon road only a couple of miles south of town and may well have come to the edge of the village itself. If Laura heard their lonely cry, it couldn't have made her feel any better. There was something in her that loved what was free and wild about wolves, and there was nothing wild nor free about lying still for days on end in a dark room.

When everyone was well again, the Steadmans began to talk about selling the hotel. They didn't do this right away, of course, but Pa decided it was time to move. So one day in January he moved Ma and the girls out of the Burr Oak House and took rooms on the second floor above a grocery store next door.

The store was located just south of the hotel, with a vacant lot in between, and was run by George Kimball and his wife. In her memoir Laura remembered that the store was operated by a Mr. Cameron and his wife, and that Mr. Cameron spent much of his time next door in the hotel saloon. But the only Camerons in the early days of Burr Oak were James Cameron, an early-day teacher when the village school was a little stone building on the north edge of town, and J. L. Cameron, the county surveyor, who did live in the village when Laura did. In another remembrance Laura recalled that the store was operated by Mr. Kimball, and old-time Burr Oak residents recall the Kimball store exactly in the place Laura remembered it, although it's gone now.

The rooms above the store were large and airy compared to the cramped quarters of the hotel. Ma once again devoted herself to keeping house, while Pa did odd jobs and spent time at the mill he operated with Mr. Porter. From the front windows above the store, Laura could look out across State Street at the splendid white house of Peter Pfeiffer, who was the township clerk and a justice of the peace, and perhaps the wealthiest man in town. Mr. Pfeiffer's two grand-daughters, May and Isadore, were ahead of Laura in school and too old to be her playmates, but they often came over to sit with Ma in the living room above the store and visit.

The only bad thing about the new lodgings was that

Laura and Mary had to climb a long run of stairs on the outside of the building to reach the second floor, and the stairs were right next to the saloon. Sometimes they scampered up the stairs like rabbits.

Not long after they moved out of the hotel, Laura finally got her laugh on Mr. Bisby, the singing teacher she'd been forced to please by learning the scales up, down, and mixed. On a cold night in February, Ma woke up Laura and Mary in the middle of the night and told them to dress quickly. The saloon was on fire, and Ma wanted to be able to leave in a hurry if the flames should spread.

"Ma and Mary and I stood at the window where we watched the flames and the men in the street carrying buckets of water from the town pump to pour on the fire," Laura recalled. "Pa was one of them."

The town pump was in the middle of the street, directly below the window. "The men stood in line," Laura said. "One would fill his bucket and run with it to the fire, while the next man instantly took his place. On returning he took his place at the end of the line, which was constantly moving."

But then something odd happened. The line stopped moving, and Ma cried out, "Why don't they hurry? Why don't they hurry?"

"They all stood still for some moments," Laura went on, "with the same man at the pump. At every stroke of the pump handle he would throw up his head and shout, 'Fire!' Then someone pushed him away and took his place." Once again the line started to move and the fire was soon out.

The man at the head of the line shouting "Fire!" and pumping so frantically was none other than Mr. Bisby, and the bucket into which he was pumping had no bottom in it. This was one event from Laura's life which found its way into the newspaper, although Mr. Bisby's bottomless bucket wasn't mentioned. The newspaper said:

On Monday night M. J. Ervin the proprietor of the billiard hall in Burr Oak, in putting out the lights, one of the lamps exploded, the oil running down and igniting, set the building on fire in the ceiling. The alarm was given, although late, and the people gathered, and in a few minutes had the flames under control. If the

building had burned down the Burr Oak hotel would
have gone with it, as the two join.

When Pa came back upstairs he said that if just the saloon
could have burned down he wouldn't have carried a drop of
water to fight the fire. But the flames had threatened to burn
the whole town if they weren't stopped, so Pa did his part.

With the holidays past, Laura and Mary once again re-
turned to school. "It seemed to us a big school," Laura said,
"but as I remember there were only two rooms. One began
in the downstairs room and when advanced enough was pro-
moted upstairs." Both girls appear to have advanced enough
by February to be sent up to Mr. Reed's class, or perhaps
they only went upstairs for their reading class. The advanced
class was very large, with fifty-seven pupils enrolled—al-
though only thirty-nine or forty showed up for school each
day. Among there were the two Pfeiffer girls, who liked to
visit with Ma, and George Syms, whose father had been a
British officer and who lived on the south edge of the village.
Despite the size of the class, Mr. Reed was a great favorite
of Laura's.

"He was an elocutionist," she wrote when she had grown
up, "and I have always been grateful to him for the training
I was given in reading. I still have the old *Independent Fifth
Reader* from which he taught us to give life to 'Old Tubal
Cain,' 'The Polish Boy,' and 'Paul Revere.'"

"We liked our reading lessons very much," Laura said,
"and used to practice reading them aloud at home nights. Pa
knew, but did not tell us until later, that a crowd used to
gather in the store beneath to hear us read."

In addition to the poems Laura mentions, she and Mary
also read "The Village Blacksmith," "The Pied Piper," "The
Bison Track," "The High Tide," and "The Burial of Sir
John Moore," which goes like this:

Not a drum was heard, not a funeral note,
 As his corse to the rampart we hurried;
Not a soldier discharged his farewell shot
 O'er the grave where our hero was buried.

We buried him darkly at dead of night,
 The sods with our bayonets turning,
By the struggling moonbeam's misty light
 And the lanthorn dimly burning. . . .

Their clear high voices carried easily to the unseen audience below, and they surely must have been good readers to attract such a crowd. Perhaps it was in the lines of these timeless poems and in the teaching of Mr. Reed that Laura first awakened to the rhythms of her own life, and began to tune her ear and mind for telling the story of it.

During these days when Laura lived above Kimballs' store, she came to know more of the people of Burr Oak. Uncle Harry Wingate was a familiar figure as he inched down the walk with his crutch and cane, all crippled up with rheumatism. Uncle Harry was a cooper and well worth remembering: he chopped the toes off his chickens so they wouldn't scratch out his garden, and he rubbed his bald head with onions in hopes that it would sprout hair. Uncle John Wingate had no problem at all with hair; his beard was long and bushy. But the pipe he smoked was extraordinarily short and stubby, and the children always kept an eye on Uncle John hoping to see his beard catch fire. That spring Sam McLaughlin got married, and no doubt Laura watched the little boys as they scampered about town, each with a cigar in his mouth and another in his hand. "Never saw Sam with a black eye till since his marriage," one Burr Oaker remarked. "Wonder what happened."

When spring came Pa sold his interest in the gristmill. Soon afterwards a terrible thing happened in the saloon, a thing that made Ma and Pa shudder. It happened to Hairpin, the beau of Amy the hired girl, and it was probably Pa who told Laura about it. She wrote the story down in her memoir.

For several days, Hairpin had spent every day drinking in the saloon. The more he drank the thirstier he got and the more he drank. Finally he fell over with a thud onto the floor. When he woke up, everybody was gone. He stood up. Reaching into his pocket, he pulled out a cigar. And then he struck a match to light it. The fumes of alcohol were so thick around Hairpin's mouth that they ignited. A tongue of flame leaped down Hairpin's throat, and in an instant he was dead.

That was the story Laura heard and remembered. Whether it was true or not, Pa decided to move. He hadn't liked having Ma and the girls living next door to the saloon in the first place; now, more than ever, he was determined to find them another place to live. If he was going to work in the fields

during spring planting, he wanted Ma and the girls in a safe place. They would be alone much of the time.

There was one other reason Pa wanted to move: Ma was soon going to have another baby, and Pa didn't want her climbing that long flight of stairs to their rooms over Mr. Kimball's grocery store.

Even though Mr. Bisby stilled lived in the hotel, he owned a nice little red-brick house on the northwest edge of the village, near the Congregational church. The house was for rent, so Pa rented it. One day he loaded the wagon and moved all the family's belongings up State Street and up Water Street to the little red-brick house. Laura thought it was a lovely place, although she now had to walk three or four blocks farther to school. But she was getting to be quite a big girl, and after all, when she'd lived on the banks of Plum Creek, she had walked two miles each way across the prairie to go to school.

Ma and Pa liked being in the house, too. It was much quieter than living above a grocery store and next to a saloon, and the countryside at the edge of town was so much prettier than the wide noisy street in the heart of the village. To make things even better, Pa bought a cow of his own, and perhaps took care of others for his neighbors.

The house stood right next to a little oak woods that was "filled with sunshine and shadow," Laura remembered. "I loved to wander along the creek and look at the flowers and wriggle my toes among the cool, lush grasses," she said. "I was such a great girl now that I wore my shoes all day, but I always went barefoot after the cow."

Another time she remembered what it was like to watch the sun go down from this pasture.

"There was one marshy corner of the pasture down by the creek where the grass grew lush and green, where the cows loved to feed and could always be found when it was time to drive them up at night," Laura said. "All through the tall grass were scattered purple and white flag blossoms and I have stood in that peaceful grassland corner, with the red cow and the spotted cow and the roan taking their goodnight mouthfuls of the sweet grass, and watched the sun setting behind the hilltop and loved the purple flags and the rippling brook and wondered at the beauty of the world, while I wriggled my bare toes down into the soft grass."

There was an old stone quarry nearby, but Ma and Pa both

warned Laura not to go near it, for it was full of water and she could easily drown there.

Between the winter and the spring terms of school, the inside of the schoolhouse had been freshly whitewashed and a post-and-wire fence strung around the school building itself, making a play yard for the children. Everything seemed so clean and fresh that Laura was happy and eager to be back when the new term began. But she soon grew worried. No matter how hard she tried, she couldn't memorize her multiplication tables. This was really not a great problem, but it grew and grew. The more she tried to learn the multiplication tables by heart, the harder they seemed to be. She began to fear that she wouldn't be able to keep up with her class.

Laura was glad, early in May, when Ma said she could stay home from school for a time to help with the housework and run errands. Laura was needed at home, for it was almost time for Ma to have the new baby, and she couldn't do as much she would have been able to otherwise. So every day Laura helped Ma, and every day between work and errands she studied over her multiplication tables, trying them in her head and glancing at the book if she got stuck. Little by little they became easier.

One day Laura returned home from an errand that had taken an especially long time and found that she had a new baby sister. It was May 23. The baby's hair was soft and golden, and her eyes were blue like Pa's. Ma and Pa named her Grace, no doubt because they felt she was a special gift to replace little Freddie, the child they had lost.

After Grace was born, Laura stayed home only a little while longer. When at last she returned to school to finish out the term, she could recite her multiplication tables perfectly. School lasted until late in July. Summer had already arrived with its theatricals and its concerts, its hum of people moving about town, and the glorious haze that covered the fields—which this year, for a change, were bountiful with crops.

"The cornfield, dark green and sweetly cool, is beginning to ripple in the wind," wrote one man, looking back on the summer he had spent as a boy in Burr Oak Township. "Waves of dusk and green and gold circle across the ripening barley, and long leaves upthrust, at intervals, like spears. . . . The blackbirds on the cattails sway and swing . . . and over

all, and laving all, moves the slow wind, heavy with the breath of the far-off blooms of other lands, a wind which covers the sunset plain with a golden entrancing haze." The man who remembered this about Burr Oak grew up, like Laura, to be a writer. His name was Hamlin Garland.

Laura would certainly have agreed with his feelings. "That was a delightful summer!" she remembered. "Work and play were so mixed that I could not tell them apart." She helped Ma take care of baby Grace and she went faithfully after the cows, even when it rained. The rain soaked her light clothes and splashed her face and felt good on her bare feet as she walked through the high rich grass in the pasture.

The amateur actors of Burr Oak put on regular entertainments at the schoolhouse on Friday and Saturday nights, sometimes for the benefit of other groups in the village—such as "that deserving organization, the Burr Oak Brass Band"— and sometimes for the benefit of themselves. Mr. Reed, the school principal and elocutionist, played a major role in these entertainments as the leading actor in such plays as "Enlisted for the War" and "The Home Guards."

One did not have to go to the theatricals to keep busy, of course. One could merely count the summer comings and goings of the townspeople.

The Steadmans had sold the Burr Oak House to William McLaughlin, who intended to turn it into a dry goods and general store. He was already ordering merchandise. D. H. Ball, the village blacksmith, moved off to a better situation in Decorah, and Enoch Rollins, an old-timer in Burr Oak, had the rheumatism so bad "he can't even brush a fly off his face." Mr. Cameron, the county surveyor, "doubled his joys and divided his tribulations"; he got married. William Masters came home to visit. Martin Ervin, who ran the saloon when it was nearly burned down, was headed for the Black Hills. The Adventists were building a church of their own at the south end of town, and State Street was being graded south of C. and C.'s store. In the deep of the night, horse thieves were at work in Burr Oak.

Laura spent many of her afternoons this summer playing with her special school chum, Alice Ward. They often walked out through the village and past the Symmses' rose-covered cottage to the graveyard at the edge of town.

Laura was a little afraid of the young man who lived in the cottage with his grandmother. He would lean on the picket

fence and watch them walking up from town, and sometimes he would act strangely. But his grandmother was a kindly woman. She often invited Laura and Alice in for cookies, and sometimes gave them a bouquet of roses from her beautiful garden.

The graveyard lay atop a low hill, in the shade of dark evergreen trees that have long since fallen to age and the cutting winter winds. "We would wander in the shade of the great trees, reading the inscriptions on the tombstones," Laura remembered. "The grass was green and short and flowers were everywhere. It was a beautiful, peaceful place."

A gentle stillness descended on the little hill as the sun moved toward the far western horizon. The white limestone markers gleamed in the light, and Laura moved slowly among them—among the dreams and memories of old Burr Oak. Here lay little Freddie Austin, and there lay Eugene Masters, who died at the age of eleven, only a year older than Laura. Across the way lay Stewart Sharp and Charity Wingate, William Manning, Joe McLaughlin, Eli Dufield, and William W. Symms, who died in the flower of his young manhood, a Union soldier in Andersonville prison. There, beneath a heavy stone, lay William Miller, aged 17:

> Sleep on sweet Willie
> and take thy rest
> God has called thee
> He knows best

And Carl Purdy:

> He sleeps in Jesus
> Gone but not forgotten

And Lysander Butler:

> Gone home

And Edwin Snel:

> Farewell.

The weathered stones were carved with folded hands and open Bibles and weeping willow trees. They spoke in a

single word or two of an entire life: Gone home, farewell.
Here, where the flowers grew and the sunlight came in long
straight lines from the distant west, Laura felt the great
silences that she had felt before, in other places and other
times. And although she wasn't the least bit afraid, she
always hurried home before the sun went down.

One day when Laura returned home from an afternoon in
this lovely, lonely place, she found a visitor talking earnestly
with Ma. The visitor was Mrs. Starr. Her husband was Dr.
A. H. Starr, a physician and surgeon, a village trustee and
the new town clerk, and together they were an important
part of Burr Oak society.

When Laura walked in the door, Mrs. Starr put her arm
around her and went on talking earnestly with Ma. But what
she said made Laura's heart sink. Both of the doctor's
daughters had grown up and moved away from home; they
were working as teachers. Mrs. Starr felt very lonesome all
alone in her big house. She told Ma that she needed a little
girl to live with her, to help with the work and to keep her
company. And Laura would do just fine, she was such a
nice little girl.

Mrs. Starr asked Ma whether she would give Laura up.
She said she would adopt Laura and treat her as nicely as
if she were her own daughter. Laura could hardly bear the
silence as Ma waited to answer. Finally Ma smiled at the
doctor's wife and said that she couldn't possibly get along
without Laura. When Mrs. Starr left the house, she was very
disappointed—but Laura, of course, was not. How could
anyone think she would want to leave Ma and Pa? Often,
however, parents did give up their children to strangers,
especially when they were pressed by hard times.

Now that summer was drawing to a close, Laura began to
think that perhaps she alone had enjoyed it. Pa had worked
hard and had not been paid much. He was haunted by debt,
and he was restless.

In the evenings, when Laura crawled into bed, she lay
awake for a while and listened to Pa play his fiddle. The
songs that he played were sad and lonely and troubled songs,
and they spoke of places far away:

Come to that happy land,
Come, come away;
Why will ye doubting stand,

Why still delay?

Pa always finished up with a rousing tune like "John Brown's Body" or "When Johnny Comes Marching Home." But he didn't fool anyone. He was dreaming about that happy land, far away.

When the girls had fallen quiet, he spoke softly with Ma and counted his debts. There were doctor's bills to pay, and grocery bills and rent bills. If he paid them all, there would be no money left to go anywhere. One day Pa asked Mr. Bisby if he could send him the rent money after he'd settled in another place and worked for a while. But Mr. Bisby was very hard-hearted about it: he said he'd have the sheriff take Pa's horses and sell them if he tried to leave town without paying up. And they wouldn't get very far in a wagon without horses.

But then the man Pa had worked for all summer came to his rescue. He offered to buy Pa's cow, and Pa quickly agreed. Now he could pay his debt to Mr. Bisby and be a free man, although he said he had a mind not to.

It was still dark outside when Ma woke the girls. Pa had already loaded the wagon, and the horses stood hitched to it in front of the little red-brick house, sniffing and snorting in the cool night air. They were impatient. While Ma looked after the little girls, Laura and Mary quickly got dressed. And then they all climbed into the wagon, with its sweet smell of oats and hay.

From the back of the sleepy wagon, Laura looked out on the dark shapes of houses passing by. The trees were black against the sky, and the stars were faint. In the east, behind the village of Burr Oak, a smudge of rosy light brightened the horizon.

The wagon pitched and rolled down the dark road, and Pa's voice spoke gently to the team. Baby Grace was asleep in Ma's arms. Only Laura and Mary and Carrie peered over the backboard of the wagon. A new day was coming, and it would find them far, far away.

6

Walnut Grove

The morning light found the little wagon far from the familiar hills of Burr Oak. Pa stopped the wagon and fed the horses; Ma made breakfast. Then everyone climbed back into the wagon and they pushed on. The road was long. Pa drove and drove, and the wagon rolled on. Laura sat in the back with Mary and Carrie and they watched the road unfold behind them.

The sun set behind the dark, distant edge of the land toward which they were headed. Dusk rose around them, and the sky gleamed with blue and purple streaks of light. At last Pa stopped the wagon and jumped down to make camp for the night. It was late. "Old Sol beat us this time," he shouted to the girls. "There's his campfire!" Laura looked behind Pa, toward a distant grove of trees. There, cold and bright, the round moon was rising.

That night the campfire burned merrily in its ring of stones. The moon made shadows on the ground. In the still night air, Pa's fiddle rang out with the wildest, most soul-stirring songs Laura had ever heard—"Yankee Doodle," "Marching through Georgia," "The Star-Spangled Banner," "Arkansas Traveler," and a song she'd first heard many years before, at a sugaring-off dance in Grandma's house in the Big Woods:

Oh, you buffalo gals!
Will you come out tonight?
Will you come out tonight?
Will you come out tonight?

Buffalo gals!
Will you come out tonight,
To dance by the light of the moon!

114

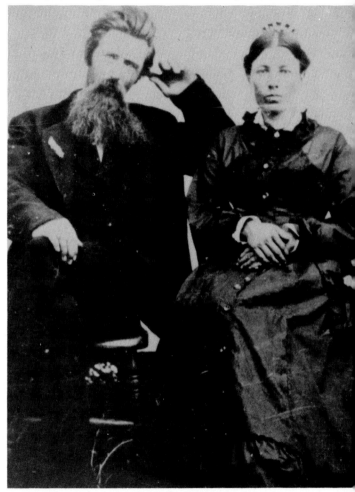

Charles and Caroline Ingalls, about 1880. The comb in Ma's hair is believed to be the one Laura and Mary gave her on Plum Creek.

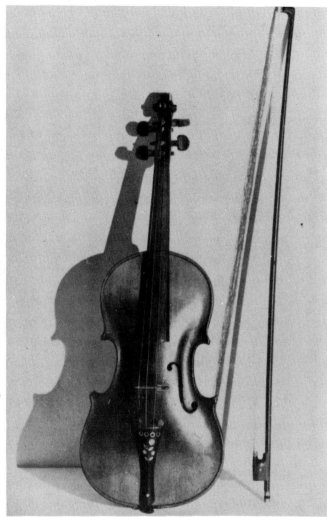

Pa's fiddle, on display today at the Laura Ingalls Wilder Home and Museum in Mansfield.

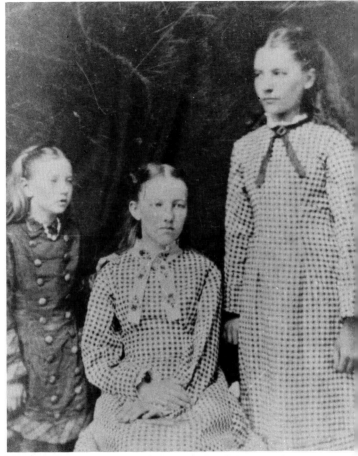

Carrie, Mary, and Laura Ingalls in 1881, after the Hard Winter was over.

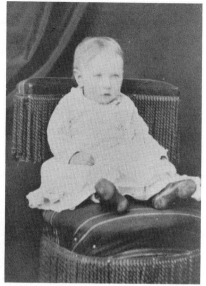

Grace Ingalls, about 1879.

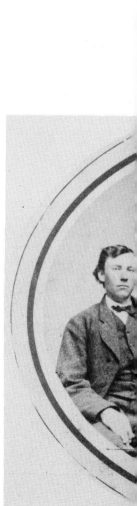

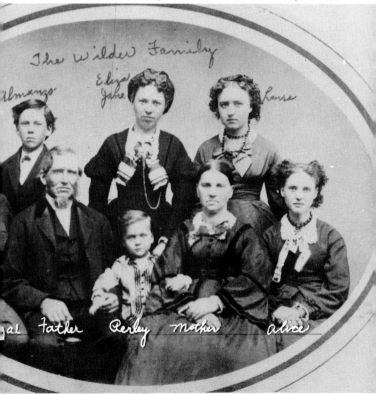

The James Wilder family, about 1870, before leaving *Malone* for the West. Seated, left to right: Royal, James, Perley, Angeline, Alice. Standing: Almanzo, Eliza Jane, Laura (Almanzo's sister).

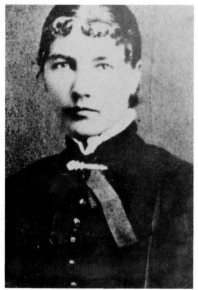

Laura Ingalls at the age of 17.

The parlor of Pa and Ma's house in town at DeSmet.

Laura's plat of DeSmet, from the draft manuscript of The Long Winter.

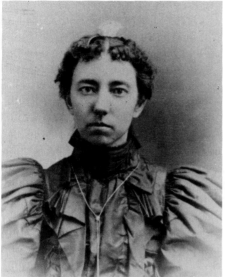

*Carrie Ingalls,
around 1890.*

*Laura and Almanzo, the
winter after they were
married.*

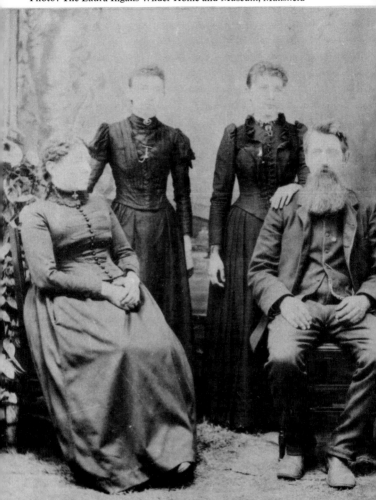

The Charles Ingalls family in 1891; Laura was 24. From left to right: Ma, Carrie, Laura, Pa, Grace, Mary.

Laura at Rocky Ridge Farm in 1900. She was 33.

Laura in her forties.

Laura in her sixties.

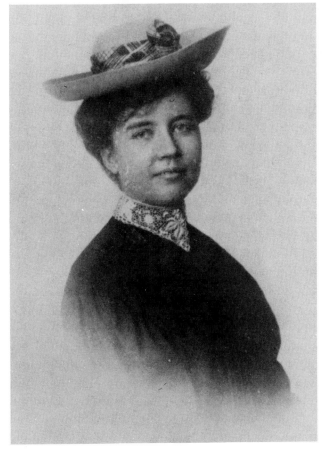

Rose Wilder Lane.

*Almanzo and Laura at Rocky Ridge Farm, around 1948.
She was 81; he was 91.*

Pa was happy. He was going home.

The crisp autumn air was signed with happy songs like these all across Iowa and Minnesota, from Burr Oak to Walnut Grove, and everyone's thoughts ran forward to the little town they had left more than a year before. In that short space of time they had moved six times. From the little house behind the church in Walnut Grove they'd moved back out to Plum Creek, and then to Uncle Peter's farm, and then to the hotel in Burr Oak, and then to the rooms above the store near the saloon, and then to the little red-brick house Pa rented from Mr. Bisby, and now home again to Walnut Grove.

Pa was more than restless. He was driven, like a leaf before the wind. He had yet to find the place where his heart could rest happy and his spirit be unbound and free.

They were going back to grasshopper country. Times would still be hard. But Ma, for one, could hardly wait to see the little town on the Minnesota prairies once again. It would be an anchor against this endless wandering.

Laura was coming home a big girl: she was ten years old, going on eleven. She had known good and happy times since leaving Walnut Grove, but she had also learned that life is not always kind, or nice. Little Freddie lay in a lonely grave. She had seen Ma and Pa sorrowing. She had heard of Hairpin's tragic end, and her heart had stopped when Mrs. Starr, the doctor's wife, asked Ma to give her up. On the hill at the edge of town, where the memories and dreams of old Burr Oak lay sleeping, she had wandered in the silent afternoons. She had her own thoughts now, and her own feelings.

So much had this restless journey done. When at last Pa drove the wagon into Walnut Grove, they could look about them and see by every familiar sight that they were home. Perhaps, after all, better times were coming.

Pa stopped the wagon in front of the house where John Ensign lived with his family. That's where Ma and Pa and the girls stayed on their first night back in Walnut Grove.

Mr. and Mrs. Ensign were good friends of Ma and Pa. They'd all been together with Reverend Alden on that summer day when the Union Congregational Church was founded and Ma and Pa were baptized. Mr. Ensign had even been elected treasurer of the church. His daughter Anna

was Mary's age and his son Willard was a year older. Laura had gone to school with the youngest of the Ensign children, and they remembered each other very well. Howard had a crush on her.

The children all got along very nicely together, and it was a good thing they did. The next morning, as Pa was about to set out in search of a place for his family to live in, the Ensigns insisted that Pa's family stay with them until Pa could build a house of his own. Pa could pay half of the expenses, and they could all live together through the long winter that was fast approaching. And that's just what they did.

Walnut Grove had changed very little in the months they'd been gone, although there were strangers in the streets now and a few new buildings had gone up beneath the wide prairie sky. The members of the Congregational Church had built a house for their minister to live in, and they even had a new minister to live in it: Leonard Moses. His son Albert was nearly Laura's age, and was both her schoolmate and her playmate. There was also a new hotel in town, made of fresh brown boards, where there had been no hotel before. The new hotel was run by William J. Masters—the same man who had sold his hotel in Burr Oak to the Steadmans.

There had been these few changes in Walnut Grove. But beneath the surface, Laura could see that life wasn't much different from the way it had been before, or from the way it was in Burr Oak or in any of a hundred pioneer towns scattered across the prairies. Good things happened, and bad things happened too.

Surely it was sad to learn that Lafayette Bedal's little baby boy was dead of the cholera. And no doubt Laura was shocked when Willie Auringer died "by drowning himself" only two days after Christmas, which couldn't have been very long after the Ingalls family returned to Walnut Grove. Willie was only a couple of years older than Laura herself.

But at the same time Laura felt very much at home, seeing so many familiar faces again.

Her good friend Nettie Kennedy hadn't left Walnut Grove after all. The Bedals, of course, were still there, and Amasa Tower and his wife and so many of the people Laura had known at church and Sunday School. Mr. and Mrs. Fitch still had their old general store a block away from the

railroad tracks, and the Owens family still lived across the street in the fancy rooms behind the store. Without Nellie Owens, life in Walnut Grove would certainly not have been the same.

Pa took a job at one of the stores in town to help pay his share of the expenses when everyone was settled into the Ensign house. Laura and Mary were soon back in school, with Carrie tagging along. In January Pa paid the taxes he still owed from the year he'd left Walnut Grove—they amounted to $2.10. Then, as the sky turned cold and blue and the snow began to drift in from the prairie, their lives once again centered on the familiar paths and streets of Walnut Grove, the little church that stood on the edge of town, and school.

Although Laura didn't write about it in her memoir, Ma and Pa had been members of the Reverend George Sterling's Congregational Church in Burr Oak. Mary certainly attended services and Sunday School there, and Laura and Carrie must have done so also. It was a small church with about fifty members, and of all the churches in the conference it belonged to, it was the poorest. But perhaps that was simply because times were harder in Burr Oak than in the other Iowa villages with Congregational churches.

When Ma and Pa returned to Walnut Grove, they brought a letter from Reverend Sterling, and they were officially welcomed back into the Walnut Grove church on January 26, 1878. The people of the church seemed glad to have them back, for soon Pa was elected a trustee, and before long Mary Ingalls was baptized, and she too became a member of the church.

Every day Laura and Mary and the Ensign children walked up to the old schoolhouse that Laura had attended when they still lived on Plum Creek. The children always played and chased each other in the snow, and threw snowballs at each other with hands that chattered inside mittens full of frost—except, of course, for Mary, who was a young lady. They were all in the *Fifth Reader*, and they studied from the same books for the other subjects too. Laura was at the very beginning of the book in grammar, arithmetic, history, and geography. Mary was in the middle of the book, and Anna and Willard Ensign were almost at the very end.

The best part of school for Laura was spelling, and the

best part of spelling was that it was such a good contest. Laura liked a challenge, and she was in the highest of the two spelling classes.

When spelling time came, all the children stood fidgeting in a line. The teacher clearly e-nun-ci-a-ted the word to be spelled, and the fun began. If the students were so unfortunate as to spell a word incorrectly, all they could do was make a disappointed face or snap their fingers. The word was given to the next child in line until someone spelled it correctly. Then that lucky person was allowed to move up in the line—ahead of the one who first missed the word. And then the teacher would clearly e-nun-ci-ate another word, more difficult than the first, and the game would go on. The greatest honor was to stand at the head of the spelling class for an entire week.

Spelling in school was fun, but the best fun of all was Friday nights. On Friday nights Laura would look out the window and see parents and children walking down the street toward the school house. Some would carry lanterns, for darkness came early and there were no lights in the school. Laura would urge Ma and Pa to hurry, and then they would all be off to school for the Friday Night Spelling Bee.

The lamps hissed in the schoolroom and black shadows crept along the walls. People laughed and talked and shouted across the room to each other until the teacher picked up the bell from her desk and gave it a good shaking. Then an ominous quiet filled the room.

The grownups took their seats around the walls and the children went to their desks. The teacher called the two best spellers to the front of the room, where the stove snapped and sizzled and cast a red glow. Each of the two best spellers took turns picking classmates for a line, until no one was left at the desks and two lines stretched down the sides of the schoolroom facing each other.

Then the teacher would clearly e-nun-ci-ate a word. In the hushed room, a small voice would carefully repeat the word and then spell it. And then there would be another word.

Anyone so unfortunate as to spell a word incorrectly on Friday night had to go to his seat. The first one to miss always felt like a dunce: everyone's eyes were on him as he took his place in a sea of empty desks. But soon he had plenty of company. As the lanterns flickered and the stove

sizzled, the lines grew shorter and the desks filled up, until at last there were only two children still standing. When one of these made a mistake, only one was left—the best speller of all.

Then everyone talked at once. The mothers and fathers stood up and stretched and talked and laughed and stuck their arms into their heavy coats. The Spelling Bee was over, and everyone walked out through the starry night to their snug homes.

That winter Howard Ensign finally asked the big question: he asked Laura to promise to marry him when they grew up. Laura considered the question very carefully. But one day Howard cried because Laura was playing with Albert Moses, the minister's son. Laura was so disgusted that she told Howard she'd *never* marry him. And that was that!

Later in the winter, Pa worked for Mr. Masters at the new hotel in town. Mr. Masters was a rover like Pa, although perhaps not as much of a rover. He'd been born in New York like Pa, and had moved west to Burr Oak, and now had come even farther west to Walnut Grove. He lived in the hotel, of course, with his wife and his son Will and young Will's wife, Nancy (who was British), and their little daughter, Eugenia, who was only a year old. It was young Will Masters who had put the bullet hole in the door of the Burr Oak House, and Nancy, his wife, who'd slammed the door just in the nick of time. Dr. R. W. Hoyt also lived in the hotel. He was a Vermonter and still a young man, having graduated from Rush Medical College in Chicago in 1875. Doctor Hoyt and young Will Masters were good pals.

Pa saved enough money working for Mr. Masters to build a small house of his own, in Mr. Masters' big pasture near the hotel. He was a Vermonter and still a young man, having Ma and Laura and Mary and Carrie and baby Grace moved in. Anna Ensign moved in with them. Mr. Ensign moved the rest of his family back to their farm and rented out his house in town, but Anna wanted to stay with Ma and Pa until the school term was finished. Then Pa rented a little room in town and opened a butcher shop. It wasn't like being a free and independent farmer, but Pa did a fine business as a butcher; through the long winter, people had used up all the meat they'd cured the previous autumn.

Near Pa's new house was a "queer little house" with their closest neighbors, and Laura remembered them very clearly

many years later—Mr. and Mrs. Pool and their grown daughter, whose name was Missouri. Missouri smoked a pipe, just as her mother and father did, and she was a very good gardener.

When Laura returned to school for the spring term, she had a new teacher. His name was Samuel D. Masters, but everybody called him Uncle Sam Masters, to distinguish him from the Mr. Masters who ran the hotel. They were brothers.

Uncle Sam was a surveyor and a justice of the peace as well as a schoolteacher. "He was tall and thin," Laura remembered, "with bad teeth and a bad breath and small brown eyes and a bald head." Uncle Sam had the annoying habit of putting his face very close to the face of whichever pupil he was talking to at the moment. Often he would pick up a girl's hand as he talked to her, and begin to fondle it absentmindedly. Laura found this even more annoying than his bad teeth and bad breath and small brown eyes and bald head.

One day she held a pin between her fingers when he came near her. Uncle Sam put his face very close to Laura's face, and he reached out to take her hand. He squeezed—and never again did Uncle Sam Masters take Laura's hand in his.

The teacher lived near the church, in the same house Laura had lived in during the winter little Freddie was born. He had a boy named George and three girls whose names were Lissie, Jessie, and Genny. Genny's full name was Genevieve, and Laura found her very snooty. She "sneered at the other girls in school because they were westerners," Laura said. "She thought herself much above us, because she came from New York."

It was true that Genny Masters dressed much more nicely than most of the other girls in school, and when she spoke she lisped a little in a very sugary manner. But she also cried just like Howard Ensign when she didn't get her way. Everyone tried to be nice to her, however; after all, she was the teacher's daughter.

In the schoolyard, the girls seemed to choose sides as to who would be their leader—Genny Masters or Nellie Owens. Laura didn't care for either of them as the leader, so she simply stayed by herself. She was too young for the "young ladies" who played with Mary and too old for the crowd of little girls that played with Carrie. Sometimes Laura would play with Genny's crowd and sometimes she would play

with Nellie's crowd, but she decided that nobody was going to boss her around.

Laura was so independent that both Nellie and Genny tried everything to get her on their side. Genny sometimes asked Laura to walk home with her after school, and Mrs. Masters gave Laura cookies hot and fresh from the oven. Nellie Owens brought ribbons and little trinkets for Laura from her father's store, and once she even gave her a pretty ring.

The other girls saw Genny and Nellie trying to get Laura's allegiance, and one day—much to her surprise—Laura found that she herself was the leader of all the girls, Genny and Nellie included. These two didn't like to go it alone; they weren't so strong-minded or so independent as Laura Ingalls.

In Walnut Grove, school continued into the summer. The warm yellow sun beat down upon the schoolyard, and Laura led the other girls into her favorite games—Anti-Over, Pull-Away, Prisoner's Base, handball, and even baseball. They played so hard that their cheeks turned rosy, and Mary complained with a haughty air that Laura was nothing but a tomboy. "Only one boy in school could throw faster than me," Laura boasted, "and not always could he do it."

That summer the Sunday School superintendent invited all the children to go on a picnic. They would meet at the house of Mr. Moses, the minister, with their baskets of lunch, and a wagon would take them southwest of town to the walnut grove. To Laura that sounded very exciting, because the walnut grove stretched for over seventy acres up along Plum Creek. Indians and trappers and traders had lived in the grove before other people came to settle and farm in the neighborhood.

But the Sunday School superintendent told the children something even more exciting. Swings had been put up in the trees, and there would be ice cream and lemonade for everyone.

Laura could hardly wait for the Sunday School picnic. When the day finally arrived, she and Mary and Carrie set off for Mr. Moses' house carrying the picnic basket. Laura remembered the day very well, and wrote about it many years later in her memoir. She was wearing a new pair of shoes Pa had bought for her, and she was carrying delicious thoughts of the fresh lemon pie Ma had made and tucked away in the picnic basket. The children climbed into the big

wagon, and the team drove off across the prairie toward the walnut grove.

Laura found that two swings had been put up, just as they'd been promised. For a while she and Mary took turns pushing each other on the swings. But the more they pushed and the more they swung, the hotter and the thirstier they got. So they walked over to where the lemonade and the ice cream were. And that's when they found out that the lemonade was five cents a glass, and that the ice cream was ten cents a dish.

Laura and Mary and Carrie hadn't brought any money along with them; they'd thought the ice cream and the lemonade would be furnished free by the Sunday School. So they went thirsty.

When dinnertime came the teachers spread a large white cloth on the ground, and they took all of the lunches out of the baskets and laid them on the cloth; everybody would share. Laura looked at all the food and didn't feel very hungry. She couldn't even find Ma's lemon pie on the white sheet. She looked for a while and then she walked away.

Just as she walked past a large box, a teacher opened it and took something out. "I saved this lemon pie for us teachers," Laura heard her say. "There isn't enough to go around anyway." Laura felt miserable.

She went off by herself and sat down in the shade of a tree. After dinner, when the other children called for her to come and play, she didn't answer. She didn't feel like playing. After a while Mary came over and asked Laura to come with her for a little walk in the woods to gather wildflowers. Mary could see that Laura didn't feel like playing games. But she knew her sister needed something to get her mind off ice cream, lemonade, and lemon pie.

At last the picnic was over and it was time to go home. All the children climbed back into the wagon, headed back across the prairie toward town. Laura didn't say anything. When the wagon stopped in front of Mr. Moses' house everyone climbed down over the sides and back of the wagon. Laura and Mary and Carrie said goodbye to their friends, and took their empty picnic basket and walked home.

When Laura got home she still felt miserable. The first thing she did was take off her brand-new shoes. There, on the heel of her right foot, was a large and painful blister.

Finally her mind was off ice cream, lemonade, and lemon pie, but she felt more miserable than ever.

Mr. Nelson, the Ingallses' old friend from out on Plum Creek, came to town and opened a saloon that summer. He was persuaded to do this by Dr. Hoyt, who liked to drink with young Will Masters. It was a pretty wild place, Laura remembered, and of course she wasn't permitted to go near it.

When school was out she was very busy anyway. Now that she was eleven, she had a paying job. Emeline Masters, the wife of the hotel keeper, had come to Pa's house and asked whether Laura could come to work for her at the hotel. She needed a girl to wash dishes, to wait on tables when the guests took their meals, and to help care for her little granddaughter. Mrs. Masters said she would pay Laura fifty cents a week for this. Pa and Ma talked it over and decided that Laura could go. Pa didn't like the idea of Laura working in a hotel, but he said it would be all right considering that the Masterses were such good friends.

So Laura went to work. She stayed close to Mrs. Masters, and even helped cook some of the meals. Before mealtimes she carefully set the tables, and she covered the food with round wire screens to keep the flies away until the guests sat down to eat. The quiet times came between meals, when the dishes had been washed, and it was then that Laura took care of the baby. This was Nannie Masters' baby. She was only a year old and much of the time she slept, so Laura curled up in a corner with copies of the *New York Ledger* and lost herself in stories of "dwarfs and villains and jewels and secret caverns." Sometimes working in the hotel could be hard and busy work, but other times it was a doorway to the world of imagination.

Often Laura visited with her friends when she wasn't working. Her special chum from Sunday School was Maud Blair. Anna Ensign came in from the farm to visit a few times, and once Laura walked out to the Kennedy place. There she spent a memorable day with Nettie Kennedy, who had always been her favorite friend. Nettie's mother and her big sister Christy made a special dinner for her visit, and they wouldn't let Nettie help. Even Sandy, Nettie's pesky brother, left them alone. The two girls spent the whole day by themselves, looking through Nettie's books, walking outside through the fields of summer flowers, and talking. For Laura

and Nettie, this was a farewell visit. In August the Kennedy family finally moved away to Amiret, Minnesota, and Laura and Nettie never saw each other again.

Summer drew to a close and Pa gave up his butcher shop, because folks were starting to put up their own meat again. For a while he did carpentry work. Mr. Masters decided to build a store with a hall above it right next to his hotel, and Pa was one of the men who worked on it. One day, however, Pa went back to a job he'd tried his hand at for a day or two many years before, on the lonely Kansas prairies. He was a cowboy.

A cattle buyer had come through Walnut Grove with a large herd of two hundred bawling cattle. He'd bought them in the West and was driving them east to market. He rented the little fenced pasture behind Pa's house and hired Pa to watch them all night while he and his riders stayed at the Masters hotel and slept.

That night Pa "rode herd." The cattle ate grass and drank water and finally lay down, while Pa walked around and around the pasture fence to keep an eye on them. From inside the house Laura heard the restless lowing of the cattle. She went to bed with all her clothes on, because Ma told her she might be needed to run to the hotel and get the men if Pa needed help. Sure enough, in the middle of the night, Ma shook Laura awake. Laura could hear the snorts and bawling of the cattle outside. When she opened the door she heard Pa's voice over the noise of the thrashing cattle and the crashing fence.

Laura ran as fast as she could through the night to the hotel, and pounded on the door. The men who were riding with the cattle buyer stumbled from their rooms and dashed for their horses when Laura told them what had happened. With a shout they disappeared into the night, and Laura ran back to the house, her hair flying out behind her.

The pasture was empty and the fence was down. Pa said the cattle had all been sleeping when one big steer jumped to his feet and bellowed. He spooked the rest of the herd. They jumped up and pawed the ground and bawled; then they roared off into the darkness, trampling down the fence. Pa had shouted and waved his hat, but one man couldn't stop a stampeding herd, even a man with a big hat.

When the winter school term started that year, Laura had a new teacher again. His name was David M. Thorpe. He

was a newcomer to Walnut Grove and a lawyer, and he taught school because he didn't have much business as a lawyer. Laura liked him as a teacher much more than she had Uncle Sam Masters. There was a new boy in town too—Clarence Spurr, the blacksmith's son. He was seventeen years old and very handsome, and Laura said all the girls in school fought over him—except herself, of course.

The snow piled up that winter much deeper than usual. At recess, Laura always ran out to join the boys in their wild snowball fights. Mary thought Laura's behavior was horrible. Once she even grabbed Laura's hair to try to keep her in the schoolroom during recess, but Laura pulled away. There was no stopping her. Even worse, Mary was hit by a couple of snowballs as she struggled with Laura. That night Mary told Ma, and Laura got a good talking to. She was too big to play wild with the boys, Ma said. So from then on Laura stayed inside the schoolhouse at recess with the "young ladies" of Mary's age. Laura was still the leader of the girls her own age, and because she didn't go out at recess they didn't go out either. The boys played alone in the snow and had all the fun.

Coming home from school was a different story, though. She couldn't stay out of the snow then, and the snowballs flew fast and furious. Laura always said that when the boys pitched snowballs at her, she could fire them back just as hard and fast as any boy could.

At Sunday School, however, Laura was a perfect angel. Ma and Pa and the girls went to preaching and Sunday School at the Union Congregational Church in the mornings, and in the afternoons Laura went to Sunday School at the Methodist Church. The Methodists met in the hall above Mr. Masters' new store. Sometimes Pa went with her, but often Laura went alone. Mary rarely went, because all that winter she didn't feel well.

Laura was anxious to go to Sunday School at the Methodist Church because of a Scripture lesson contest. Every week the children learned a Golden Text and a Central Truth. At the end of the year, all the children were to recite the Golden Text and the Central Truth for each week in order, and the one who could do the most of them would win a special prize—a reference Bible.

When the last day came, one child after another tried to recite the Golden Texts and the Central Truths for the entire year in order. One child after another failed to do it. Then

it was Laura's turn, and she gave them all in order perfectly. But after Laura came Howard Ensign, the boy who had asked her to marry him when they grew up and who had cried when she played with Albert Moses. Howard too got all the Golden Texts and Central Truths correct in order, just as Laura did.

Now there were two winners, and only one prize to be given out. The preacher's wife told Laura that if she'd agree to wait for her prize, she would order a special reference Bible with a clasp on it. Laura agreed, and when she finally got her Bible she wrote her name in the front of it, and the date, 1878, and she kept it all her life. Howard Ensign got the Bible that was already on hand, and that was just as well. Nobody wanted to see Howard cry again.

All her life Laura treasured the Bible verses she learned in Sunday School at Walnut Grove. Even when she was grown up, she kept a little tablet on a table near the rocking chair where she liked to sit and read, and on the tablet she kept references to her favorite Bible verses. Each of these was for a different kind of situation. "When things are going from bad to worse" she read Second Timothy, the third chapter. "When friends go back on you" she held to First Corinthians, the thirteenth chapter. She had a favorite verse for facing a crisis and for when she was lonely and afraid and for when she was discouraged and even for those times "if you are having to put up a fight." Then she read the end of Ephesians.

With the coming of the new year a Good Templar Society was organized in Walnut Grove. This was a group dedicated to fighting a battle against selling and drinking whiskey. Ma and Pa joined up, although they didn't like the temperance lecturer who organized the lodge. He made his fiery speeches against "Demon Rum" with a bottle of whiskey plainly visible in his pocket.

On the evenings of the temperance lectures, Laura had a babysitting job at the Goffs'. Mr. Goff was a carriage-maker and a carpenter. He'd been a soldier in the Union Army and a prisoner in Confederate prisons at Richmond and Belle Island. He and his wife Delia had one child, a little girl named Belle, and this was the baby Laura sat for.

People got so worked up at the temperance meetings that the ministers in town decided to have a revival. The Congregationalists started and the Methodists followed, and everyone said it was a great success. Reverend Moses wel-

comed sixteen new people into the Congregational Church.

Although Laura never did like the regular midweek prayer meetings, she liked the revival meetings for their singing. Laura especially liked to watch a young man named Will Ray sing. She listened to him sing too, of course, because he had a beautiful tenor voice, but watching him sing was the most fun of all. When he reached for a high note, he stretched to his tiptoes. When he sang a low note, he came back down. The higher the note, the more he stretched for it. He was worth watching as well as listening to.

Laura loved music, and the kind of music she loved best, of course, was the music that came from Pa's fiddle. She had heard it in Burr Oak and on the banks of Plum Creek and in the Big Woods and even in Indian Territory, although then she'd been too young to remember it. Now Pa played in the dark and biting winter nights, when the wind moaned and sighed outdoors and the fire gleamed and crackled in the fireplace. He taught Laura and Carrie how to do the polka and the waltz and the schottische and other dances, and they laughed and danced together. Sometimes when friends of Ma and Pa came for a visit, Pa would play his fiddle and Laura and Carrie would dance, and that would be the entertainment.

That whole long winter wasn't all singing and dancing and snowballs, though. For two weeks Laura stayed with a lady in the country, two miles from town. This was Sadie Hurley, a sister of Nannie Masters. Mrs. Masters came and asked Ma if Laura could go. She said she liked Laura's work in the hotel, and she told Ma that Sadie wasn't well and needed looking after. So Ma gave her permission and Laura stayed out of school all that time, although she brought her books with her so she could keep up with her class.

It was a long lonesome time for Laura. At night she felt a terrible homesickness. Sadie's husband, John, spent the days making brooms to sell in town from his crop of broom straw, while Laura cooked and cleaned and looked after Sadie.

One day Laura went to call Mr. Hurley in for dinner and was surprised to find Pa there working on the brooms with him. She was happy to see Pa, of course, but she realized with a start that Pa must be having terrible times too, if he could only find work a day at a time and had to

help make brooms. The next day Pa didn't come back, and Laura's homesickness was worse than ever.

The Hurleys lived in a little two-room house, and Laura's bed was in the front room behind a calico curtain. Every night she said her prayers before falling asleep. One night after Pa had been there she said her prayers and felt something she couldn't name—a feeling of power and comfort that came from outside her. Nevertheless, she was glad when Mr. Hurley had finished making his brooms and could take care of his wife himself. Then Laura went home to Ma and Pa.

Winter storms sometimes kept Laura and Mary and Carrie home from school. Blizzards struck quickly and without warning, and the girls knew that the safest thing to do was to stay in one place. Not everyone followed this sensible rule, however.

One day after a blizzard had blow itself out, word spread around town that some children were missing from their house, three miles out in the country. Their parents had come into town the day before the storm, and the storm had come up so suddenly that they couldn't return home to their children. When at last the storm ended and they rushed home, the children were gone.

Pa was one of the men who helped search for them. The children were finally found buried in a snowdrift; they had left the safety of the house and wandered into the fury of the storm. Three of them, two boys and a girl, were frozen to death. The oldest child, a girl Laura's age, was badly frozen but still alive. She had kept the baby of the family inside her coat all the time they were out in the storm, and the heat of her own body kept the baby alive. But one of the girl's own legs was frozen so badly the doctor had to cut it off. Pa told Laura about this, and no doubt used it as a lesson on what not to do in a blizzard.

Pa was elected a trustee of the church early in March. A few days later the village of Walnut Grove was officially incorporated, and the first village election was held. Elias Bedal, the grain and lumber dealer, was elected president of the little village. The trustees were Thomas Quarton, a blacksmith; John Leo, a farmer; and Christ Clementson, a Norwegian who ran his own small hotel. Nellie Owens' father was elected treasurer and Pa was elected justice of the peace. Pa had his justice of the peace office in the front room

of his house, and that's where he held trials when it was necessary. On those occasions, Laura remembered, all the rest of the family would retire to the kitchen.

When spring came Pa found a few odd jobs of carpentry work. He fixed fences for Mr. Masters, but it seemed there wasn't any steady work to be had. Mr. Nelson had taken over the meat market, and Pa no longer had enough money to start up another business for himself. Perhaps he could have become a clerk in a store, but that didn't seem very interesting to a man who had once been a free and independent farmer and whose fiddle always sang of far-away places. For Pa, the spring of 1879 was hardly full of promise. He was trapped between his dreams and his duties.

In these hard times Laura went to work again. Nannie Masters had moved into a room over the Masters store, next to the hotel, and she was having fainting spells. So Laura went to spend long hours watching over her and helping her, just as she had with Nannie's sister. Laura was only twelve years old, but one can see from the kind of jobs she was given just how responsible grownups felt she was—taking care of Nannie Masters, taking care of Sadie Hurley, working in a hotel full of strangers. She was a hard worker, and she could be trusted in even the most delicate situation.

It was true that neither Pa nor Laura was having a happy time. But one day something happened that made their own troubles seem small and unimportant. Mary was suddenly taken with a pain in the head.

She quickly grew worse, not better, and Ma and Pa hovered over her while Laura kept the little girls out of the way. Mary was very, very sick. For a time everyone thought she was going to die. "She was delirious, with an awful fever," Laura recalled many years later, "and Ma cut off her long beautiful hair to keep her head cooler. We feared for several days that she would not get well, and one morning when I looked at her I saw one side of her face drawn out of shape. Ma said Mary had had a stroke."

After the stroke, the fever passed and Mary began to get better. But as her strength returned, her eyes began to fail. Mary was going blind.

Doctor Hoyt had looked after Mary from the beginning of her sickness. Now Pa called in another doctor as well—Jacob W. B. Wellcome, a New Englander who had practiced medicine in New Ulm when Ma was sick on Plum Creek,

and who now lived in Sleepy Eye. He was also general
surgeon for the railroad that passed through Walnut Grove.
Doctor Wellcome came on the train, to see if he could do
anything for Mary's eyes. But it was too late.

"He said the nerves of her eyes had the worst of the stroke
and were dying, that nothing could be done," Laura wrote.
"They had a long name for her sickness, and said it was the
result of the measles from which she had never wholly re-
covered. As Mary grew stronger, her eyes grew weaker,
until when she could sit up in the big chair among the pillows
she could hardly see at all. The last thing Mary ever saw was
the bright blue of Grace's eyes, as Grace stood holding by
the chair looking up at her."

Laura never forgot how brave and patient and uncom-
plaining Mary had been through her sickness. From then on,
Laura knew she would have to see for Mary as well as
herself. Pa said so, and Laura knew it was only right.

One day not long after Mary had lost her sight, she was
sitting in her chair when outside she heard the prancing of
a horse's hooves and the crunch of wagon wheels. She asked
Laura who it could be. Laura peered out the window and
saw a strange woman in a sunbonnet and buggy, driving a
bay horse. She didn't know who it was. But as soon as Ma
opened the door and exclaimed out loud, Laura knew: it was
Pa's sister, Aunt Docia, and she had come all the way from
the Big Woods of Wisconsin.

While Ma and Laura scurried to make dinner, Pa sat in
the kitchen, and Docia stood there telling them all about
the folks in the Big Woods. To Laura, the Big Woods
seemed far away and long ago.

Docia also told about her husband, Hiram, and his job
as a contractor on the railroad. Every year the railroad was
pushing farther west. Already it had crossed into Dakota
Territory, and right now that's where Docia's husband was—
at the farthest end of the railroad, going west. Best of all,
Docia said, he was in need of a storekeeper and bookkeeper
and timekeeper. The pay was fifty dollars a month, and she
had stopped by Walnut Grove to see whether Pa wanted the
job.

Pa's face was thin with work and worry, but his eyes
brightened. A homestead in the West was the dream of his
life, and this would be one way to get it. But Ma grew
silent.

She didn't want to leave the settlements. She didn't want to go out again on the uncharted prairies of life. *Who would want to wander forth in the world, and dare its tempests and storms? Not one.* Here were schools and churches and stores and people. Mary was blind. How could she travel? What advantage would she have beyond the settlements? Here were friends they would have to leave behind.

But for every reason Ma could give, Pa had a saying: "Where there's a will, there's a way." He had the will to go West. He would find the way.

Aunt Docia said that a decision had to be made at once, and that night Ma and Pa talked it over. That night Pa made a promise to Ma: he promised that if she would agree to go, this would be the last move he ever made. No more would he wander. It was a hard promise, but he kept it.

The next day Pa sold the house and the lot back to Mr. Masters. He put the canvas top back on the wagon. Laura helped Ma wash Pa's clothes and iron them, and make some hardtack for his journey, and then, before she knew it, Pa was gone. Laura was alone with Ma and the other girls.

More than ever, Laura felt how much Ma and Pa depended on her. She couldn't be a little girl any longer. She would have to help Ma and help take care of Mary and watch after Carrie and Grace. She would have to look after herself as well, for Pa was gone and Ma had plenty of her own work to do.

It had been a long time since Pa had called Laura his little half-pint of sweet cider half drunk up. She was still not very tall, and she was still only twelve years old, but now she would have to be big in other ways.

This time the wagon went west without her. But every day Laura remembered one thing. Far out in the West, Pa was working hard too. Soon he would send back his paycheck, and then they would all be "on our way again, and going in the direction which always brought the happiest changes."

7

Silver Lake

Laura wanted to go on and on forever. The little wagon rolled gently across the soft prairie. The blowing grasses all around were bleached brown and gold by the summer sun. The hollows of the prairie had little pools of shadow, and in the shadow were wildflowers smoldering like red and purple stars fallen to earth. The wind caught the white canvas cover of the wagon. The canvas shuddered and billowed up and then fell across the wagonbows. Silence. The sky burned with a harsh white light.

Now that she must see for Mary as well as for herself, Laura saw everything—the way the wind bent the grass, the way the land rose to meet the sky, the way the sky seemed lit by a strange luminescence. Only at the far edge of the prairie could she see a faint pale band of blue.

Necessity had sharpened her perceptions, and she struggled for words to express them. When she saw a white horse and a rider and the sun come together where the rim of the prairie touched the sky, she saw more than a man and his horse and the red blazing sun. She saw something wild and free and beautiful. When she tried to tell Mary about it, she felt how poor words were for telling what she had seen. She tried to find the right words, but there were some things which couldn't be fitted into words.

She fell silent, and the wagon rolled on into an even deeper silence, and Laura wished in her heart that she could just go on forever and ever.

They had come this far from Tracy. Ma and Laura had brought Mary and Carrie and baby Grace on the train from Walnut Grove to Tracy. They had stayed for a while in the hotel there; then Pa came with his wagon and at last they were all together again. They had driven in the wagon across

what was left of Minnesota and had crossed over into Dakota Territory. After supper one day, Pa hitched up the team again. He wanted to push on.

Now they were pushing on across the prairie toward the railroad camp at the Big Sioux River. The stars came out, cold and blue. In the distance Laura saw a small yellow square of light, all alone on the dark prairie. Aunt Docia was waiting for them.

All during the previous winter, while the track was still open, railroad cars had rumbled west with their great cargoes of bridging lumber and ties and steel track, to the very end of the railroad. Surveyors had gone ahead, laying the path and setting grade stakes for the railroad that was to come. Then, in the spring, it came. Graders, scrapers, digging crews all swarmed out onto the prairie, working feverishly for the Dakota line. They reached it and crossed it and pushed on, into the heart of the western prairie. The track layers were on their heels, hoping to reach the Big Sioux before winter came again. Behind them stretched mile after mile of shining track, back across Minnesota and over the Mississippi and all the way back to the biggest cities in the East. Along the track a single telegraph wire stretched the same distance, singing with news and messages and the strange vibrations of civilization.

Laura could think of it for all the miles Pa's wagon followed the track west from Tracy—tacking here and veering there like a schooner on the prairie sea. These rough gangs of men who worked on the railroad were wild and proud. They were like an army, marching onward forever and ever. Nothing could stop them except darkness and blizzards. It was a wild and sleepy thought.

By the time Pa stopped the team in front of the little square of yellow light and Aunt Docia popped the door open with a big welcome, Laura could hardly keep her eyes open. Inside the shanty, Aunt Docia talked a blue streak while she put supper on the table. Uncle Hi, her husband, threw his arms up in the air as if to say, "What can I do?" And standing quietly by were Laura's two cousins, Lena and Gene.

Lena had a rare, dark beauty. Her hair was black and curly, and her eyes were bright with independence. Laura hadn't seen her since those long-ago days in the Big Woods when they were both little girls, when they'd watched Uncle

George dance the jig with Grandma at sugaring-off time. Like Laura, Lena remembered that dance all her life.

Cousin Lena was only three months older than Laura, but to Laura it seemed a whole year. Perhaps this was because Lena seemed so sure of herself, so confident and independent. Lena's life had been much harder than Laura's, and she'd grown up even faster. In the days that followed they took quiet walks on the prairie; it would be interesting to know whether they told each other about the kinds of lives they'd led.

Lena's father had been a young Swiss homesteader in Wisconsin, only eighteen years old, when he married Aunt Docia. He burst through the woods one day to help her as she came up from the spring with barrels of water and a sledge and two young red steers that were running away. His name was August Walvogel. After they were married, he built a little two-room cabin in a valley in the Big Woods. He cleared a farm and bought some cows, and he was also the paymaster for a nearby logging camp. One night some men came through the darkness to get the money he kept in the log cabin. He warned them away, but they kept coming, so he got his gun and fired into the night. One of the men fell dead. For this, Lena's father was sent to prison for eight years.

Lena was a very little girl when this happened, and her brother was not yet born. August Eugene—everybody called him Gene—was born shortly after his father went away to prison. By then, Aunt Docia had divorced August Walvogel. Lena and Gene were taken through the Big Woods and left with Grandma and Grandpa Ingalls while Aunt Docia went out to look for work.

When Lena was eight years old, her mother was married again, this time to Hiram Forbes. Hiram was a hard-driving man, a trader and a railroad contractor, and they began to travel the country in a covered wagon, stopping to live in a little shack here and a little shack there. Sometimes Lena's stepfather was very cruel, and sometimes he played mean tricks on her. Once, in Minnesota, Hiram wanted to put Lena and Gene in an orphanage. But Lena wouldn't go, so he took her and Gene along with Aunt Docia and himself on their endless wandering. And Lena had learned goodness from Grandma and Grandpa, and she'd learned from life how to take care of herself.

Aunt Docia and Lena were cooks at the Big Sioux railroad camp, and Uncle Hi bossed the men. He was a contractor. In later years, when she was a teenager, Lena worked as a waitress in a hotel in Wisconsin, where the other ladies of the place were as rough and wild as any railroad man or logger. Eventually she attended school in Nebraska; she became a teacher and married a young schoolmaster. She had many children of her own, and told them stories of long ago—and taught them all to jig, just as she had seen Uncle George and Grandma do it in the Big Woods.

Pa and Ma didn't stay at the Big Sioux camp very long. They didn't even unload the wagon, because the camp was being taken down and surveyors were already staking out the streets where a town would rise on the prairie. The railroad men had laid track across the river and the teams and graders were churning their way westward. They were doing much better than they had thought they could; they'd planned to get only to the Big Sioux by winter, and it was not yet winter.

While Ma and Pa waited for Uncle Hi to pack up the company stores, Laura spent her time with Cousin Lena. She slept in a tent like an Indian, and Lena let her ride Gene's horse. Laura was caught between fright and joy, but soon she was racing across the prairie on the back of the beautiful horse. Her eyes were screwed up tight and her hair streamed backward and she clung to the horse's mane with all her might. She whooped, she hollered, she raced the wind, and when she finally came back to the shanty she had a bloody nose and scratched legs. She looked just like a wild Indian, Ma said.

And then once again she was in the slow wagon with Mary and Carrie and Grace. Ma and Pa sat quietly on the wagon seat, and once in a while Pa would whistle a happy tune. But there was no other sound except the rustling grass and the creak of the wheels. They were all alone on the vast rolling prairie, and Laura thought how tiny they seemed—one family, alone, going west.

The silence was real and close and immense, and the prairie seemed different from any Laura had seen before. On their way to the camp at the Big Sioux they had crossed one creek after another; here there were no creeks. Here on the high prairie there were only wallows and depressions, and occasionally a slough or a little lake of blue water. The

year had been very dry, and the prairie grasses rippled and swept like a golden carpet to the horizon. In the distance Laura could see great flocks of birds rising in the clear air and the silence. They wheeled in circles against the failing light, so far away she couldn't hear their cries.

From the camp on the Big Sioux to the camp on Silver Lake was a distance of about thirty-five miles. Pa was anxious to push on, because he'd come all the way from Silver Lake to get Ma and the girls, and he had a surprise waiting for them when he returned. So when the shadows rose from the prairie and the stars began to prick the darkening sky with silver points of light, the wagon kept on and on.

Laura was sound asleep when the wagon finally moved slowly into the darkened shadows of Silver Lake Camp. But when she heard a surprising, laughing voice, she woke with a start. The voice belonged to Uncle Henry, and for a moment Laura thought that she was a little girl again in the Big Woods. But she wasn't. She was a big girl on the lonely wild prairies of Dakota, and Uncle Henry was there too, with Cousin Charlie and Cousin Louisa. The surprise took Ma's breath away, it had been so long since she had seen her brother. Cousin Charlie was almost a man now, and if he had been spoiled he didn't show it. He called Laura "half-pint," just as he had heard Pa do in the Big Woods, and he helped everyone down from the wagon and into the cooking shanty, where Louisa had supper waiting.

Uncle Henry and Charlie and Louisa were working on the railroad to save money so they could go even father west, to the Big Horn country. Aunt Polly wasn't with them; she'd stayed back on the farm in Wisconsin. When he'd saved enough money, Uncle Henry would go back to the Big Woods and sell the farm and get Aunt Polly, and they would all go west together. Ma and Pa and the girls heard all this as they sleepily ate their supper. Then Uncle Henry showed them to the paymaster's shanty, where they would live.

In the darkness, Laura listened to the powerful silence of the prairie. Occasionally a horse whinnied in the stable up around the curving shore of Silver Lake. But then the silence returned seeping through the door and windows of the little shanty and surrounding Laura as she lay half awake on the straw mattress Ma had borrowed from Louisa. At last she

closed her eyes. The silence came closer, and she drifted slowly into it.

The day shrieked with birds. The sun burned down on the little shanty, half-hidden by the prairie grass. Pa unloaded the wagon. Ma swept the dirt floor of the shanty and put everything in its place, so it would be like home. Laura took Mary by the hand, and painted a word picture of Silver Lake Camp.

The lake itself wasn't very large, but it lay flat and silvery beneath the high Dakota sky with a breathtaking beauty. South of the shanty the lake seeped into the Big Slough, with its high grasses that waved and screamed with the sound of hidden birds. A little to the east of the Big Slough and almost directly south of Silver Lake was a low prairie knoll; Pa already had his eye on it for a homestead. Along the northern shore of the lake were a few low scattered buildings of the railroad camp, where the men slept and ate and kept their teams. A large frame house stood proudly among these huddled shacks. This was the Surveyor's House. All the way across the lake at its northeast edge was a smaller slough, and across it the teams of men and horses were already laying a grade beneath small puffy clouds of yellow dust. The voices and shouts of the men mingled and murmured across the flat water of Silver Lake.

Many years later, after Laura had written of her life by the shores of Silver Lake, she wrote a little poem to tell how even then she couldn't forget the things she saw and heard there when she first arrived:

At evening still my fancy sees
The flash of snowy wings:
And in my heart the meadow lark
Still gaily, sweetly sings.

The autumn days blended one into the other. The clear air carried a sharp tang, and every day the sky seemed colder and more perfectly blue. The prairie grasses turned a dull, bone brown. In the mornings the prairie glistened with tiny beads of frost, and high above the shacks and shanties of Silver Lake Camp long vees of geese sailed southward, trailing their honks and cries behind them like a drifting curtain of fine rain. Pa hunted in the Big Slough and in the marshes

around Silver Lake. Laura helped Ma in the little shanty, watching Carrie and Grace and doing chores. Mary had learned how to sew a little and to quilt, even though she couldn't see, but she could no longer help Ma with the cooking and the cleaning. So Laura had to help out with these jobs as well.

She had little time to play with Cousin Lena, who had come along to Silver Lake. Everything seemed so busy. Aunt Docia kept Lena at the stove, cooking for the hot, hungry crews that came in singing hearty songs from their day's work. Once Pa took Laura out to watch the graders at work. The teams and men worked in perfect circles, plowing and scraping and dumping as the grade worked its way west across the little slough north of Silver Lake. They had pushed on even farther west, across the prairie to the Stebbins camp, where even more men were at work.

As Thanksgiving drew near, Pa rushed into the shanty one day for his gun and then hurried away, hoping for a shot at a late-flying flock of geese that had settled in the slough. Laura clapped her hands to think that they might have roast goose for Thanksgiving dinner.

"Roast goose and dressing seasoned with sage," Mary insisted.

"No, not sage!" Laura answered quickly. "I don't like sage, and we won't have it in the dressing!"

Then they quarreled, Mary demanding sage in the dressing and Laura saying they wouldn't have it. When Pa finally came back, the question was settled: he hadn't been able to shoot a goose, so now they would have no goose at all. Laura thought how silly their argument had been, and, meekly, she said to Mary, "I wish I had let you have the sage."

Work on the railroad grade continued into early December. Then day by day the camp grew more silent. The men were leaving. The track layers had made it to within thirty miles of Silver Lake, laying ties and spiking rails. Behind them a black steam locomotive hissed impatiently, but they stopped where they were, and where they were, a town sprang up: Volga.

The sloughs around Silver Lake had long since fallen silent. One day Uncle Hi and Aunt Docia drove by in their wagon to say goodbye. They too were leaving. Then Uncle Henry left, with Cousin Charlie and Cousin Louisa. And soon the little camp at Silver Lake was nearly empty. It sat

desolate and lonely beneath a high blue sky scrubbed clean by winds that whistled of winter.

Pa like this country, and he liked this place on the shores of Silver Lake. It was a new country and it was free and it was open to anyone with the courage and energy to claim it. Homesteaders had already reached Lake Henry, and by spring—Pa was sure—there would be a great rush of settlers coming to the shores of Silver Lake. Pa knew he couldn't wait a day longer to file on his claim, and he had already picked out the spot.

Only a few men were left in camp when Pa decided to go to the land office at Brookings. Pa asked one of them to stay with Ma and the girls while he was gone, and the man agreed. This was Robert A. Boast, a young Canadian-born homesteader who had been working on the railroad and who had already filed his own claim east of Silver Lake. Robert Boast was tall and very strong and had black hair. He had "the blackest eyes," Laura said, and "a laugh that would have made a fortune on the stage." Mr. Boast was so jolly that Laura liked him very much, and Ma felt quite safe on the lonely prairies of Dakota while Pa went off to file his claim.

When Pa came back he made a deal with the head surveyor of the railroad company. All that winter he would keep an eye on the railroad's property. In return, the railroad company would let Pa move his family into the big Surveyor's House. Mr. Boast had planned to go back to Iowa, to spend the winter with his bride. But when he heard that Pa was going to stay, he decided he'd fetch his bride back to Silver Lake and spend the winter too.

Mr. Boast was the last man out of camp. When he was gone, only Ma and Pa and the girls remained, and Laura and Carrie and Grace had Silver Lake all to themselves. More than ever, Laura felt the eerie silence of the prairie; she knew how far away they were from help or friendship. Their closest neighbor was a young bachelor named Walter Ogden. He was staying on his own claim near Lake Preston, although he often walked across the prairie to spend a day or two at the Surveyor's House with Ma and Pa. Pa made a checkerboard to occupy the time, and Mr. Ogden often played checkers with Pa or Laura.

That whole winter was very mild, except for a cold snap just before Christmas when Mr. Boast came back with his

bride. Her name was Ella, although Mr. Boast called her Nell and she called him Rob. Laura remembered her as "small and plump and merry," with light-colored hair and blue eyes. "She slid on the lake with Carrie and me," Laura said. "She exchanged cooking receipts and visited with Ma and Mary, and she loaned us books and papers which we always read aloud so Mary could enjoy them too."

Mr. and Mrs. Boast were good neighbors to have through the long Dakota winter, and they took up housekeeping in a shanty near the Surveyor's House. Ma had them over for Christmas dinner, and Mrs. Boast had the Ingallses over for New Year's dinner—a day so mild they ate with the doors to the little shanty wide open. Walter Ogden was there that day too, from Lake Preston. Thus began a tradition between Ma and Mrs. Boast, one having Christmas dinner and the other New Year's, that lasted over many years.

There was very little to do that winter, so Pa often called for his fiddle and played merry tunes for an hour or two in the evening. He played polkas and waltzes, and Laura and Carrie danced across the floor of the big room in the Surveyor's House just as they had the previous winter in Walnut Grove. He played happy songs—jigs and reels and hornpipes and marches—just as he had in the Big Woods, and everyone sang happily along. Once he played a song that sounded rather heathenish to Ma, but Pa's eyes just twinkled and he played it anyway.

Sometimes Pa played to the low sound of the wind, and sometimes he played Laura's favorite song of all, "I Am a Gypsy King!" But of all the songs Pa played that lonely winter in Dakota, he loved best to play the hymns he'd learned in the Union Congregational Church. Ma's favorite, and one she often sang as Pa fiddled, was "There is a Happy Land, Far, Far Away." Pa's own favorite was "Sweet By and By," written in the very year Laura was born:

> We shall sing on that beautiful shore
> The melodious songs of the blest,
> And our spirits shall sorrow no more,
> Not a sigh for the blessing of rest.
> In the sweet by and by,
> We shall meet on that beautiful shore;
> In the sweet by and by,
> We shall meet on that beautiful shore.

This was Pa's heart's favorite, and when he died it was sung at his funeral:

In the sweet by and by,
We shall meet on that beautiful shore!

These songs of Pa's made the winter fly. They eased pain, they took the ache out of heartache, they smoothed the rough edges of loneliness. Whether dancing jig or hymn of faith, they worked their way into Laura's heart and memory, and she never forgot them.

Laura celebrated her thirteenth birthday in the Surveyor's House early in February. Winter had already relaxed its weak grip on the cold Dakota prairie. "Early one morning there was such a noise that we ran out of doors to find the lake covered with wild geese, swimming and splashing— every goose talking," Carrie remembered many years later. "Our parents told us that they were choosing their mates, as it was St. Valentine's Day. Mornings we could watch the lake, and with the wind blowing the water in little waves and with wild ducks and geese and occasionally swans, it was a sight no child could forget."

Pa had been right about the spring rush; more than geese came to Silver Lake that spring. Over the low swales of prairie from the east, wagons and teams came now, bringing families and supplies to homestead and to build a town on the shores of Silver Lake. The Surveyor's House seemed turned like magic into a hotel, and once again Pa was an innkeeper. The house crowded full of strangers, full of hope and enthusiasm, and Laura was kept quite busy helping Ma with all the cooking and cleaning.

Henry Hinz, a young shoemaker from Wisconsin, was one of the early birds who came across the prairie with a wagon-load of lumber and of dreams. He stayed with the Ingalls family for a time and, Laura remembered, they liked him "very much because he was so quiet and well mannered. He was building a business house, but he never told us what kind of business he intended to start. When his building was finished and his goods came, we learned that the first build-ing on the actual town site of DeSmet was a saloon!"

Another young man to share the hospitality of the Ingalls family was 18-year-old Dave Gilbert—the mail boy of the

Hard Winter—who stopped by for dinner before walking into DeSmet. He had come from Volga, where the railroad crews were already preparing to push the tracks west, and he brought with him his parents, three brothers, and three sisters.

One evening late in February everyone in the Surveyor's House gathered around Pa as he played hymns on his fiddle. The voices of Laura and Mary and Ma and all the guests in the house swelled up and filled the big room as Pa fiddled merrily. Then Pa cocked his head to one side. He drew the bow from the fiddle. Outside the door, a familiar voice was heartily answering back in the words of the same hymn Pa had been playing. Pa flung open the door and there stood an old friend—Brother Alden, the home missionary who many years before had started the little church in Walnut Grove, and who had always looked at Laura and Mary with his kindly blue eyes and called them his "country girls."

Brother Alden had left Minnesota and entered the missionary field in Dakota. He was on his way west to raise new churches with Reverend Stewart Sheldon, the young missionary superintendent for all of Dakota Territory. That night there was a grand reunion, and the stories of many years were swapped back and forth. And then Brother Alden conducted the first church service ever held in the community that was about to become DeSmet, and he held it in the Surveyor's House.

About twenty-five people were crowded into the living room, people who had come to build a little town on the prairie. Thomas H. Ruth, a young banker from Pennsylvania, was there with his wife Laura, and so were farmer William O'Connell and his son, Will, Jr., and Walter Ogden and Mr. and Mrs. Boast. Brother Alden soon went on west, but he came back several times, and he always held church services when he visited. Ma and Pa were always glad to see him. The Boasts also soon moved out to their claim—a "soddy" or sod house east of Silver Lake not far from the railroad grade. They were one of the very few families in the neighborhood to live in a sod house.

Every day seemed to bring new gangs of immigrants and merchants. "Spring came, and with it the surveyors," Carrie recalled. "Father used to go with them and one day he came home and said the town was all located. After dinner I went to the top of the hill, east of where the courthouse now is, to

see the town, and all I saw was a lot of stakes in the ground. I went back and told Mother there was nothing but a lot of sticks stuck in the ground and she told me that where they were would be houses, stores, a schoolhouse and a church."

For weeks Laura had worked so hard helping Ma that she barely had time to think. There was a constant rumble of wagons past the Surveyor's House as teamsters and immigrants streamed in from Volga ahead of the railroad. But now the strangers didn't stop. They went directly to the town site, and the sound of hammers and saws and crashing lumber came back across the prairie.

The surveyors had finished staking out the town by March 28, and by then some shanties and stores had already been built. Henry Hinz's little saloon was built by then, a small building sixteen by twenty-four feet that was soon torn down and replaced by a larger building. Henry Hinz had hoped to have it on a corner, but he missed by three lots.

When Jake Hopp and George Matthews rode into town on April Fools' Day with a wagon load of printing equipment, the Fuller brothers had their hardware store up. The brothers had been born in New York, although their parents were British. They may well have been twins, because both listed their age as thirty on the census later that summer. One was Charleton S. G. Fuller, and the other Gerald C. R. Fuller. Laura wrote about Gerald C. R. Fuller, who was quick on the trigger when he shouldn't have been, but who was also a very good speller. Because of all his initials, his friends called him "Alphabetical" Fuller.

Jake Hopp was a printer who'd run newspapers in the eastern part of the Territory, and his partner, George Matthews, was a lawyer from Brookings. Mr. Hopp, of course, was the man from whom Laura one day bought the most beautiful pastel calling cards. In the spring rush of 1880 he soon had his printing press running in the back of Fuller's Hardware, and was turning out copies of the *Kingsbury County News*.

DeSmet grew like magic, and so much happened so fast that it was hard for Laura to keep track of it. Roscoe Sheldon came with his family from Illinois to build a little hotel, the DeSmet House. Banker Ruth was hard at work on his bank. Charles Tinkham, a young cabinetmaker from Maine, walked into town ahead of a wagonload of lumber and began work on his furniture store. He boarded with William Crook,

a Wisconsin-born tinsmith who had already built a tinshop and store.

George Wilmarth put up a grocery near the railroad grade, and every day people peered down the grade to see if the track layers were in view yet. Work started on the station house where Horace Woodworth, the stationmaster, was going to live with his family. George Harthorn put up a grocery and feed store next door to the Beardsley Hotel, which was run by Jerome Beardsley, a hotel keeper from New York. Across from Wilmarth's, Charlie Mead built another hotel. He was in a good spot, between the railroad tracks and the saloon.

Pa was busy all this time knocking the old railroad shanties down and hauling the lumber across the prairie to the town site. He built one store for someone else and then another for himself, across from Fuller's Hardware. Although Pa's building wasn't quite finished, he moved Ma and the girls into town on April third. The day was nice and warm but the night turned cold, and the next morning Pa had to sweep snow off Laura's bed.

In town Laura could see how fast DeSmet had grown. The buildings went up like ghosts in the night. All but two—Pa's store building and Wilmarth's grocery—faced toward the east. It seemed as if the owners of these buildings wanted a view back toward all the places they had been. Pa's building faced west. His view was toward all the places he would never go.

The morning sun reflected its red light off the glass windows of the stores across the street. Their false fronts were unpainted and their square-cornered tops stood sharply against the blue prairie sky. In the morning, when the street in front of Pa's store was empty, wisps of gray smoke curled up from the buildings across the way.

There was something both desolate and hopeful about the scene Laura saw every day. The town seemed so small and fragile sitting on the vast expanse of prairie swells. The prairie wasn't yet broken into farms or ribbed with roads. It swept up from the east, around the unfinished depot and right to the little stable behind Pa's building. Beyond the stores across the street, the new schoolhouse was going up a lonely block away. And that was the edge of town. From there the prairie grasses rippled and rolled like ocean waves,

far, far to the west. All around was silence and grass and sky. Against these things, the little town seemed helpless.

But there was also an air of hope about the town, especially when the street filled with men and wagons. Teamsters raced up and down with their loads of lumber and provisions—boxes, bales, barrels. Clouds of yellow dust rose above the wide street. The railroad was coming, that was for sure, and the air rang with the cries of progress. In every house that was built, in every new store building that went up, behind every door that stood open to the smell of prairie grass and wood shavings and leather, there were men and women who dreamed. They had come here across the prairies of Dakota to make their lives and fortunes. Ma was certainly correct. Where only stakes had stood a few short weeks before, a burst of energy and dreams had raised a town. Civilization had come to the wild prairie, and Laura was not at all sure that she liked it.

When Brother Alden passed through DeSmet on his long roundabout journeys, he held church services in the unfinished depot. When he wasn't there, and he wasn't often there, church was conducted by Horace Woodworth. Mr. Woodworth was a minister, but he had come west with his family to be the station agent for the railroad. He seems to have been a better station agent than a minister, however. Few people attended his church services, but after the railroad came through people were always using his station.

One day the field was taken over by a new minister, who carried a letter of introduction to Pa from Brother Alden. This was Reverend Edward Brown. Like Brother Alden, he had been granted a commission from the Home Missionary Society to preach at DeSmet, Lake Henry, Lake Preston, Kingsbury, Iroquois, and other new settlements in Dakota. But to Laura, he didn't seem at all like Reverend Alden.

Reverend Brown claimed kinship with the fiery abolitionist John Brown, and he burned with a zeal to lay the foundations for a church at DeSmet. Laura well remembered her first impressions of him—a rude, rough man with thick white hair and long whiskers and a soiled, rumpled white shirt. She didn't like him. Whether Laura ever changed her opinion we don't know. But she became friends with Reverend Brown's adopted daughter Ida, and one day she stood before him to marry Almanzo Wilder.

Reverend Brown organized DeSmet's first church, the First Congregational Church, at a meeting in the railroad depot. Boxes and boards were used as seats. Ma and Pa and Mary were founding members, along with Reverend Brown and his wife, Silliman M. Gilbert and his wife, and Vischer V. Barnes, a young lawyer from New York.

It was a very small congregation. Several months later, when the church was officially incorporated, only two new members appear to have been added to the rolls (Laura was not one of them). But churches, like dreams, sometimes grow slowly before coming true, and the First Congregational Church soon became one of the most energetic congregations in town.

When the rails were finally laid through DeSmet and the first trains came chugging through, they brought more immigrants than ever. Many of them came crowded into boxcars with the freight and stock. The noise of turmoil and building hardly stopped for a moment.

Starting at First Street near the tracks, Laura could walk south on Calumet Avenue (she called it Main Street) past an almost solid line of storefronts now. Mead's Hotel was first, and it was filled with workers from the railroad. The saloon sat noisily next to the hotel, and beyond a vacant lot was the little shack Royal Wilder called a feed store. Then came a grocery run by Charles Barker, who had come to the prairies all the way from Canada. Next to Barker's was the Beardsley Hotel, where grain dealers and railroad workers also stayed. Ma felt sorry for Martha Beardsley, having to keep hotel when the building wasn't even finished. Edelbert Harthorn's grocery came next—he ran it with his son Frank—and past another vacant lot stood E. H. Couse's hardware on the corner of Second Street. This was the building Pa put up before he built his own store building kitty-corner across the street.

Fuller's Hardware was directly across the street from Pa's store, and Pa spent much of his time there with the other men of the town. Pa was a constable now, and had to keep an eye on things up and down Calumet Avenue.

Next to Fuller's Hardware was Bradley's Drugstore, run by young George Bradley and his wife, Hattie. Then, quick in a row, came a new building where Mr. Power would soon put his tailor shop; Daniel Loftus' general store, which was still being built while he boarded at Mead's Hotel; and the

carpentry shop of J. W. Noyes. A vacant lot separated the carpentry shop from Banker Ruth's bank at the end of the block.

But that was just one street. There were other buildings scattered back of it. George Ferguson had his butcher shop in one and John H. Carroll had his law office in another. He was the clerk of the district court, and he once gave Pa his old desk. Jerome Woodruff ran a feed store with his son Merrill, Ed McCaskell had a blacksmith shop, and there were several other businesses back from Calumet Avenue and up along the railroad tracks.

Laura found it all a little overwhelming, and Alphabetical Fuller often added to the confusion. When geese flew straight down Calumet Avenue, he would rush from his store with his shotgun in hand, and from the middle of the street, start firing wildly at the birds.

Even in their own house things were getting crowded. George Masters, the oldest son of Uncle Sam Masters from Walnut Grove, came through town working on the railroad. He begged Ma to let his wife, Maggie, stay with her while he clerked in the company store. Ma agreed, and soon Maggie had a baby right in Pa's house. It was the first baby born in DeSmet.

All of these things made Laura feel crowded. Even after she'd gone to bed, even when the house was dark and silent, the town outside settled and shifted to its own noises: a rider dashing down the street, a wagon rumbling by, a shouted hallo, a slamming door, someone stumbling home from the saloon. Once upon a time Laura had lain in bed and heard the distant, wild cry of wolves. Often there had been no sound at all, only a presence, a great silence that even her imagination could not penetrate. But here was a town full of strangers, and Laura felt trapped among them. Not even the walls could keep out their eyes. There were too many people here, too many strangers.

"The farm was home to us," she would come to say. "Town was just a place to spend the winter."

Laura was happy when Pa said the time had come for them to move out to the claim southeast of town, but there was urgency and danger in his voice when he said it.

For several weeks an old railroad man named Hunt had been camped with his wife and his son, Jack, and Jack's wife and their two babies on the little patch of prairie behind

Roy Wilder's feed store. One day Jack Hunt and his father rode south of town to check on their claim. A claim jumper had taken over their shanty, and when Jack threw open the door the claim jumper shot him in the stomach. He tried to shoot the old man too, but the old man got away with the team.

The death of Jack Hunt sent DeSmet into an uproar. Pa had known both Jack Hunt and Jack's father. And now he also knew that claim jumpers were trying to take over the claims of settlers who weren't living on them. He told Ma that it would take him a day or two to build a shanty, and then they would move.

Out on the claim, Pa dug a shallow cellar and put up the frame of a little shanty. He covered it with rough boards and put a slanting roof on it that caught the morning sun. The shanty was half-hidden by the prairie grasses, and it wasn't finished yet, but he was anxious to get Ma and the girls out to the claim, and he knew that he could chink the walls and finish up the work another day.

Then he came back to town for what Laura remembered as one of the happiest moves of her life. It was also one of the shortest.

The wagon rolled down the street, past the stores with their yellow boards and their strangers. At the end of the street a faint wagon road led off across the prairie. It crossed between Silver Lake and the Big Slough and turned south. When they'd gone nearly a mile, Laura saw a low knoll of prairie land. Just to the east was the little shanty, floating on a sea of grass.

The prairie was sparkling with white and yellow and blue and pink flowers, and the green prairie grasses shivered in the cool spring breeze. Pa stopped the team, and before she knew it, Laura was out and running across the prairie. Her bonnet slipped down to her neck. She felt the wind in her face. She threw her arms out wide, and the air was cool and silky on her bare arms. She was free. She was happy. And when she stopped running, the silence of the prairie welled up around her and swept over her.

Across the neck of the Big Slough, Laura could see the little town on the prairie. It looked more desolate and fragile than ever, caught between the rolling prairie and the high blue sky. The town was full of teamsters, full of the sound

of hammers and of strangers. Here on the claim there were only Ma and Pa and Mary and Carrie and Grace, and Ellen the cow, and the soft sound of the wind in the grass. She was home.

"The first night as Pa was sleeping," Laura remembered, "he dreamed the barber was cutting his hair, and putting his hand up to his head caught a mouse in his fingers. He threw the poor mouse on the floor so hard he killed it. But in the morning there was a patch of his hair cut close to his scalp where the mouse had been at work."

With his fresh haircut, Pa himself went straight to work the next morning, chinking the walls and putting a covering of black tarpaper over the bare boards. Ma and the girls swept out the shanty and put up curtains and unloaded all the things they'd carried out to the claim from town in the wagon. Pa went off a ways and dug a well so they could have fresh water. He was far below the surface of the prairie when he hit quicksand. He clawed and sputtered and climbed out of the well just in the nick of time, for the water followed him up to within two feet of the surface. When Laura tasted it, the water was cold and sweet and clear. Pa made a little stable for the cow. And soon the claim looked lived on.

The shanty was in the northwest corner of the claim. The stable was west of the house, "dug into the side of a little rise in the prairie," Laura said. "The rise of ground behind the barn was a little sand hill where the grass grew sparsely. Just beyond the sand hill was the western edge of our farm and the country road to town which was just a wagon track across the prairie." Level prairie stretched east of the shanty, and the Big Slough "lay all along the north line just beyond the well." To the south, Laura remembered, "about halfway across the farm, was an old buffalo wallow of about two acres."

One day Pa took the wagon and drove off toward Lake Henry, where the Lone Tree had seeded little cottonwoods along the shore. He brought back a whole box of seedlings, and soon Ma and Pa and Laura had them planted all around the shanty. There they would grow tall, shading the little shanty from the harsh summer sun and protecting it from the strong winds that rose on the prairie. Pa and Ma and the girls have been gone from the Dakota prairies a long, long time. But some of those same cottonwoods still grow along

the line of Pa's claim today, a reminder that the Ingalls family was there.

There were more chores on the claim than one man could fairly handle, but Pa worked hard at them. As part of his bargain with the government, a settler had to break five acres of the tough prairie sod during his first year on the claim, and there were only a few short weeks in which to do it. Sod broken before the end of May or after early July wouldn't rot, and couldn't be worked the following year. When the land had been plowed and the sod lay in great clumps open to the sun, settlers could usually plant a little sod corn or potatoes or turnips or even flax and wheat in the furrows. Pa planted turnips. And then he went down to the Slough, where the grass grew taller than Laura's head, and began cutting hay. He loaded it into the wagon and hauled it back to the little stable and went back for more.

While Pa worked so hard, the sun seemed to stand still. It burned like a ball of fire. Dry winds whispered in the prairie grass and the air shimmered over the prairie swells; the grass turned gold and brown. Pa's face grew thin. He thought of town, and how the hunting had become so poor. The wild birds no longer stopped in such numbers as they once had. They sailed on, and didn't stop. Pa looked across the shining prairie at the little town in the distance, and then back at the claim shanty he had built for Ma and the girls. He thought of Oregon, far away and cool and green. Then he hauled another load of hay.

Pa had worked so hard—finishing the house in town and hauling lumber, building the shanty and digging the well, making the sod stable and breaking the prairie, planting the turnips and making hay—that he hadn't had time to make any money. And they needed money. The sun burned hot and Pa shivered, thinking of winter and how they would live.

"Nothing was said of money difficulties," Laura recalled, thinking back on these times, "but I knew our funds must be low. When I noticed Pa leave the table after eating very little—when I knew he must still be hungry—I understood that he was leaving the food for the rest of us. Then my appetite failed me too, and I followed his example of eating raw turnips between meals."

There would be no crop to sell this first season on the claim. Hard times were coming. Laura was big enough to sense that without being told, and she was big enough to do

what Pa did. When she offered to help with the last of the haying, Pa looked at her with his gentle blue eyes for a long while. Then he agreed. So Laura spent day after day in the hot hay wagon beneath the white, burning sun. She was doing a man's work almost, helping Pa. At night her arms and legs were weary with work, and her face was brown as a nut from the hot prairie winds. Once she got out the old reader she had used at Burr Oak, when Mr. Reed had taught her how to give life to what she read, and she read some lines about the prairie

> Stretching in airy undulations far away
> As if an ocean, in its gentlest swell,
> Lay fixed and motionless forever.

The lines were by the poet William Cullen Bryant, and Laura particularly liked them. When she read them, she was ready for another day of work with Pa.

When the haying was done and the hay neatly stacked, Pa went off every day to look for carpentry work. Laura helped Ma. The fall rains began, and the long dry prairie grasses lay matted in wet clumps. And then one day tiny beads of white frost covered the prairie, as far as Laura could see. Yellow smoke rose in curls above the chimneys of the stores and buildings in town.

The sky was clear and pale. Pa said they could never last out the winter on the claim, protected only by the thin pine boards and tarpaper of the shanty. It was time to move back to town. But before they could move, rain began to fall again. So they didn't go.

On the morning of October 13 it was still raining, a fine misty rain. Clouds of gray pearl hid the faint sun, and a chilling wind swept across the prairie. The rain slowly changed to sleet, and then to snow. The wind swirled and grew faster and then blew furiously, driving the snow before it. Suddenly the world turned white.

From inside the shanty Laura could hear the shriek and moan of the wind, and then its full-throated roar. Snow filled the air outside, and from the window she couldn't even see the stable. The wind blew and the snow fell all that day and the next and the next, and the wind stopped as suddenly as it had started.

When Pa went out to check the cow, the sun gleamed brightly on glistening drifts of snow six and seven and eight feet deep. That was when he found H. J. Burvee's cattle with their muzzles frozen to the ground, like statues in a snowy field. They'd been driven before the winds just like the snow, from north of town. And that was when Pa rescued the tiny little dovekie that waddled like a little gentleman in his black coat. That was the October Blizzard.

The snow was so deep it took nearly a week to clear the tracks west from Volga. When the first train made it through, DeSmet still lay buried beneath giant drifts of snow. A little girl named Neva Whaley was on that train, and one day she would be Grace's classmate in school. Her father, Josiah, was a stonemason, and he had come on west ahead of his family from Illinois. Little Neva, her brother, and her mother were coming to join him. When she grew up, Neva Whaley remembered her introduction to DeSmet with an air of bemused affection.

"The town consisted of a few shacks, the largest of which was Charley Mead's hotel at the north end of Main street," Neva wrote. "Here we found father, and stayed for a few days till we could get our household goods moved out to the claim.

"The real spirit of frontier life and good fellowship was found in this hotel. Railroad grading crews, train crews, land seekers, embryonic merchants, people from all parts of this country and Norway, people of culture and education, mingled on equal terms with the more crude and roughneck. . . . We were given what was termed 'The Bridal Chamber' to sleep in—simply a curtained-off corner of the partitionless upstairs. The rest of the place was strewn with cots for men. The mattresses were ticks stuffed with hay, the pillows so tiny as to inspire someone to remark, 'Say, I've lost my pillow,' and someone on the far side of the room to call back, 'Look for it in your ear.' We could hardly suppress our giggles as we listened to every word the men said and the pranks they played on each other while they were trying to settle down to sleep."

When good weather came, Mr. Whaley moved his family east of town to the claim he'd selected. It turned out to be right next to Mr. and Mrs. Boast's claim, and Rob Boast told Neva about an Indian scare the summer before.

"Rob was breaking with the oxen on a far part of the

claim," Neva remembered. "Someone rode by and gave the alarm that the Indians were coming. When Rob came home he found Ella, his wife, had packed all their goods in the wagon, and was sitting in it with her pet antelope in her lap, all ready for him to hitch on the oxen and start." Not long before a doctor from Chicago had found a mummified Indian baby at the old Stebbins railroad camp on Turkey Creek, west of DeSmet. He'd taken the body off the scaffold and sent it to Chicago, and this had naturally angered the Indians. The Indian scare turned out to be a false alarm, but it gave Mr. Boast a good hearty laugh.

Mr. Boast and Mr. Whaley both decided to spend the winter on their claims, but Pa took advantage of the good weather to move his family back into town. The October Blizzard had shown him how frail the claim shanty was to withstand a real Dakota winter.

There were more strangers than ever in town, and Laura got a "gone feeling" in the pit of her stomach whenever she had to meet them. Ma of course was happy to be back in town close to church and school, although she took one look around the crowded kitchen in Pa's store and exclaimed, "There isn't room in here to swing a cat!" But that only showed how glad she was to be back.

Even Laura was looking forward to going to school again. She didn't like town and she didn't like the feel of dirt and she didn't like to sew and she didn't like red flannel underwear and she didn't like sweet food—when she had hotcakes, she never used syrup. But she did like school. Even though she hadn't gone to school for more than a year, she had studied her reader in the claim shanty.

While Ma and Pa and the girls had been living on the claim, two new houses had filled up on the street behind Pa's store. Both were boarding houses. The larger was run by Arthur Sherwood, a young carpenter, and his wife, Jennie. The other one, directly back of Pa's office building, was run by Margaret Garland, a widow who had spent the previous winter in the little settlement near Lake Henry. Widow Garland lived with her two daughters, Lovenia (Laura called her Vene) and Florence, and her son Edward.

Florence Garland was eighteen years old, and she was the teacher in the school on Second Street at the edge of the prairie. School had already been in session a week by

the time Ma and Pa were settled in the house in town. Then one November morning Laura and Carrie set out from home alone to go to school among strangers. Laura was thirteen going on fourteen, and Carrie was just past ten. They were both frightened as they walked past Mr. Fuller's store and out toward the lonely little schoolhouse where the boys were playing ball.

Once before Laura had felt this choking feeling as she walked toward school for the first time. That had been on the prairie, as she and Mary walked from Plum Creek to school in Walnut Grove. That time Laura couldn't help herself, and she had blurted out that the noisy children in the school yard sounded like prairie chickens. This time she couldn't help herself either. As she and Carrie drew close to the school, one of the boys who was playing ball saw Laura coming. His bright blue eyes lit up and he threw her the ball. Without thinking, Laura dropped her books in the dirt and made a leaping catch of the ball. Then she threw it back. She knew it wasn't very ladylike, but sometimes Laura just could not help herself. She said what she said and she did what she did.

The boy who threw the ball Laura caught was named Edward. No one called him Edward, of course, everyone called him Cap—Cap Garland. He was a big boy, fifteen years old, and he lived with his mother in the boarding house behind Pa's store. The teacher was his sister.

There were fifteen boys and girls in school that term. Laura soon made friends with two of the big girls, Mary Power and Minnie Johnson. Mary Power was a tall dark girl with blue eyes, and with long black hair her mother had put in a knot on the back of her head. Her father was Mr. Power, the tailor. Minnie Johnson was the opposite of Mary Power. She was very thin and fair; her face was pale and covered with freckles. Her brother Arthur was also in school. Ben Woodworth was another of the boys. He was brown-eyed and had dark hair and was Laura's exact age. Laura thought Ben was more handsome than Cap Garland, although Cap had a carefree air about him that invited your affection. Ben Woodworth lived above the railroad depot, where his father was the station agent.

The two Beardsley boys were probably in Laura's class too. They were Jim, who was ten, and Walter, who was thirteen. Their father ran one of the hotels in the little

town. When Laura wrote about school she also mentioned the Wilmarth boys, who were much younger. She didn't mention May Burd, who was fifteen and whose father was a cooper, or Mary McKee, who was younger than Carrie and whose father had a dry goods store, or Willie McCaskell, who was nine and who was the blacksmith's son, or Ben Woodworth's younger brothers, Walker and Richard. But some of these may also have been in her class that term.

Laura had been out of school so long that she was glad to be able to keep up with Mary Power and Minnie Johnson, who had both come from school in the East. In the evenings she would read her lessons aloud so Mary could learn them too.

Ma and Pa hoped to send Mary to a college for the blind next year, and she would need every advantage she could get. Mary was very intelligent, of course. She was a fast learner and she had always wanted to be a schoolteacher. She couldn't be a schoolteacher now, because she was blind, but she still enjoyed learning things. With Laura's help, Mary could soon recite the entire "Speech of Regulus" from the *Fifth Reader*.

Near the end of November, Laura was invited to Ben Woodworth's birthday party. Mary Power was invited too, and they went together through the dark streets of DeSmet one evening to the depot, where Ben lived. The good weather came to a sudden end not long after the party. While Laura and Carrie were in school one afternoon, a blizzard struck without warning. The walls of the little schoolhouse shook before the wind. The storm scratched and clawed at the glass windows and the air outside filled with snow. Only good fortune got the children safely through the swirling storm to their homes that day.

Blizzards came with fearful regularity after that. They struck always by surprise, whistling in from the north or the northwest, and howling for two or three days. Then they would stop. The deep ominous silence of the prairies was drawn over DeSmet by the trailing skirts of the storm. "The blizzard just let go to spit on its hands," Pa would say, using an old woodsman's expression he'd learned a long time ago. And he was right. After a day or two of eerie silence, another blizzard would roar down on the little town, and then another.

The last train to go west from DeSmet was a mail and pas-

senger train that made it through to Huron, on January 5, 1881. It was stranded there by a blizzard and didn't come back. To the east a freight train reached Volga two weeks later, at noon on January 21. The crew was exhausted, the snow loomed up in giant drifts, and the train stopped there. It couldn't go on to DeSmet.

From then until the first week in May, the little town on the prairie lay snowbound and isolated, with no hope of help except for the courage and resources of the men and women and children who were trapped there.

"During January there was a breathing spell between blizzards of several days," one old settler of the country recalled, "but during the month of February they came so close together as to be almost continuous. There was never more than one-half day of good weather between storms during the month. It would come from the northwest for three days —fine pellets of ice almost like a mist and driven with such terrible force that one could not face it, and after a few hours of rest it would come back from the southeast for three more days.

"So the weary days dragged on.

"Fuel was the worst problem of the settlers. Most of the timber was cut from around the lakes and after that was gone hay was the only thing left. It took two persons to get an armful of hay out of the stack, one to pull it out and the other to keep it from blowing away. Of course, the coffee mill had to be kept going, grinding wheat for bread, but there was plenty of wheat and appetites were good. Tea, coffee, sugar, kerosene and tobacco had to be gone without."

Not all communities had plenty of wheat, however. In DeSmet the last sack of wheat sold for fifty dollars, and the last of the sugar went for one dollar a pound. Then there was none. When the supply of wheat ran out, Laura told how Almanzo Wilder and Cap Garland rode miles across the bleak white prairie between storms to search out a settler who still had a cache of seed wheat. Neva Whaley remembered that several times during the Hard Winter men walked the tracks east to Tracy and returned. No doubt she meant Volga instead of Tracy, but even Volga would have been a perilously long journey on foot, perhaps deadly in a season of blizzards, and very little could have been carried home. At times, the drifts across the track were forty feet deep, dwarfing the spirit of even the most resolute men.

Pa's face was already pinched with hunger, although Carrie seemed to suffer most from the cold and the scarcity of food. Laura's fingers ached from twisting straw into sticks or "cats" to burn. "In the main street of town," she remembered, "snow drifts in one night were piled as high as the second stories of the houses and packed hard enough to drive over and the next night the wind might sweep the spot bare." At night Pa played his fiddle, making lonely music that echoed the low moaning of the wind outside the door. He waited and listened. The wind cried on, alone, and he put the violin away.

Christmas came and went almost unnoticed, without the barrel of gifts Reverend Alden had promised to send from his home in the East. One day drifted unchanged into another, bridged only by the long bitter nights in which even hope seemed swallowed up by darkness and by fear. Pa's fingers became too stiff to play, and once, while the blizzard raged, Laura watched Pa raised his blistered fist into the air and roar back, like a caged animal. His voice was thin and shaking, but his spirit burned as strongly as ever.

This was the spirit that defeated the terrors of the Hard Winter. In March the storms came less often, although the cold was still intense. In April came the thaw, and never was there a more joyous sound that the steady drip-drip-drip of melting snow from the rooftops of DeSmet. Before long, the cry of a train trumpeted across the prairie from the east.

"A train got through May 10th and stopped at the station," Laura recalled. "All the men in town were down at the tracks to meet it, eager for supplies, for even the wheat had come to short rations. They found that what had been sent into the hungry town was a trainload of machinery. Luckily, there were also two emigrant cars well supplied with provisions, which were taken out and divided among the people. Our days of grinding wheat in coffee mills were over."

Great pools of water glistened on the prairie, and the grass was suddenly sweet and green. The breeze was soft from the south. Pa and Ma and the girls had come back to the claim shanty, and Mr. Boast had brought his wife over from their claim east of town. The door was open, the sky was pale blue, and it was time at last for Christmas dinner.

Ma brought out the turkey and put it on the table. It had been sent by Brother Alden. The warm smell of food rose

from the table like a prayer. Pa looked at Laura and at Ma and at Mary, and at Carrie with her little pinched face, and at Grace. Then he bowed his head and said the blessing: "Lord! We thank Thee for all Thy bounty!"

"That was all," Laura thought, "but it seemed to say everything."

8

Golden Years

In 1881, Laura had her portrait taken with Carrie and Mary—perhaps just before Mary went away to the School for the Blind. It was the first photograph they sat for. Ma and Pa saw it as a treasure and a remembrance, the three girls together. For us it's a window into the golden years of long ago, already passing by.

Carrie was eleven years old. In the portrait she stands frail and bent and sweetly still; her little nose is turned up, her mouth is parted, her eyes are faint and very light. Her face is that of an even younger child, and seems pinched by the rigors of the Hard Winter.

Mary was sixteen, and she sits in a pose of serene resignation. Her hands are carefully and correctly crossed upon her lap. She was proper. Her eyes are open but unseeing, her mouth is set firmly in endurance of darkness. She most certainly would not wish to swallow the only bug in Dakota Territory.

Laura was fourteen years old, going on fifteen. Like her sisters', her hair is parted in the middle and combed back from her forehead, and falls clean and graceful below her shoulders. But she is neither serene nor childlike. She stands straight and strong. Her face is firm and determined. Her lips are not merely closed, but held closed. Her eyes are dark, and they flash with an air of defiance and independence. Her right hand is clenched in a tight, very unladylike fist, full of tension and energy. The camera caught her as she was: a girl in command of herself, who knew her own heart and mind, who stood in certitude.

Through the blizzards and the bitter cold and the deep starry nights when the little town lay helpless on the prairie, she had survived the most awesome adversities. "There is

something in living close to the great elemental forces of
nature," she would say, "that causes people to rise above
small annoyances and discomforts."

But the Hard Winter had worked its changes on both
Laura and the little town. When she walked in from the
claim with Pa, she found that the town seemed new and
different. There were board sidewalks. A new grain elevator
stood at the north end of Calumet Avenue near the railroad
tracks. A new livery barn stood on the block where Pa's
store was, and the street swarmed with strangers. So many
men in the country around DeSmet had spent the white
silent months of that Hard Winter feeding on dreams of
going east, going home. But when the trains finally came
through from Volga and Brookings and Tracy and all the
towns to the east, they brought car after car of new immi-
grants anxious to find jobs in town or to take up claims out
upon the prairie. For every man who wanted to leave the
country, it seemed that five had come to take his place.

"I didn't care much for all these people," Laura said
honestly. "I loved the prairie and the wild things that lived
upon it much better." Her shyness remained, and her fierce
sense of independence from "these people." But for the first
time she began to look at strangers with interest and amuse-
ment, if not affection.

She thought of the darkness in which Mary moved.
Standing on the prairie, with its slow graceful curves and
its sprinkle of rose-colored wild flowers and the blue sky
of spring reaching down to touch the farthest, brightest crest
of prairie grass, she was more thankful than ever that she
could see. She felt more deeply than ever a sense of duty to
Mary, who could not.

But Laura still didn't like town. The raw pine boards of
the new stores, the clouds of yellow dust that exploded be-
hind the prancing teams and racing wagons, the stale and
musty smells, the sense of hurry—all these she found offen-
sive. Her heart went back to the time when there were no
people on the prairie. She thought often of the time when
the tall grass moved only to the wind and the shoulders of
buffalo and the stealthy steps of wolves, when geese spilled
lonely songs down upon the anonymous prairie, when
silences welled up in the night and the stars burned cold
and blue and close. Like Pa's, her dreams went west—to the
edge of the prairie and the mountains beyond and the land

going on forever and ever. Her dreams were of distances and departures. Once she could follow them. But now, again like Pa, she felt the anchorage of town. She knew she couldn't leave.

For Laura, the best feeling of all was the thought that all the days of her life were strung like beads on a single thread. Each day was different, and yet the same. No matter where their little house was, Ma and Pa were there, and by the warm firelight, Pa's fiddle sang each rounded day of her life in equal measure. Grasshoppers might fall from the sky, blackbirds might eat the corn. The little town might grow, strangers might come, but nothing ever really seemed to change. There was always Pa and Ma and Mary and Carrie and Grace.

She stood in certitude. But as the Hard Winter passed into memory, this golden thread snapped. Laura's days tumbled together, sharpening their edges into something called growing up.

Pa went off across the prairie every morning to work as a carpenter on the new stores and buildings going up in town. Across Second Street from Pa's office building were the beginnings of another bank and a post office. Up the block toward Wilmarth's general store, past a few vacant lots, was the building Pa was working on, almost done: a dry goods store for Chauncey Clayson. Soon even the vacant lots were filled in, and before long a boot store, a barber shop, a land office, a paint store, a grocery, a meat market, Mr. Hooker's house, a harness shop, a newspaper office, and Wilmarth's stood in a straight, neat row along the east side of Calumet Avenue.

The summer was barely started when Pa came home and asked Laura if she'd like to take a job in town. She hadn't expected the question. She didn't really want to go. But she knew that Ma and Pa could use the money to help send Mary to the School for the Blind, and so she went. She worked in Mr. Clayson's dry goods store for Martha White, Mr. Clayson's mother-in-law.

For six weeks that hot summer she basted and sewed and made buttonholes in men's shirts as fast as her fingers could fly. Once in a while she would stop and stare at the strangers who passed by on the street, in front of the glass window of the store. And then she'd put her head down and sew

furiously, until her arms hurt and her back ached. Each Saturday she carried home her wages of a dollar and a half; the only good feeling she had all week was when she gave the money to Ma, so that Mary might go to college.

The summer flew, and Laura was back on the claim before it ended. At harvest time the prairie swept to the horizon in one gold wave after another, the nights grew sharp and cold, and the days seemed shorter than they should have been. The time had come for Mary to go away.

Mary was good and Mary was brave, and in her heart Laura loved her. When they were younger, Laura had sometimes thought that she could never be good as Mary, and so they sometimes fought. But that was then, now was now. Laura had shown that she could be as good as Mary. She had talked in pictures so Mary could see the prairie within her dark world. She had read her lessons aloud, going over them again and again so Mary could learn as well as she had. Laura had seen Pa get up from the table hungry, and she too had eaten turnips raw from the plowed furrows of the claim without a word being said. She had helped Ma, and that was the same as helping Mary because it gave Ma more time to spend with Mary. And Laura had worked hard all summer so there would be money enough to send Mary to college. Laura hadn't earned much, only nine dollars, but that nine dollars was earned by hard work and aching arms and a heart that felt both love and duty.

Then one day Mary was gone, and Laura was alone on the claim with Carrie and Grace and all the cooking to do, and the wash, and the cleaning, and the cow to look after. Ma and Pa took Mary on the train to Vinton, Iowa, and had to wait there with her until she passed her examinations—which she did easily enough—and was properly enrolled. They were gone for more than a week. When they returned the train made its lonely cry across the prairie, and Laura missed Mary more than ever. She knew for sure that things would never be the same.

It was late in November by the time Ma and Pa came home, and Pa was anxious to move back into town for the winter. But for a short while, Laura and Carrie walked to town together along the little wagon road to attend school.

On her way home one day, Laura was stopped at the south end of Calumet Avenue by a great bull, snorting and pawing the ground and blocking her way. It belonged to Banker

Ruth, and it frightened Laura so badly that she ran the long way around in order to reach the claim shanty. When she told Pa what had happened, Pa got mighty mad and stalked off to talk to Banker Ruth. "I never saw Pa angry but two or three times," Laura said. This was one of them.

Once again Laura had to fight that "gone feeling" in her stomach when she started school. But seeing her old friends Mary Power and Minnie Johnson made things easier, and she soon had a new friend. She was a slim girl with black hair and soft brown eyes, and she blushed easily because she was the new girl in school. No doubt her "gone feeling" was even worse than Laura's. Her name was Ida B. Wright, although she was called Ida Brown because she was adopted and lived with Reverend Brown and his wife on their claim southwest of town, not far west of Pa's. Laura knew how Ida felt coming to school among strangers, and she took her as a seatmate.

Ida Brown wasn't the only new face in school that term. Much to Laura's surprise, Genevieve Masters was there too. Her father, Uncle Sam Masters, had come to DeSmet from Walnut Grove and set up as a surveyor. Genny Masters was a new girl to everyone but Laura, who knew her very well indeed. "She had not changed in disposition since the Walnut Grove days," Laura remembered, "but had grown tall and slim with a beautiful complexion and was always dressed in pretty clothes." The other girls in school soon had reason to know Genny as well as she did. Laura remembered that there was a common saying about Genny Masters: "Her tongue is hung in the middle and runs at both ends."

The new teacher that fall was Miss Eliza Jane Wilder, a 31-year-old single lady who had taken up a claim north of town near the claims of her brothers Royal and Almanzo. Laura thought Miss Wilder was unfair, mean, hypocritical, and even a liar. Genny Masters was Miss Wilder's favorite pet, and that didn't help Laura's opinion any either. But in many ways Eliza Jane Wilder was a remarkable woman, trying to homestead alone on the Dakota prairie, which had broken more than one man with its hardships and loneliness.

She had already taught in the East for several years, and denied herself the luxury of rest and comfort to homestead in Dakota. She put in her own crops and pulled the weeds herself and was poisoned by bean bugs. The prairie winds whistled through the walls of her claim shanty, and she was

forever scurrying back and forth between Minnesota and Dakota to take care of friends and family. Eliza Jane Wilder was a strong-minded and independent woman, but when she taught school in DeSmet she was worn out with work and worry. It was hardly a surprise that her classroom sometimes got out of hand.

Miss Wilder herself made the mistake of telling the class that when she was a girl her classmates had called her "Lazy, Lousy, Liza Jane." After that, she said, she always preferred to be called "E. J." by her friends. But one day Ida Brown drew a picture of an ugly woman on her slate and Laura wrote a verse under it:

> Going to school is lots of fun
> By laughter we have gained a ton.
> For we laugh until we have a pain
> At lazy, lousy Liza Jane.

"I have no excuse to make," Laura confessed after she had grown up. "I should have been whipped." And it wasn't even a good verse!

When the cold weather began all the big boys returned to school from the fields where they'd been working all summer long—Ben Woodworth and Frank Harthorn and Art Johnson and Cap Garland, with his shock of blond hair and his quick smile. With the boys back in school, the baseball games began again. Although Laura pictured herself as having given up her tomboy ways, she still joined in. "School became more interesting," she admitted. "Again I played baseball."

All that long mild winter, DeSmet hummed with things to do. Once Laura and Mary Power went to a sociable where Reverend Brown appeared. They didn't like it because they were the only girls there, and Laura didn't care for Reverend Brown anyway. He had yellow stains on his beard. But Ma predicted that the sociables would catch on, and they did. The town newspaper wrote about one such meeting; perhaps it was the one Laura went to:

A sociable was held at the residence of Mr. E. F. Barrows on Thursday evening. The house was filled with people, and a "splendid time" is reported by all who attended. It being the sixty-ninth anniversary of Rev. E.

Brown's birth, a liberal cash donation was raised impromptu and presented to him as a birthday gift. These social gatherings are proving to be a great success, and will be continued.

The sociable was one way in which the little town on the prairie was growing into a real community. Another was the Friday Literaries Pa helped organize. About these, Laura had no complaint. On Friday evenings the people would find their way through the dark streets of DeSmet to the schoolhouse, and there they would all gather, happy and laughing, just as people had for the spelldowns in Walnut Grove. One night there would be charades and another time there would be group singing and another time still there would be a debate on some important issue.

Once Hattie Bradley, the druggist's wife, sang a solo that was so beautiful Ma couldn't help but cry. Mrs. Bradley was a very young woman, only 23, and she had a beautiful soprano voice. When Mrs. Jarley's Wax Works performed at the Literary, even Almanzo Wilder and Cap Garland came. Pa was one of the black-faced Mulligan Guards in the minstrel show, of course, and Laura wrote about how Pa spelled down the entire town at one Literary—even to Alphabetical Fuller—winning with X-a-n-t-h-o-p-h-y-l-l.

When the season of Literaries was over, the newspaper grandly allowed that "its eloquent ones may bottle up their gas until another winter." But Laura remembered the round of Literaries this winter as a whirl of gaiety. Even better, she remembered the first time she was asked for a date—and turned it down by mistake.

It's a sweet story, for it shows Pa in a sly mood and Laura as saucy as ever. "On one of these entertainment nights," Laura remembered, "a young lawyer named Alfred Thomas came in and stayed and kept on staying for no reason that I could see until I was afraid Pa and I would be late. At last he asked Pa if he were going to the meeting, and to my surprise Pa said 'No.' Then he asked me if I were going, and I—thinking if Pa didn't go of course I wouldn't—said 'No' too.

"So Mr. Thomas went away and then Pa laughed at me and said all Thomas had come for was to take me. I had refused my first offer of an escort and I was indignant. If he wanted to take me, why couldn't he say 'Come with me!' and not be such a coward?

"Not that I wanted to go with him," Laura added, "but I hated to miss the fun and now Pa and I couldn't go, but sat home all evening."

The next time a boy asked Laura, we can be sure she wasn't so concerned about Pa's feelings. Once, she said, she went to a square dance with Ernie Perry, who lived on the claim south of Pa's. "I didn't like the kissing games, and always managed to let the kiss land on my ear," she remembered.

Laura didn't care much for Ernie Perry, either. She really had her eye on another boy—a boy with a shock of blond hair and blue eyes and a quick smile. But she was flattered enough by Ernie Perry's attentions, and she kept track of him. Many years later she wrote: "Ernest Perry went to Oregon with the rest of the Perrys a few years later, and stayed a bachelor for the sweet sake of his ideal of me until just a few years ago."

If winter was a whirl of gaiety, the spring and summer that followed were nothing but hard work. Pa moved back out to the claim before the April blizzard of 1882, and Laura spent long, tedious hours studying her books and lessons. She was preparing to be a teacher, even though she didn't want to be one. All around her the prairie blossomed, and Pa worked his fields and the wind gently blew. But Laura had to study. she had to prepare to be a teacher, so she could earn money to help Mary stay in the School for the Blind, where she already had such a good start.

By the time Pa moved the family back into town in the fall, the new Congregational Church was completed. A year earlier, members of the church had subscribed for the building, and now it was done, standing proudly on Second Street kitty-corner from the schoolhouse. Reverend Brown decided to have a revival meeting.

Laura didn't like prayer meetings. It offended her sense of privacy when people spoke their prayers aloud, she said. And when she went to the revival meetings in Walnut Grove, the thing she remembered most about it was not the exhortations and the prayers but Will Ray, standing on tiptoe and reaching for a high note. But all of her friends said they were going to the revival meeting at the new church; Ma and Pa were going to the meeting too. Everyone seemed to be going to the revival meeting that November, so Laura went too.

Once she was there, she knew for a fact she didn't like it. She sensed something dark and troubling in the air. She felt surrounded by strangers, although they were all people she knew. When the meeting was over the first night, even Pa stood up quickly and moved toward the door.

All through that meeting, Oscar Rhuel and Cap Garland and Almanzo Wilder had been sitting together quietly in the back of the church. Laura's mind wasn't entirely on the pulpit-thumping preaching of Reverend Brown. "To be perfectly truthful," Laura said, "I was noticing Cap." But as Laura followed Ma and Pa down the aisle toward the door, it was Almanzo Wilder and not Cap Garland who reached out to touch her gently on the arm and ask to see her home.

"In sheer astonishment, I made no reply," Laura remembered about that moment. Almanzo, however, did not require a reply. "Ma looked around, but Pa propelled her gently on and we went out the door and home. I'm not sure whether a dozen words were said on the way. I was tongue-tied, wondering why he of all people should pay any attention to me. Later I learned that Oscar had dared him to ask the girl who walked just behind me, and they had made a bet that he would not see her home. But Oscar did not make it plain which girl he meant. So although he knew perfectly well, the Wilder boy asked me as he intended and collected the bet from Oscar by claiming a misunderstanding."

Pa wasn't the only sly one in DeSmet. But except for the fact that Pa seemed to like him, Laura really knew very little about Almanzo Wilder.

Almanzo was nearly ten years older than Laura, and of course was no longer in school. He was already a homesteader, like Pa. Laura had first seen Almanzo in the springtime before the Hard Winter, when she watched him racing upright in his wagon across the prairie with his brother Royal. She knew Almanzo had gone with Cap Garland across the frozen prairies to get the wheat that saved the town. Once, when she and Carrie got lost in the Big Slough, they found their way out at the very place where Almanzo and Roy were haying. And of course Laura had admired Almanzo's dashing brown Morgans from a jealous distance. When Almanzo's sister came to teach school, Laura had hoped she might have a chance to ride behind them. But that hadn't happened.

Almanzo saw Laura home every night during the revival at the Congregational Church. They walked through the new-fallen snow down Second Street toward Pa's office building, and little by little Laura learned to know him better.

Almanzo had been born in 1857 on a farm in northern New York State. His birthday was February thirteenth, and hers was February seventh. Almanzo's father wasn't a fiddle-footed wanderer like Pa. James and Angelina Wilder were prosperous farmers who ran a farm so large that they worked from the first light of dawn until after dark to keep up with it. The family was a large one too, and it spread out over many years. Almanzo's oldest sister, Laura Ann, wasn't too many years younger than Pa. His youngest brother, Perley Day Wilder, was a year younger than Carrie. In between were Royal and Eliza Jane and Alice and Almanzo.

Almanzo grew up in a big red-painted farmhouse on a hill overlooking a branch of the Big Trout River, just west of the village of Malone. He was a farm boy through and through. He planted pumpkins and hoed the carrots (very slowly) and carried water and fished for trout and dug potatoes and caught a pig and shocked oats and pulled onions and threw a blacking brush at bossy Eliza Jane and picked huckleberries and packed ice in the ice house, and once a week he took a bath. He also ate like a horse. Once he ate baked beans and salt pork, boiled potatoes and ham gravy, ham and bread and butter and mashed turnips, yellow pumpkin and plum preserves and strawberry jam, grape jelly and watermelon rind, and a piece of pumpkin pie, all in a row.

What Almanzo wanted most of all was to be a farmer, and what he loved most of all were horses.

When he was about thirteen, his mother and father and the children who were still at home moved west from New York to Spring Valley, Minnesota, and made a big farm there. When Almanzo was twenty-two he left home himself, and went west to Marshall, Minnesota, to raise seed wheat. The same year he and Royal came to the Dakota Territory and took up claims north of DeSmet, on the prairie. This was 1879, the very year that Pa came and got Ma and the girls from the hotel in Tracy and drove them west to Silver Lake. Almanzo and Royal went back to Min-

nesota for the winter, but in the spring they were back to break their land. They had spent the Hard Winter holed up in Roy's little feed store next to Mr. Fuller's grocery.

Laura didn't find out all these things about Almanzo at once, of course. But after her first tongue-tied walk home with him, she was at least able to think of things to talk about. Still, she didn't know what to think of Almanzo's interest in her. When the week ended, she was no nearer to finding the answer to that question than when he first reached out and touched her arm.

One day after the revival meeting had ended, Rob Boast visited Pa's house with a stranger. The stranger was so lean and brown that Laura knew in a moment he was a homesteader, and Mr. Boast explained that he was a distant relative of his. His name was Louis Bouchie.

Mr. Bouchie lived on a claim about twelve miles south of DeSmet, where there was a little settlement of three or four lonely shanties huddled together for protection on the wide prairie. One of those shanties, Mr. Bouchie explained, was abandoned, and had been turned into a schoolhouse. Now the settlement needed a schoolteacher to go with it. Mr. Boast had recommended Laura.

Laura didn't know what to say. Even though she had prepared to be a teacher, she didn't especially want to be one. And the Bouchie school was so far away that she'd have to live there. And she was still only fifteen; she had to be sixteen to get a teaching certificate. And anyway, she was still in school herself. And Ma would surely need her at home, and . . . and. . . .

Mr. Boast said that it would be a good opportunity—and Mr. Bouchie said they could pay her twenty dollars a month for two months. Laura thought about Mary, and she said yes.

George A. Williams came to Pa's house especially to give Laura her examination. Mr. Williams was the county superintendent of schools. He quizzed her in orthography, writing, arithmetic, geography, English, grammar, and history, and of course she knew all these things quite well. Not once did he ask her how old she was. She knew that quite well too, but he just signed her certificate. It was December 10, 1883, and Laura Ingalls was a teacher.

The Bouchie school began a week later. Pa drove Laura

south across the cold prairies to the little settlement. He
took her to Mr. Bouchie's house, and then, with a wave
that said good luck, he was gone, back across the prairies
to town. Laura was on her own.

She could see after the first few hours in the house that she
would dread it. Mr. Bouchie's wife, Lib, was lonely and sul-
len and unpleasant. Although Laura tried to be pleasant and
helpful, Mrs. Bouchie called her a "hoity-toity snip." Mrs.
Bouchie was not well—she was obviously very unhappy with
a homesteader's life—and there was an air of danger in the
house. Even when she wasn't there, Laura felt something
menacing.

One uncomfortable day, Mr. Bouchie was working in the
stable and didn't come into the house until nearly supper-
time. Then Mrs. Bouchie threw a shawl over her shoulders,
stalked out into the cold, and slammed the door behind her.
Not a single word was spoken. Laura didn't know what to
do. She studied her history book. For a while Mr. Bouchie
played with his little boy Johnnie. Then he got up and
finished making the supper his wife had left. He put it on
the table and called Laura, and she took her place at the table
with her back to a window that had no curtains.

She began to get an eerie feeling that she was being
watched. She turned her head slowly to the side. From the
corner of her eye Laura saw the window behind her, and in
the window she thought she saw a large white face, staring
at her. She finished her supper with a gulp.

Mr. Bouchie was still eating when Mrs. Bouchie came
back into the shanty from the darkness. She didn't say a
word; she didn't even eat. She merely sat by the fire. When
Laura went to bed behind the curtain that separated her
place from the Bouchies, there was a strange, ominous
silence in the house.

The dread Laura felt at living there was almost matched
on her first day at the Bouchie school. She walked alone
across the half-mile of trackless prairie and opened the
school door to find that three of her five scholars were taller
than she was. But Laura found a courage and a wisdom she
hadn't known she had, and her first experience as a country
schoolteacher was easy compared to the thought of return-
ing each night to that house.

One cold and blowy day, Mr. Williams, the county super-
intendent, came to visit the schoolroom. The wind whistled

outside while the big stove inside glowed red and hissed out its ring of warmth. For a time Mr. Williams sat quietly, watching Laura teach and the children recite. When he was about to leave, Laura asked him politely if he had anything to say, and to her surprise he said yes.

"He rose to the full height of his six feet while my heart stood still," Laura remembered many years later. "Had I done anything wrong? After all, I wasn't sixteen yet. Then with his head almost touching the ceiling, he smiled at us all and said, 'Whatever you do, keep your feet warm!'

"And with another smile and a handshake he was gone."

Mr. Williams' friendly manner was a welcome encouragement for Laura's teaching. But nothing was so welcome to her as the sound of bells she heard when her first week was up. They were the bells of Almanzo's cutter, and he had come across the frozen, windswept prairie to take her home. She flew into her coat and mittens and rushed to climb into the cutter beside him, thankful that she wouldn't have to spend the weekend with Mrs. Bouchie. That first time when Laura came home, Pa played love songs on his fiddle, and dancing tunes, and Laura was reminded again how much home meant to her.

After that Almanzo drove his cutter down Calumet Avenue and out over the prairie every Sunday afternoon, taking Laura to the Bouchie school. Every Friday he came alone across the prairie to get her when school was finished for the week. For a time the little town was isolated again by blizzards and drifting snow, and it wasn't until the end of January that the blockade was lifted and trains could once more make their way to DeSmet.

"A great crop of frostbitten ears and noses is ready to be pulled," the newspaper jokingly announced. Perhaps that was when Laura and Almanzo took their hardest ride of all —on a cold day that kept getting colder and colder until the temperature fell to forty degrees below zero. That was the day when Almanzo stood looking at the thermometer in town, and Cap Garland called out, "God hates a coward!" So Almanzo went for Laura, and the snow swept across the frozen prairie and the cold worked its way through the robes and blankets she was wrapped in, and she nearly froze. When she got home she had to be carried into the house and thawed out. Laura always remembered that that ride took place on

Christmas Eve. But then, it always seemed like Christmas when Almanzo brought her home.

Laura and Almanzo talked about many things on these long rides between town and the Bouchie settlement, and one of the things they talked about was what they should call each other. Almanzo explained that his mother and father had always called him Manzo, while his brother Royal had always called him Mannie. But Laura misunderstood.

"I'll call you Manly, like Roy does," she said.

"When he told me of my mistake," Laura recalled, "I said I would call him Manly anyway, for Mannie was silly." And so from then on, Laura called Almanzo by the name of Manly.

"And what shall I call you?" Laura remembered Almanzo asking her. "I have a sister Laura, and I never did like the name. What is your second name?"

Laura Elizabeth Ingalls thought for a moment and then recited an old nursery rhyme:

Elizabeth, Elspeth, Betsy, and Bess
Went over the river to seek a bird's nest.
They found one with three eggs in it.
They each took one and left two in it.

"He said he could call me Bessie," Laura remembered. And so from then on, Almanzo called Laura by the name of Bess.

Even though they called each other Manly and Bess, Laura wanted to make it clear that Almanzo wasn't her beau. One of the children in the Bouchie school had shouted out that he was, and Laura blushed to think that Almanzo might have heard. Even in town, her friends talked as though Almanzo was her beau. So Laura told him that he wasn't, in words she knew immediately were cold and cruel. Almanzo said nothing; he had learned patience as a farmer boy.

In this case, however, he didn't need very much patience. Laura was no sooner home than she saw her friends riding up and down the snowy street in front of Pa's store with their own beaus. When Almanzo came by with the sleigh bells jingling on his cutter, she hurried into her coat to join him. She had forgotten her promise not to ride with him again. But Almanzo said nothing.

By the time the Bouchie school ended, Laura had turned

sixteen. She was happy to give the forty dollars she had earned to Ma and Pa, and even happier to be going back to school again in town like a regular schoolgirl, with Ida Brown and Mary Power and May Burd and Minnie Johnson and Hattie Dorchester. Cap Garland and Frank Harthorn and Art Johnson and Fred Gilbert and Alfred Ely, whose father ran the lumberyard north of the tracks, were also in school when Laura came back. She had studied well during the two months she was gone and was proud to be able to keep up with her own class.

The winter before, Laura said, had been a whirl of gaiety. Now she took a job on Saturdays with Mrs. McKee, the dressmaker. Her life became a whirl of school and work and Sunday rides in Almanzo's cutter. There was still gaiety enough.

Before spring came, Laura's Uncle Tom Quiner paid a surprise visit to DeSmet. If ever there was a half-pint, it was Tom Quiner. Tiny and tough, he had worked in the Big Woods as a lumberjack and foreman, bossing roughnecks and bringing logs down the rivers to the Mississippi and doing the work of a man twice his size. Laura found him "a small, quiet, kind man with a pleasant smile that made me feel at home with him." One long winter evening, Uncle Tom told Ma and Pa and the girls about his adventures in the Badlands and the Black Hills. All the time Laura had been living in the dugout on the banks of Plum Creek, Uncle Tom was in the first party of private Americans to make its way across Indian Territory and explore for gold in the Black Hills. The story he told was full of peril and excitement, and Laura listened with amazement.

It was on a bright, crisp October morning in 1874 that a wagon train of adventurers left the banks of the Missouri River across from Sioux City, Iowa. There were twenty-six men in the party, one woman, and her nine-year-old boy. The woman was Annie B. Tallent, and she wrote up the story of the expedition in a book she called *The Black Hills; or, Last Hunting Ground of the Dakotahs.*

There were five canvas-covered wagons in the train, and five horsemen rode along the flanks as the party made its way west across the prairie. Some of the men rode in wagons, some walked along with the small herd of cattle they were taking with them. Two sleek greyhounds loped across the prairie after antelope and jackrabbits.

The party was divided into outfits or messes, and Uncle Tom Quiner was in the "Logan outfit" with his mates from the Big Woods. Annie Tallent called them "a half dozen muscular fellows from the pineries of Wisconsin, who were not afraid of work, and not very much afraid of Indians. Some of them, as their names indicated, were brave Scotsmen, whose ancestors, at least, came frae the hills o' bonnie Scotland." Besides Uncle Tom, these were B. B. Logan, Dan MacDonald, another Dan MacDonald, James Dempster, James Powers, and J. J. Williams. The first Dan MacDonald was called Red Dan, because he always wore a red shirt, and the other was called Black Dan because his shirt was black.

While they were still in settled territory, Mrs. Tallent wrote, no guard was necessary, and everyone gathered around the campfire at night to tell stories and sing songs. A young artist named Harry Cooper sang so beautifully that his "rich tenor voice, as it floated out on the still night air, made one think of New Jerusalem." Another gay singer, Uncle Nute Warren, couldn't wait for the campfire to raise his voice in song, but sang all the time. "His voice could be heard blithely and joyously singing from early morn to dewy eve without cessation, in fact he sang always except when asleep," Annie Tallent recalled. And he always sang something about:

> Down in the coal mines
> Underneath the ground,
> Digging dusty diamonds
> All the season round.

These good times came to an end when the adventurers left the settlements and rode out onto the trackless prairie where the Sioux moved silently on horseback, in paint and feathers. "I now recall," Mrs. Tallent said, thinking back on the small crowd that gathered to see them off from the last settlement, "how utterly horrified these kind people looked as our train pulled out of camp. They assured us that we were rushing headlong right into the jaws of death."

Ice had already formed along the banks of the Niobrara River when the party pushed its way through the quicksand and cold waters to the other side. Every few miles the wagon train moved in larger and larger circles, and then veered off in another direction entirely—to throw Indians and the U. S. Cavalry off their track. They were on forbidden ground. At

night there was no singing, and the campfire was kept low. Fresh water ran out. By the time they reached the Badlands there was only an "unpalatable conglomeration of chalk and congealed water" to slake their thirst. One member of the party died.

"Gloom, like a dark pall, hung over our little camp on the dreary, lonely prairie that night," Annie Tallent said. "Death was in our midst and every gust of wind that blew adown the valley seemed laden with the wails and groans of our departed comrade."

The party reached the Black Hills in December, and found the wagon trail made a short time earlier by General Custer and his troops. A snowstorm swirled down to greet them. The gloom of the Badlands was replaced by the immense solitude of the empty hills. "We found the Black Hills a profound solitude, with peace, like a guardian angel, reigning over the whole wide expanse, and without a single vestige of civilization, and as we marched along under the shadows of the lofty hills, I remember how greatly I was impressed with their vastness, and our own comparative insignificance and littleness," Mrs. Tallent said. "No sound was to be heard amid the solitude, save our own voices, which sounded strange and unnatural; the rumbling of the wagons over the rough trail, and the cracking of the drivers' whips, which reverberated from hill to hill and through the corridors of the woods."

Lonely Christmas came uncelebrated by anything except "a powerful sermon in the beautiful quartz that lay scattered about on the hillsides." Two days later another snowstorm struck, two feet of snow falling on the level and the wind pushing it into even deeper drifts. During the storm, work was started on a stockade, and when it was completed seven little cabins stood within its walls.

The finest of these cabins was built by Uncle Tom Quiner and his outfit from the Big Woods. It was conspicuous, Annie Tallent wrote, "because of the peculiar construction of the roof, which consisted of small hewn timbers with a groove chiseled out in the center of each to carry off the water. As a substitute for shingles it was an ingeneous contrivance. The same cabin had a floor of hewn logs, a door of hand-sawn boards, a chimney, a fire-place, and an opening for a window, but no sash."

The snow soon melted off, and many members of the party

panned for gold. Others laid off a town, to be called Harney City, and thus the long winter was passed. A blizzard struck in April, and during the storm four men rode into the stockade. Two were former comrades who had ridden off to Fort Laramie several weeks before. The other two were soldiers of the U.S. Cavalry, with orders to remove the adventurers from the Black Hills and tear down their stockade. The great adventure was over.

Uncle Tom didn't stay long in DeSmet. While he was there Ma and Pa told him all about the little town, and Uncle Tom allowed as how it might be a good place to settle down. But he still had family in the Big Woods, and that's where he was bound.

After Uncle Tom headed east, Laura was surprised to find another visitor in town: Nellie Owens' father arrived on the railroad from Walnut Grove. He had a whole carload of hogs and milch cows to sell, and he sold them quickly. Then he too was gone. Wild geese came flying high over the little town on March 12, and soon afterwards more immigrants poured in on the railroad. Even Pa was surprised at how quickly people came and went in DeSmet.

When spring came, Laura took a new job—claimsitting with Mrs. McKee. Under the law, a homesteader's claim had to be occupied a certain part of every year, and Mrs. McKee was going out to their claim with her daughter. But they were really town people and were afraid of the wild prairie, so they asked Laura to come along. After all, she had lived in little houses and claim shanties all her life.

They took the railroad to Manchester, a little town about seven miles down the tracks from DeSmet, and that night stayed in the still unfinished hotel—all three of them in one bed. The next morning a teamster drove them north across the prairie to the claim. Laura kept busy, but every so often she felt a pang of homesickness, especially when she thought about Almanzo. When Mrs. McKee, trying to be helpful, declared that Almanzo had his eye on Laura, it didn't help a bit.

At night she walked the prairie around the little shanty. In every direction the horizon glowed from the light of distant fires on the prairie. In the mornings Laura heard the yellow meadowlarks singing from the tall grass outside the shanty door. But she didn't feel at home. By the end of May, when

Mary was expected home for a visit from college, Laura was eager to be back with Ma and Pa.

By staying with the McKees, Laura had missed the last part of the school term. Now that she was home, school was no longer in session. She took a job with Miss Florence Bell, the milliner whose little shop was down the street at the opposite end of the block from Pa's building. Laura Wilder— Almanzo's older sister—also worked for Miss Bell, and Laura Ingalls and Laura Wilder worked together all through June, July, and August.

Mary came home in June. It seemed amazing that she could come all that distance by herself on the train, but she explained that she was learning to do many things by herself at the School for the Blind. Some of them she brought home with her—presents she had made for everyone. Even the newspaper took notice of Mary's return and her handiwork. "Miss Mary Ingalls, while in the blind asylum, worked a beautiful watch case of bead-work, as a present to Rev. E. Brown," it said.

The Fourth of July celebration in DeSmet that year was the best ever. A special pavilion was built for the occasion, and it was crowded with people. Judge Carroll read the Declaration of Independence in a booming voice and Mr. Wilmarth the grocer delivered an oration, and in between the speeches, the DeSmet Coronet Band played lively music. After dinner one of the townsmen dressed up as Captain Jinks and paraded through town with a company of harlequin horse marines, and then everyone rushed for the race track on the prairie north of the tracks. There were horse races and footraces and even a four-inning game of baseball, Blues 10, Reds 2. As darkness fell, fireworks were set off and lit the sky above the town, and in the pavilion, the band gave a rousing concert.

It was certainly the most romantic and glorious Fourth DeSmet had ever had. But Laura missed it. She stayed home with Ma and Pa and Mary, Carrie, and Grace, and she thought about Almanzo.

The town was changing. The times were changing too. For Laura, the times of childhood seemed a long time ago. That summer a gravel road was built through the Big Slough south of town; no longer would a winter's drive to the claim be as dangerous as it was for Pa when he went to get hay during the Hard Winter. North of town on Almanzo's claim, sulkies and

plows were being demonstrated for the benefit of farmers. A spirit of improvement was in the air. In the East, people were talking on the telephone between New York and Chicago. It seemed a miracle.

Laura thought about Almanzo. For her there was no miracle.

In September, after Mary had returned to college, Laura went to school again with Carrie. A new teacher was in charge of the upper class, and Laura liked him very much. He was even more alphabetical than Gerald Fuller, because his name was V. S. L. Owen. His first name was Vidocq, which may explain why he preferred the initials.

Hoop skirts were in fashion that fall, and of course she wore one. She learned how to sashay back and forth to keep the wind from blowing up her skirts on the way to school and back. As she walked she thought about Almanzo and she hummed a little tune she had first learned from Cousin Lena long ago:

> If he goes let him go
> Let him sink or let him swim,
> He don't care for me
> And I don't care for him—

Almanzo swam. Once again he came to call on Sunday afternoons. He had a new team that needed to be broken, and Laura helped him do it. They raced up and down the street past all the stores and out onto the prairie. They swung north of town and circled back and streaked down the street and out onto the prairie again. Laura's hair flew behind her, the wind smacked against her face, her blue eyes sparkled—and at the window of the house, Ma stood shaking her head.

It was harvest time, and Laura had a beau. Mr. Williams had a Teacher's Institute in October. Mr. Owen was there, and Cap Garland's sister Florence, and even Genny Masters. But Laura didn't go. Laura was racing down the street behind Almanzo's team and turning out onto the prairie, and the wind was in her hair and her eyes were all asparkle. Laura had a beau.

Pa worked his crops out on the claim. He cut the hay and pulled potatoes and stood for a long time on the golden prairie, looking west. "Pa was very thin and tired from the work of harvesting," Laura remembered, "but strong and

hard as nails." Once again Pa talked of going to Oregon. Once again Ma said no. That was the last time Pa spoke his thoughts about moving on.

But Laura had no thoughts of moving on. Laura had a beau.

Winter brought Uncle Tom back to DeSmet with a carload of lumber—"with which he proposes to build a store," the newspaper reported. He stayed only a week and hurried home to Fountain City in the Big Woods, hoping to get there in time for Christmas.

On Christmas Eve, Ma and Pa and the girls went to the Christmas Tree ceremony at the Congregational Church. It was a special treat for Grace, because she had never seen a Christmas tree before. It was a special treat for Laura, because beneath the tree she found a surprise from Almanzo, although he didn't put his name on it. And it was a special treat for all the people in the little town for quite another reason.

The Congregational Church at last had a church bell. It was the first church bell in the entire county, and on this night it was dedicated. On this night everyone's heart rang with gladness, each for a different reason.

Alfred Thomas, the young lawyer who hadn't had the courage to ask Laura to come with him, opened the ceremony by reading a brief history of bells. Then Reverend Ames of the Baptist Church, which didn't have a bell, stepped before the crowd to read a poem by John Greenleaf Whittier on the ringing of bells, perhaps "Three Bells of Glasgow." He was followed by Reverend Brown. With his white beard shaking and his abolitionist eyes afire, Reverend Brown recited Longfellow's "Christmas Bells":

> I heard the bells on Christmas Day
> Their old familiar carols play,
> And wild and sweet
> The words repeat
> Of peace on earth, good-will to men!

Reverend Brown read through the poem with strong passion. Longfellow, after all, had called bells "the best of preachers." Laura Brown, the reverend's wife, was next to recite, and she read a treasured passage from Tennyson's long poem "In Memoriam," full of sweet sadness:

Ring out, wild bells, to the wild sky,
　The flying cloud, the frosty light;
　The year is dying in the night;
Ring out, wild bells, and let him die. . . .

And then before the sweet sound of her voice had died
away, J. F. Smith began to ring the new church bell itself,
and its sound boomed out through the white and sleepy
streets of the little town on the prairie.

The men of the church rose to their feet and pushed back
toward the vestibule, and the children—their eyes lighted
up—slowly took their places in the front. They began to
sing "Bell Echoes," a song that had been especially com-
posed for the occasion. With every peal of the children's
clear, high voices, an answering peal sounded from the
wild, deep voices of the men in back. Back and forth the
song leaped over the heads of the crowd, the peal of the
bell, an echo, the sound of angels. Once again Mr. Smith
pulled down on the long bell cord, and the ringing of the
new church bell was added to the hymn, and as the people
of the church rose to their feet each heart rang out, each
for its own bright reason.

Even later, as the people walked home through the dark
streets with their lanterns bobbing before them, the air itself
—so clear and crystal pure—seemed to ring in celebration.
It was an evening that couldn't be forgotten, a jewel in the
dull crown of life. Laura's own heart rang with a special
song.

All around that season were sounds and signs that made
Laura glad. At night the wintry air sighed with the song of
prairie wolves, which the paper reported "are frequent and
bold in the neighborhood." Beneath the sizzling stars, the
prairie stretched off like rolling white waves into the dis-
tance of her dreams. The moon floated in a black sky, and
one night a halo formed around it and a "perfect cross"
extended outward to the ring of light. The blades of Al-
manzo's cutter made a sharp scratching sound on the snow.

Near the time of Laura's birthday, Mr. E. A. Forbush
announced that he would hold a singing school. There was
no trouble in making a class, and Laura and Almanzo were
among those who met at the church every Saturday and

Monday evening, singing scales and songs that made the heart leap up. They worked from Thompson's *Class and Concert*, an old singing book. "Mr. Forbush's singing school is growing in numbers and doing good work," the newspaper announced a month later, and by the end of March classes were being held three times a week instead of two, so the work of the school could be finished before spring.

After every class Laura and Almanzo raced across the prairie in Almanzo's buggy. They were breaking Barnum, and at night across the dark prairie, where the wild horse and the buggy and Laura and Almanzo swept beneath the stars, the sound of Laura's voice drifted for a little while and faded out.

In the spring, Silver Lake was alive with ducks. Geese and brants flew overhead by the countless thousands but didn't stop. Royal and Almanzo worked on the claim north of town, painting their barn with a new coat of bright red paint. Pa, too, moved out to his claim. Before he did, he resigned as justice of the peace—a job he had held for almost five years.

Out on the claim Pa thought himself free. Overhead were flashing wings, sailing onward, and Pa watched them go. But he wasn't free. The land needed his attention. Thin and wiry, he spent himself upon it, trying to coax from its dry heart the crops for another year. At night in the shanty, Laura went to bed to the lonely whistle of the train coming in from the west and slowing for a stop at the depot. And then, before the sun rose, the thin cry of another train carried across the darkness, going west. Laura lay in bed, listening.

In April she took her school examination from Mr. Williams again, and again was certified as a teacher. Her own school term was drawing to a close, and Mr. Owens and Minnie Barrows, who taught the little children, put on their first school exhibition. Perhaps this was the same exhibition at which Carrie recited the words of George Washington Doane's "Life-Sculpture" so sweetly and clearly and never missed a word:

> Chisel in hand stood a sculptor boy
> With his marble block before him,
> And his eyes lit up with a smile of joy,
> As an angel dream passed o'er him.

Perhaps this is when Laura herself recited the history of America.

"The exhibition given by the DeSmet school Friday evening, of last week, was a complete success," the newspaper reported:

> The church was packed, and almost $50 was netted. The dialogues, declamations and songs were well rendered and gave credit to their instructors, who have taken the utmost pains to make the entertainment a success. This closes the most successful term of school ever taught in DeSmet. The people showed their appreciation of Mr. Owen and Miss Barrows by the passage of a resolution thanking them for their efforts in behalf of the schools.

The exhibition was a success, but Laura had grown tired of school. The ceremony of the bells, the singing school, her rides across the winter prairie with Almanzo—these things made her feel that she was growing up. They answered her heart. One day that spring Laura had stayed home from school with a sore throat—or so she told Ma. Ma made a special syrup for her, from vinegar and brown sugar and butter and spices all mixed together. It was like life. Laura liked it. But she found school boring.

Once again she felt her old feeling of wanting to go on and on. She was restless, and she wanted something more.

That spring Pa helped build a new school in the corner of the Perrys' claim, just beyond the south line of his own, and that's where Laura taught for $25 a month. Sometimes she walked west across the flowered prairie to Reverend Brown's and talked for hours with Ida, while the white clouds drifted overhead and the Wessington Hills shimmered in the distance. Ida was a good friend, and she had a beau of her own—Elmer McConnell. Sometimes in the evenings Pa played his fiddle, although he was busy with crops and he was building a house in town on Third Street for Uncle Tom Quiner. Still, when the sun set on the prairie, Pa reached for his fiddle. He played all the old songs and his eyes still twinkled merrily, and once again he called Laura "Half-Pint" and "Flutterbudget."

Perhaps he didn't know it. Perhaps she didn't know it. But she was drifting away.

Every Sunday she stepped outside and looked off across the prairie and the slough toward the little town. Pierson's livery barn was bright red with new paint, and she kept her eye on it until she saw a horse and buggy make the turn from Calumet Avenue and head out onto the prairie along the gravel road. It was Almanzo, and he always arrived promptly at two o'clock in the afternoon. Then Laura would get into the buggy, and they'd be off for their ride across the prairie.

Sometimes they'd double back and ride far north of town to Spirit Lake, where buffalo were trapped during the Hard Winter. More often they'd ride southeast to Lake Henry, where the horse would slow to a walk and the buggy would wobble across the slow prairie, and Laura and Almanzo would talk.

The wind blew softly and the hours flew. Sometimes darkness would catch them far from town, and they'd race back beneath the stars. Although Laura remembered going to the races on the Fourth of July this year, it rained, and there were no races. But she hardly needed the Fourth of July. She had her own beau and her own horse, which she had helped break, and her own buggy. On one of their rides a terrible storm came up suddenly. It blew down the new Catholic Church, which was not yet finished, and it lifted the new band hall from its foundation. The storm was dark and windy and wild, but Laura loved it. It suited her mood. It drew her closer to Almanzo.

Before the summer was over Almanzo proposed. That night, Laura remembered, when he brought her home from their ride, "he kissed me good night and I went into the house not quite sure if I were engaged to Manly or to the starlight and the prairie."

For a time it seemed to be only the starlight and the prairie. On the first of November, Royal and Almanzo said goodbye and went away "with a covered hack and a stock of notions to sell on the road." They were bound for New Orleans and the great Exposition being held there, expecting to spend all winter on the journey and return in time to put in a spring crop—or so the newspaper said. Laura remembered that "they expected to travel through Nebraska into and through Iowa and come to Spring Valley, where

their father lived, to spend the winter." For Laura it was a long lonesome time while Roy and Almanzo were gone, wherever they had gone. Roy had left Lady, his horse, with Pa to keep in the stable on the claim, and once Laura took her for a ride. But it wasn't the same as being with Almanzo.

All of Laura's friends seemed to be having a high time while she sat home and pined. Mr. G. C. Westervelt, who, like Pa, had put a new sidewalk in front of his house in town, was trying to organize a new singing class. But Laura didn't feel like going without Almanzo. The band hall, built by the DeSmet Coronet Band, had been turned into a roller skating rink; the band played one night a week and all Laura's friends went to skate with their beaus. On one evening, Mary Power and her beau won a mile race against Hattie Dorchester and her beau, even though Hattie's beau was the fastest boy in town as a footracer. But Laura didn't feel like going without Almanzo. In the middle of December the newspaper carried a little item about him:

> We hear from the Wilder brothers that they are progressing well on their way to the Exposition, and enjoying the trip immensely.

Perhaps Laura heard from Almanzo too. But it couldn't have been the same as having him there.

Just before Christmas a sudden storm signaled the start of winter. "Winter arrived this week with both feet and a very bad breath," the newspaper announced. And so did Almanzo—at least with both feet. It was a week before Christmas when Laura heard a knock on the door, and the door flew open and there stood Almanzo, unable to stay away a moment longer.

"I couldn't stay away all winter," Laura remembered him saying, and then she added: "and he kissed me right before all the folks!"

Even though the Friday Literaries were considered "old time" and had been abandoned, DeSmet sang with things to do all that long winter. On Christmas night there was a dance at the roller rink, with an oyster supper at the Exchange Hotel. The Christmas Tree celebration was also at the rink this year, beneath the branches of a giant spruce that had been brought on the railroad all the way from the

Big Woods of Wisconsin. George Westervelt had so many young people attending the singing school at his home on Monday and Thursday evenings that he divided the class in two, creating a special advanced class in choral singing.

The plaster had dried on the inside of the new brick schoolhouse, and the building was formally opened in January, with Mr. Owen teaching the upper grades, Miss Barrows the lower, and Miss Elgetha Masters—Genny's sister—teaching the intermediate class. In January there were also revival meetings at the Congregational Church one week and at the Baptist Church the next.

Bradley's drug store entered the modern age—a soda fountain was installed. "Thither will the young men go," it was predicted, "for the cup that phizzes, and cools, and comforts and cheers." The town was dry, of course.

And the roller rink was replacing the Congregational Church as the social center of town. It was open on Wednesday, Friday, and Saturday afternoons and evenings, gents ten cents, ladies free; on Friday evenings when the band played, gents and ladies both free. Masquerades were held at the rink on special nights, and all the girls and their beaus came dressed up as characters from story and song—none but masquers were allowed to skate on those nights. Occasionally there were other entertainments at the rink as well:

Mrs. Jarley's Wax Figures were exhibited in the rink on Thursday evening last to a large and appreciative audience. The several "figgers" performed their parts well, as did Mr. and Mrs. Jarley. Receipts about $25, for the benefit of the Cong'l church.

How many of these activities Laura and Almanzo joined we don't know. But Laura well remembered the Sunday evenings when Almanzo paid his regular visits and they sat together in the sitting room.

"The folks left us alone about nine o'clock," Laura recalled, "but we knew that Manly was expected to leave when the clock struck eleven. He always did, except one stormy night when he stopped the clock just before it struck and started it again when his watch said twelve—so that it struck eleven just as he left.

"I hastily pushed the hands ahead to nearly twelve, blew
out the lamp, and went to bed in the dark."

School wasn't even out when Mr. Williams announced the
spring teacher's examinations, and thirty-five candidates at-
tended them when they were held in April. Soon the school
board began hiring teachers for the next term. Genny
Masters got a school in Hamlin County, and Laura's friend
Ida Brown got a school in Manchester Township. Clara
Wilkins was hired to teach the spring term from April 20
to July 20 at School No. 4, where she had also taught the
winter term.

Laura's name wasn't mentioned in the newspapers as
having been hired this spring, but she wrote of teaching a
three-month term at the Wilkins School, three and a half
miles to the northwest of DeSmet. She remembered staying
with her classmate Florence Wilkins, and her father and
mother and married brother and his wife and their little
baby on the Wilkins claim, close by the new schoolhouse.

There is no doubt, however, that Laura did teach school.
Most likely her classmate's name was Clara, not Florence,
and Laura for some reason taught in her stead. She came
home with only two months' salary, sixty dollars. "The other
$30 could not be paid until some time in the fall," she re-
called in her memoir. "This was the $30 that bought the
colt, that was sold to buy the sheep, that with their increase
were sold for the money that bought Rocky Ridge." And
Rocky Ridge was the happy little farm in the Missouri
Ozarks where Laura and Almanzo spent most of their lives.

Summer was long and lazy in DeSmet that year. Except
for a musical in May at the Congregational Church, with
a dinner of doughnuts and syrup afterwards, there was little
for Laura and Almanzo to do. Laura's teaching, of course,
lasted until late in July, and then once again she and Al-
manzo resumed their gay rides across the summer prairie
behind Skip and Barnum—until August came.

August came, and the prairie writhed in heat. "The heat
this week has been simply terrible," the newspaper con-
fessed. "Let's go North!" And that is just what Laura and
Almanzo did. They went north of town to Almanzo's tree
claim, as man and wife.

Only a few weeks earlier, Eliza Jane had returned from
Minnesota—no doubt with plans for a big wedding. But
Laura and Almanzo beat her to the punch.

"On the morning of August 25th, 1885, at half past ten o'clock," Laura wrote in her memoir, "Manly drove up to the house and drove away with me in the buggy for the last time in the old way. We were at Mr. Brown's at eleven and were married at once, with Ida Brown and Elmer McConnell as witnesses. Mr. Brown had promised me not to use the word 'obey' in the ceremony and he kept his word. At half past eleven we left Mr. Brown's and drove home to dinner, which Ma had ready and waiting for us. Then with good wishes from the folks and a few tears, we drove over the road we had traveled so many times before, across the Big Slough, around the corner by Pearson's livery barn, through DeSmet and then out two miles north to the new house on the tree claim, where Manly had taken my trunk the day before."

Thus in the little gray house in the west, one long adventure ended and another began.

As Laura sat in the doorway that Tuesday evening, she could think back on days that were both happy and sad, nights by the fireside ringing with songs from Pa's fast fiddle, stars that hung low and blue over the prairie and seemed to sing to her. She could look back on a lifetime of little houses, and long journeys she had once wished would go on forever and ever.

Life had brought her this far, swept her across the golden prairies and deep green woods of America, made her strong and happy, and left her in the doorway of a little gray house in the west. She was eighteen years old; a lifetime lay before her. She couldn't know what happiness or what sorrow it would hold.

In the newspaper the next week, this notice appeared:

Married. WILDER-INGALLS—At the residence of the officiating clergyman, Rev. E. Brown, August 25, 1885. Mr. Almanzo J. Wilder and Miss Laura Ingalls, both of DeSmet. Thus two more of our respected young people have united in the journey of life. May their voyage be pleasant, their joys be many and their sorrows few.

First the sorrows, then the joys.

9

Life Together

Laura and Almanzo's first years together were spent on the tree claim and homestead north of town, across the autumn prairie from all the places they'd known. In town bell-ringers and comedians bowed to the cheers of happy couples at the rink. Ida married Elmer, and moved away. Geese and brants boomed southward.

But Laura and Almanzo could neither cheer nor laugh nor move away. They worked the uncertain harvests of the land.

From the safe harbor of memory, Laura said these first years were years of "sunshine and shadow." They were in fact overwhelmed by darkness. No longer was there the gaiety of all Pa's little houses, the sweet songs of his fiddle by the fireside, the comfort of knowing that home was home and always there. Laura and Almanzo were on their own, alone, and in the account of these first years that Laura wrote and didn't have the heart to publish—although it was published after her death—each month is grim and dark and worked through with worry. They lived on work and dreams, hoping the one would ease and the other be fulfilled.

In the first autumn of their life together, the days shortened toward winter. In the frosty light of evening, when the sky was like milk and the prairie ran gold and brown, Laura sat in the little gray house on the tree claim and dreamed. In her hands she held the thin, green-covered catalogue of Montgomery Ward & Co., with its giant warehouse in far-off Chicago and its hint of what the world was like beyond the prairie. In it she found "interesting facts": Envelopes were first used in 1839, a horse will live twenty-five days without solid food, a ton of gold is worth $602,798.90. But better yet, she found the stuff of dreams.

She found cake baskets and castors and canes and brace-

lets and baseballs, catcher's mitts and wall tents, fishhooks
and Colt revolvers, pipes and pocket knives and napkin
rings ("Sailor and Anchor," "Dog," "Bird"), sewing ma-
chines and trunks and pellissiers and sheet music, celestinas
and banjoes and violins, Bauer organs, harmonicas, ice
skates and roller skates, pocket puzzles and match safes
and clothes wringers and potato parers, corn poppers, slop
jars and bread baskets. There were spittoons and cuspidors,
rawhide saddles, sealskin caps, sombreros and bustles and
hoopskirts, cloaks and corsets and dice and hair oil,
Smyrna rugs and specie pouches, Christmas cards and
books—*The Language of Flowers, How to Win and How to
Woo, Laughing Gas, Charley Fox's Ethiopian Comicalities,
How to Cook Potatoes, Peck's Bad Boy and His Pa*, Scott's
Waverley novels, Dickens' complete works. Thackeray and
Bulwer-Lytton, James Fenimore Cooper and Washington
Irving, Milton and Dante and Bertha M. Clay. There were
drawing slates and papeterie, back combs, and ladies' fichus
and chenille collarettes, baby bibs and angora hoods, Sara-
toga waves, Terry bangs and Langtry Coquette, passemen-
terie and Spanish lace, Fouragere ornaments and pillow
shams, carriage robes and mittens.

This was America in the year Laura and Almanzo were
married. And from these happy crowded pages—from page
145—Laura picked a Christmas present she and Almanzo
could give each other. It was a set of glassware called the
City Set. In it were a sugar bowl and creamer, a butter dish,
a spoon holder, a covered jug, a pickle dish, a pitcher and
twelve goblets "Bismarck Plain," two covered comports and
twelve specifically for fruit, and last, a bread plate.

On the bread plate, circling a shock of wheat, were these
words: "Give us this day Our daily bread." It cost $3.61. It
was a merry Christmas.

The winter was mild, even balmy. It hardly snowed at all.
Spring was early, and in the spring Laura was pregnant. Still
she cooked and washed and did the chores. "I learned to do
all kinds of farm work with machinery," she boasted. "I
have ridden the binder, driving six horses. And I could ride.
I do not wish to appear conceited, but I broke my own
ponies to ride. Of course they were not bad, but they were
bronchoes."

Fall came, and winter, and on the fifth day of December,

a Monday night, Laura had her baby. She had already picked out a name for a girl, and she called the baby Rose, after the beautiful prairie flowers she had always loved. Dr. Ruggles A. Cushman, a new doctor in DeSmet, came out from town to look after Laura when the baby was born.

Rose had big blue eyes and golden hair, and Laura watched her grow fat and saucy. Laura's sister Grace had a little diary in which she kept track of "blisserds" and prairie fires and visitors and school: "Mr. Owens is just the horridest thing that ever was. Minnie and I had to go in his room for whispering. . . ." In January, when Rose was a month old, Grace wrote: "Laura has a baby and it is just beginning to smile." And a little later, in March, before the snow had left the prairie: "Laura was over a week ago and put Rose in short dresses, Rose is a big fat baby now but just as pretty."

Sometimes Laura and Almanzo would ride the buggy down to town and out to Pa's claim to visit with the folks. Sometimes Ma and Pa would ride up through town and out across the prairie to visit with Laura and Almanzo. But the visits were few. Pa was sometimes sick—once, as Grace wrote, "for a long while." For Laura there was work and Rose and dreams. There was some little sunshine. But mostly there was shadow.

Laura wasn't sure she wanted to be a farmer's wife. What she did want, she couldn't say. But in her heart she always called herself a pioneer girl. Even after many years, when she began her work on the *Little House* books, her first thought for a title was simply *Pioneer Girl*. That was Laura. She was used to being free and singing songs on the prairie and dreaming dreams that would come true. A farmer wasn't free, it seemed to her. A farmer was a slave to work and worry and weather, and was at the mercy of the market. Even Almanzo said it, the rich got their ice in the summer and the poor got their ice in the winter. Farmers were poor. As for Almanzo? He was a farmer through and through. Almanzo had always been a farmer boy.

So Laura worried. She worried about the money they didn't have. Pa had always cut his wheat and oats with an old-fashioned cradle—whether a straight or a grapevine or a mooley we don't know—but he swung it himself beneath the summer sun. Pa wouldn't buy a harvesting machine because he didn't have money enough to pay for one in full and he

refused to go into debt to get one. He remembered Plum Creek, and his high hopes, and a cloud of grasshoppers, and a long journey alone to pay his debts. As for Almanzo? Almanzo was young and full of hope. Almanzo bought a sulky plow and a mowing machine and a hay rake and a binder. Each was on payments, each with interest. There was a mortgage on the horses. There was another mortgage on the cows, and on some of the other machinery. When a sudden summer hailstorm destroyed the crops, Laura learned to her surprise that a large debt was still owed on the house—$500. Almanzo hadn't told her.

They scraped by, paying interest on the notes to keep the notes renewed. That meant more interest to pay. There were taxes to pay too, and doctor's bills and medicine; in the winter, coal; in the spring, seed. They moved from the tree claim to the homestead; they mortgaged the homestead and then sold the homestead and moved back to the tree claim. Drought and heat killed the trees, so Almanzo couldn't prove it was a tree claim. He filed for preemption rights, because they had already lived there. And Laura worried. She worried about short crops and about no crops. She sent butter and eggs into town with Almanzo, but no one wanted them. Almanzo bought her a beautiful, expensive clock for Christmas. For Laura, it tolled only slow hours of worry.

She said these years were sunshine and shadow. The shadows were specific. In the summer of 1887, the barn and the haystacks burned down. The next spring Laura and Almanzo both fell sick with diphtheria. Royal Wilder came out to take care of them, and baby Rose was taken into town to Ma and Pa. "She is the best girl I ever saw," Grace wrote in her little diary. "She can now say a good many words such as gramma and grampa and bread and butter and cracker." But Laura and Almanzo lay so sick they nearly died.

Almanzo especially felt the darkness of these days. He forced himself up from his sickbed and suffered a stroke. It left him partially paralyzed: he couldn't lift his feet over a plank on the ground; he couldn't move his hands with ease, until inch by painful inch he taught himself how to do so again. He was stubborn, and he fought, but his strength had left him. He was only thirty years old, and he could not do a whole day's work. For the rest of his long life he shuffled as he walked, and leaned sadly on a cane.

The shadows lengthened. Laura had another baby in the summer of 1889. It was a boy, and he looked just like Almanzo. Laura hadn't thought to pick a name for him, and had no need to. In twelve days the baby was dead, of convulsions. For the first time Laura made the long journey to the cemetery southwest of town, near Reverend Brown's claim, and there her baby boy was laid to rest without so much as a name.

Less than two weeks later, on August 23, Grace had another entry for her diary:

Last friday Manly's house caught fire and burned to the ground. The furniture in the front room and in the bed room and pantry was saved but nothing in the kitchen where the fire started. Laura had just built a fire in their stove went into the other room and shut the door so she could sweep when the noise of the fire startled her and on opening the door she saw the roof and side of the kitchen was on fire . . . help soon came but they could not save the house and only some of the old clothing was saved they stayed down here for a while and then went to keep house for Mr. Sheldon one of their neighbors taking a hired girl with them.

From the kitchen Laura actually saved one thing—a glass bread plate with a shock of wheat in the center and on the rim the words: Give us this day Our daily bread.

They built a two-room shanty to live in, or had one built. But the crops had failed. The winds blew hard and hot from the south, the prairie withered, dust whipped up into the air. "There was a great wind storm last week," Grace wrote one day, "the dust was so thick the houses on the other side of the street could hardly be seen. The prairie got on fire and a great many people were burned out and some burned to death."

These were desolate times, and when Laura wrote about them anguish echoed in her words. But looking back, she saw what they had taught her.

"There were dry years in the Dakotas when we were beginning our life together," Laura wrote many years later. "How heart breaking it was to watch the grain we had sown with such high hopes wither and yellow in the hot winds! And it was back breaking as well as heart breaking to carry

water from the well to my garden and see it dry up despite all my efforts.

"I said at the time that hereafter I would sow the seed, but the Lord would give the increase if there was any, for I could not do my work and that of Providence also by sending rain upon the gardens of the just or the unjust."

In the furnace of hard times she came to learn the last lesson of growing up—that men and life have their limits, that there are dreams enough in simple things. She came to know the cost and eventually the comfort of the self-sufficient spirit.

These first hard years drove Laura and Almanzo from Dakota. In a spring that was both cold and dry—the spring of 1890—Almanzo sold the flock of sheep Laura had bought with money earned by teaching school. The sheep had undergone a natural increase, and the profit was handsome. But still the winds rattled on the prairie. "Such dredful sandstorm as we have here," Grace exclaimed, "they come up just as a rain storm and it blows, and blows, and blows, all the time." Peter Ingalls, Laura's cousin, had been in DeSmet and helped Almanzo on the claim, doing work Almanzo could not do. He too would go. In town there were "Italians and beggars." Grace again:

> a little while ago one of them came along with cinnamon bear a great ugly looking brute for ten cents he would perform, Mrs. Brunnell paid half and pa the other, he danced, turned springs and everything else. The man sang when the bear danced.

But Laura and Almanzo could not sing. There was nothing in Dakota to lighten their hearts.

It was May before they finally got away—Laura and Almanzo, Rose and Cousin Peter. They drove the stock and they had a covered wagon, although Laura rode her "pretty poney." The plum trees were in bloom, but the air was filled with the scent of broken promises.

The road took them east past Volga and Brookings and back along the way that Pa had come so long ago, past Plum Creek and Walnut Grove, eastward through the green meadows of eastern Minnesota to the farm where Almanzo's parents lived: Spring Valley. There they rested. After a time, Peter left them—sailing down the Mississippi with Al-

manzo's younger brother, Perley Day, for adventures of
his own.

After a time, Laura and Almanzo and Rose left too—on
the train, bound for the salty coast of far-off Florida. Past
the great farms and cities of the Middle West, through the
red fields of the southland, the train carried them at last
to the piney woods of the Florida panhandle, hoping for
health and a small cup of happiness. They settled in the
tiny village of Westville. It was a place, Laura wrote, "where
the trees always murmur, where butterflies are enormous,
where plants that eat insects grow in moist places and alli-
gators inhabit the slowly moving waters of the rivers. But
at that time and in that place a Yankee woman was more
of a curiosity than any of these." She carried a silver re-
volver.

That time, in that place, they didn't find what they sought.
They were gone two years. Almanzo moved about a little
easier, but Laura grew ill—wilted and worn down by the
damp climate near the coast. There was no place to go now
but home, and no home to go to but Dakota. And that was
where they went, arriving in time to observe their seventh
wedding anniversary.

They found the prairies brown and dead. In the dread,
drought years their finest dreams had withered and gone
dry.

Pa and Ma lived in town, in a white frame house Pa had
built on Third Street near the church. They had moved in
on a Christmas Eve before Laura and Almanzo left for the
East. It was the last move Pa ever made. The claim south
of town was rented out. Once Laura had raced there in the
wind, and watched the prairie grasses sweep in ever distant
waves toward the sun. Now strangers lived there, and
worked the dry land.

Mary had long since graduated and come home from
college. In the summer Laura came home with Almanzo,
Pa and Mary had made a long trip by train to Chicago.
There Mary had undergone delicate surgery on the nerves
of her face, to ease the severe pains of neuralgia that so
often tested her patience and her peaceful spirit. Now she
sat in the darkened parlor, doing handwork, in silence.
Carrie was already a young woman, twenty-two years old,
and she worked in the back of the newspaper office in town,
setting type. She was learning to be a printer. Grace was

fifteen, fresh and jolly from being a schoolgirl, and already growing fat. Like Carrie and Mary, she lived at home. For a time Pa had a little general store in the heart of town. For a time he sold insurance. Mostly he did carpentry work.

Laura and Almanzo moved into a rented house near Ma and Pa in town. Some days she could stand at the window and see Pa walking down the street, thin and alone, with his carpentry kit. The happy songs, the little houses, the carefree wandering, the golden years—all these seemed to be a long, long time ago.

Laura didn't like town and she didn't like to sew. But she lived in town—although she told Rose they were only "camping"—and took a job with a dressmaker, perhaps with her old schoolmate Hattie Dorchester, who herself was a dressmaker. Almanzo found odd jobs to do, sometimes carpentry, sometimes driving teams, sometimes clerking in a store. Rose started school, smart as a whip.

In the months that followed Laura once again lived on the edge of hope. Six days a week she bent to her work at the dressmaker's. Little by little she saved. When she and Almanzo had saved enough, they were going away. They were going to start over, in a place far away from the hot winds and dusty prairies of Dakota. They were going to the Land of the Big Red Apple, with what Rose would one day call the courage of despair.

Their time came on a hot day in July, 1894. Almanzo's two-seated hack was painted black and covered with oilcloth and loaded with all their worldly goods. Rose crawled in the back, Laura and Almanzo sat up front, and on every side there were goodbyes, goodbyes, from Ma and Pa and Mary and Carrie and Grace. Laura didn't like to think of it, but perhaps they would never meet again. And then they were gone, out across the brown and thistly prairie south of town.

At their backs, dust storms rose into the Dakota sky. Each night, Laura wrote in her little journal—of Russians and rainstorms and crops and clear rivers. Emigrants were everywhere, uprooted by the wind and the drought and the financial panic. Some were going north, others south; some were going west, others east. All followed the same small flicker of hope, that somewhere else things would be better. Almanzo's wagon rolled on into Nebraska, and then Kansas, and then into the Missouri hills, past persimmons and

paw-paws, peaches and plums, into what seemed to be a land of plenty.

"We were looking for a place where the family health might make a good average," Laura explained many years later when she had made the Ozarks her home, "for one of us was not able to stand the severe cold of the North, while another could not live in the low altitude and humid heat of the Southern states.

"It was before the days of 'Tin Can Tourists' "—that's what Laura called folks who drove around in automobiles—"and we traveled with a team and covered wagon. It was rather unpleasant journeying in the heat of the summer, but as we climbed into the hills this side of Springfield, the air grew fresher and more invigorating the farther we went until . . . we found the place we were seeking, far enough south so that the winters are mild; high enough for the air to be pure and bracing; sheltered in the hills from the strong winds of the west, yet with little breezes always blowing among them; with plenty of wood for fuel and timber and rocks for building; with low lands for cultivation and upland blue-grass pastures for grazing; with game in the woods and fish in the rivers; and springs of pure, cold, mountain water everywhere.

"Here on the very peak of the Ozark watershed are to be found good health, good homes, a good living, good times and good neighbors. What more could anyone want?"

Laura whistled, just like Pa—Rose remembered that. The wagon creaked up the ridges from Springfield, through the little village of Seymour, into the mountain town of Mansfield, and Laura whistled and whistled. She was coming home to her dreams.

They camped in the woods near town, and Laura and Almanzo went to search out a farm. Soon enough they found it, a mile east of Mansfield.

"The place looked unpromising enough when we first saw it," Almanzo remembered, "not only one but several ridges rolling in every direction and covered with rocks and brush and timber. Perhaps it looked worse to me because I had just left the prairies of South Dakota where the land is easily farmed. I had been ordered south because those prairies had robbed me of my health and I was glad to leave

them for they had also robbed me of nearly everything I owned, by continual crop failures.

"Still coming from such a smooth country the place looked so rough to me that I hesitated to buy it. But wife had taken a violent fancy to this particular piece of land, saying if she could not have it she did not want any because it could be made into such a pretty place.

"It needed the eye of faith, however, to see that in time it could be made very beautiful."

Laura had the eye of faith, as well as the "violent fancy"—what a wonderful juxtaposition of words. With hard work and the passage of years, Laura and Almanzo turned this scrawny ridge land into what was for them a small paradise, ringing with the sound of redbirds and cool in its green shadows and sharp slopes, making it their home for the rest of their days. They called it Rocky Ridge Farm.

When they bought the land, only four of the forty acres had been cleared, and these had been planted in apple trees. Among the young trees was a little log house with a fireplace and no windows. It is no wonder Laura loved it, it was so much like the little houses she had lived in all her life. She sent Rose down the road to school, and Laura and Almanzo pitched into the work of making a home.

"It was hard work and sometimes short rations at the first," Almanzo admitted, "but gradually the difficulties were overcome." They cleared land and planted twenty more acres of apple trees. They picked up rocks and carted them off in a wagon. Neighbors helped them build a log barn and a henhouse, and then Laura and Almanzo thinned out the timber around the buildings. They sowed seed for pastures and meadows.

"The garden, my hens and the wood I helped saw and which we sold in town took us through the first year," Laura said. "It was then that I became an expert at the end of a crosscut saw and I still can 'make a hand' in an emergency." Almanzo told her that he "would rather have me help than any man he ever sawed with." But after all, Laura could work like a little French horse. It was like old times, helping Pa.

The years began to fly—years of sunshine and hard work. The farm grew from the forty acres they began with to two hundred acres. They raised hogs and sheep and Jersey cows and goats. Almanzo bought a Morgan horse, a bay called

"Governor of Orleans." It was the smartest breed of horse he knew of, and he hoped to improve Ozark horses by breeding them to the Morgan. Laura looked after the Leghorn hens, among her other chores, and when a neighbor lady searched for the perfect compliment to pay her, she said of Laura: "She gets eggs in the winter when none of her neighbors gets them." With the farm fairly established—it took them only two years to put it on a paying basis—Almanzo could hardly believe his eyes.

"When I look around the farm now," he said, "and see the smooth, green, rolling meadows and pastures, the good fields of corn and wheat and oats; when I see the orchard and strawberry fields like huge bouquets in the spring or full of fruit later in the season; when I see the grape vines hanging full of luscious grapes, I can hardly bring back to my mind the rough, rocky, brushy, ugly place that we first called Rocky Ridge Farm."

That of course would have taken the eye of faith, which Laura had. The farm was fruitful, and so now was her life with Almanzo. She often walked over the hills to town, carrying fresh butter and produce for which she got good prices. By keeping the name of Rocky Ridge for the land they tamed together, Almanzo said, it "serves to remind us of the battles we have fought and won."

The house at Rocky Ridge was a battle in itself, and triumphantly won. It grew over a period of twenty years, a dream slowly being realized, a promise fulfilled. When at last it was completed it was large and comfortable and had been built entirely from material on the farm itself. Like Laura, it grew from the soil and circumstances of these pioneer days.

Almanzo began by building a one-room frame house near the little windowless log cabin that had come with the place. He and Laura felled the trees, cut and planed the boards themselves, and built the little house together. In front of the house was a gentle sloping meadow in which giant oak trees stood as sentinels. Behind the house was a deep ravine, and behind that was the high shoulder of a hill. The one-room house one day became the kitchen of a larger house, which itself grew year by year and room by room.

Next to the kitchen were a dining room and a sitting room, with a screened-in porch to the right and a door to the left leading into the back bedroom. In the far corner

of the house, through the bedroom, was a tiny windowed study, full of light and sunshine. An oak staircase led upstairs to a storeroom and two more bedrooms, and a landing led through to the spacious living room with its window seat and its comfortable furnishings and its ceiling lined with heavy oak beams, which Laura and Almanzo cut and hewed and set by hand. At the far end of the parlor was a magnificent fireplace made with stones from the farm, and a walk-in library of bookshelves no higher than Laura's head. The last room was a formal dining room, and there one day would stand the organ that Pa and Ma and Laura had bought so long ago for Mary.

Of all the features of the house at Rocky Ridge—and it bore many marks of Almanzo's inventive mind—perhaps the most pleasing to Laura were the spacious windows, for they opened her view to the world she had loved as a child. The four great windows of the parlor framed "landscapes of forest and meadow and hills curving against the sky." The curtains hung straight, the glass was always uncovered.

"I don't want curtains over my pictures," Laura would say. "They're never the same for two hours together, and I like to watch them changing."

In the kitchen was a window with a special purpose. "She hates kneading bread," Rose said. "All her life she has hated it, and baked twice a week. So the window is there. She forgets the kneading in looking at the sheep pasture. She has windows everywhere," Rose added, "not only in her house, but in her mind."

If the view from Laura's windows was forever changing, so too was Laura's life. The farm grew prosperous. Rose was growing up. The century in which Laura had been born came to an end, and a new century began—full of hope and light. Long ago Laura had walked with Mary on the prairies of Dakota; the sun had gone down and blue shadows filled the land between the waves of prairie grass, and they had decided that everything changes. Nothing stays the same. That was a part of growing up.

But in the spring of 1902 came a change that Laura did not expect. From the far-off prairies of Dakota came a message she did not want to hear. Pa was sick. Pa was going to die.

Laura left Rocky Ridge in a rush. She made her way from one train to another across Kansas and Nebraska and Dakota

to DeSmet. It was a long way to go, and she didn't have much time. Now she hurried, she hurried home, as though across the prairie she could hear—ever so faintly—the last fading song of a honey-brown fiddle, a word, a bright whistle in the night.

For all the years that Laura had been gone, Pa had lived in town with Ma and Mary and Carrie and Grace. He was a townsman. He roamed no more.

But surely, as she rushed for home, Laura saw him elsewhere—on the bench in front of the fire in the Big Woods, and in the wagon on the ice across Lake Pepin, and in the proud and golden field of wheat along the banks of Plum Creek, before the grasshoppers came. Surely she saw him come home happy from the harvest in the East, and felt his hand hold hers on the long walk across the prairie to church in Walnut Grove. Surely she saw him on the prairies, pitching hay into the dusty wagon where she stood, and in the store in town, his face thin, his fist upraised against the moaning blizzard wind. Surely, in her mind's eye, she saw the blue twinkle in his.

On a Sunday afternoon, June 8, 1902, at three o'clock, Pa died. Laura was there, at his side. She had come home in time. Pa was buried in the prairie graveyard where Laura's unnamed baby lay.

And today, on the low swell of prairie southwest of town, Pa lies there still. Even when the other trees are bare, the pines there catch the prairie wind, and whisper, and sigh.

In summer the sun leaps high into the sky. Overhead it burns without mercy. It sets in flames, far away to the west. In winter the blizzards come, straight and white and blinding. The prairie turns white, and snow skids and swirls over the little prairie knoll. In the summer, in the winter, in the cold spring, in the hazy harvest time, the slow seasons turn over Pa's grave. And above him, the tiny needles of the pine trees catch the prairie wind, and they whisper, and they sigh. They whisper for distances, they sigh for auld lang syne.

Laura went home to Almanzo. She was thirty-five years old, and she was the farm wife she once thought she never could become.

Very likely it was that summer that Eliza Jane, Almanzo's sister, came up for a visit to Rocky Ridge Farm from her

home in Louisiana. It had been a long time since Laura had written her little poem about "Lazy, lousy Liza Jane." Eliza Jane had married and had a son—she gave him a rough, manly name: Wilder—and had become a widow. When she left Rocky Ridge she took Rose with her, back to the town of Crowley in Louisiana where the high school was larger and better than the one in Mansfield. Rose was happy to go.

"No one can tell me anything about the reasons why young people leave farms," Rose said when she had grown up. "I know them all—the drudgery of farm tasks; the slavery to cows and pigs and hens; the helplessness under whims of weather that can destroy in a day the payment for a year's toil; the restlessness of ambition with its sense of missing, on a farm, all the adventures and rewards that one dimly feels are elsewhere. Stronger than these, there is the lure of material things, and of satisfied vanities."

So Rose went, and became a brilliant scholar, and Laura and Almanzo were left alone at home, knowing the "warm, feathery feeling" of the henhouse, caring for the cows and sheep, meeting each demand of every day of life on the farm. From a distance they followed Rose's career as a telegrapher, as a businesswoman in California, and then as a newspaper writer and correspondent. Before long Rose was famous, and her travels took her far away to places Laura could only dream of, to New York and London and Paris, to Prague and Vienna, to Rome and Athens and Constantinople, to Cairo, Tiflis, Damascus, and Bagdad.

Once, during these early days of Rose's career, Laura and Almanzo were given the chance to sell the farm on Rocky Ridge and move to the city of Saint Louis. Rose urged them to go.

"I was a newly grown up daughter," she remembered with a little laugh, knowing the laugh was on her, "and if that alone had not made me feel infinitely wiser than my parents, my city experience would have done so. They were dears, but they couldn't know as much as I did. I took their life in hand and splendidly made it over in every detail; I knew exactly what they should do and exactly how they should do it. The only difficulty with my plan was my parents. They wouldn't move."

After the cozy rambling house was finished at Rocky Ridge, only once did Laura and Almanzo move from it. "I have a fancy," Laura had said so often, "that a farm home

should seem to be a product of the soil where it is reared,
a permanent growth as it were, of conditions surrounding it,
wherever this is possible, and nothing gives the effect more
than a house built of rocks from the fields." So Rose had a
little fieldstone house made for Laura and Almanzo across
the ravine and through the woods a short distance from
the big frame house. And there Laura and Almanzo moved.
But not for long. They soon moved back to the house they
had built themselves, with the slow tedious work of years,
and Laura told her friends, "I was homesick."

Laura was always homesick, although once—when Rose
was writing for a newspaper in San Francisco—Laura made
the long railroad trip across the country alone to see her and
to marvel at the great Panama-Pacific Exposition and China-
town and the Golden Gate. The year was 1915, and Laura
faithfully sent postcards and letters home to Almanzo, telling
him of the things she had seen and done (she fell off a bus).
She stood at the very edge of the continent, on the shore
of the Pacific with the waves rolling in at her feet, and she
seemed to see into eternity:

> I looked over the waters as far as my eyes could reach
> until the gray of the ocean merged with the gray of
> the horizon's rim. One could not be distinguished from
> the other. Where, within my vision, the waters stopped
> and the skies began I could not tell so softly they blended
> one into the other. The waves rolled in regularly,
> beating a rhythm of time, but the skies above them
> were unmeasured—so vast and far reaching that the
> mind of man could not comprehend it. A symbol of
> time and eternity—time spaced by our counting into
> years, breaking at our feet as the waves break on the
> shore, and eternity, unmeasurable as the skies above
> us—blending one into the other at the fartherest reach
> of our earthly vision.

When she came home, Almanzo was impressed—not with
time or eternity, but with how much work there was to do
when Laura was away. "If any man thinks housekeeping is
easy work and not all a woman ought to do," he declared,
"just let him roll up his sleeves and tackle the job!" While
Laura was gone, someone had stolen the grapes; the dog
had been sick.

"Mrs. Wilder is a woman of delightful personality," a neighbor said in admiration, "and she is a combination of energy and determination. She always is cheery, looking on the bright side. She is her husband's partner in every sense and is capable of managing the farm. No woman can make you feel more at home than can Mrs. Wilder, and yet, when the occasion demands, she can be dignity personified." Because Laura was so often exuberant and impulsive, because she took a "violent fancy" to things, she always seemed to be her father's daughter. But she also had Ma's ladylike respect for what was proper. Like many people who are not pushed in among the crowds of city strangers every day, she was often shy and somewhat distant.

These quiet times came midway between the hard years of Dakota and the happy years in which she mined her memory for the stories of the *Little House* books. When Laura went west to visit Rose, she was forty-eight years old. She had already reached middle age, that balancing point in life from which many people look backward with less than satisfaction and forward with less than hope.

But Laura was happy, and she seemed always to look forward with hope. Her life was anchored in the success she and Almanzo had made of the farm at Rocky Ridge, in its quiet ways and places, in the moments she put aside from her busy chores to reach out and touch the face of nature she had always adored. The hard shadowed years at the beginning of her life with Almanzo had tutored her in the paths of simplicity, and in her own memory she held the most vivid remembrances of her life as a pioneer girl with Ma and Pa and Mary. She was never far from the sweet, lonely sound of Pa's fiddle, or the feel of the wagon as it rolled on and on beneath the prairie sky.

Laura looked around her and she thought she saw "a madness in the cities, a frenzy in the struggling crowds"— her words. "We who live in the quiet places," she realized, "have the opportunity to become acquainted with ourselves, to think our own thoughts and live our own lives in a way that is not possible for those who are keeping up with the crowd.

"In thine own cheerful spirit live," she said:

Nor seek the calm that others give;
For thou, thyself, alone must stand

Not held upright by other's hand.

She found her rest in the quiet purposes of Rocky Ridge, far from crowds. "I have never lost my childhood's delight in going after the cows," she said. "I still slip away from the other things for the sake of the walk through the pasture, down along the creek and over the hill to the farthest corner where the cows are usually found. . . . The voices of nature do not speak so plainly to us as we grow older, but I think it is because, in our busy lives, we neglect her until we grow out of sympathy. Our ears and eyes grow dull and beauties are lost to us that we should still enjoy.

"Life was not intended to be simply a round of work, no matter how interesting and important that work may be. A moment's pause to watch the glory of a sunrise or a sunset is soul-satisfying, while a bird's song will set the steps to music all day long."

Laura's eyes of course were never dull, and she was never out of sympathy. Sunrise, not sunset, was her favorite time, and Rose—home once on a visit to Rocky Ridge—told how Laura greeted the morning.

"Outside the barn the morning was gray," Rose wrote, "and as I came up the path I was surprised to see my mother, wrapped in a shawl, standing outside the kitchen door. 'Hurry!' she called to me. 'It's changing every second!'

"The barn behind me was black against a rosiness in the east, but it was not the sky she wished for me to see. It was the evanescent colors, the lights and shadows subtly changing down the length of the valley at the coming of the dawn. We stood and watched them silently till the rosy sky faded to the color of water, and sunshine came yellow across the fields. A new day was there, a day as fresh and miraculous as though it were the first that ever dawned, and a chill little wind that ran before it went westward, followed by a promise of warmth."

Later in the morning, when the rolls had come piping hot from the oven and breakfast had been eaten, Laura asked Rose if she had ever in her life seen such beauty as the Ozark dawn coming up over Rocky Ridge. "Some morning early, when I can get away," Laura said, "I want you to come with me along the edge of the hill in the woodlot. When the shadows of the trees begin to come down the slope, as the

sun rises you feel the turning of the earth. You feel the whole globe under your feet rolling into the sunlight."

For Rose it was difficult to say whether she had ever seen such a beautiful sunrise, she was so cosmopolitan. In twenty years she had seen only four sunrises—over the markets of Paris, between the minarets of Constantinople, above the Red Sea, over the Syrian desert. Four dawns, twenty years. But for Laura the sun came up every day over Rocky Ridge and the farm she and Almanzo had made with the work of their hearts and their hands, every day over their home in the wooded hills and their life together. Beneath her feet, the world was always turning toward the sunlight.

"At long last," Laura said, thinking back on their first dark years of life together, "I am beginning to learn that it is the sweet, simple things of life which are the real ones after all. . . . I believe we would be happier to have a personal revolution in our individual lives and go back to simpler living and more direct thinking. It is the simple things of life that make living worth while, the sweet fundamental things such as love and duty, work and rest and living close to nature."

Life is complicated; people hurry and seem helpless. "Notice the faces of the people who rush by on the streets or on our country roads," she said. "They nearly all have a strained, harassed look and any one you meet will tell you there is no time for anything anymore." But that wasn't the way she wished to live. "The true way to live," Laura said, "is to enjoy every moment as it passes and surely it is in the everyday things around us that the beauty of life lies." And once, when she had a large audience, she recommended "a good New Year's resolution for all of us to make: To simplify our lives as much as possible."

If sunrise was Laura's favorite time of day, autumn was her favorite season. It meant a summing up, a taking stock. It meant for Laura an invisible harvest.

She saw its beauty: "There is a purple haze over the hill tops and a hint of sadness in the sunshine," she wrote, "because of summer's departure: on the low ground down by the spring the walnuts are dropping from the trees and squirrels are busy hiding away their winter supply. Here and there the leaves are beginning to change color and a little, vagrant, autumn breeze goes wandering over the hills and down the

valleys whispering to 'follow, follow,' until it is almost impossible to resist."

But as Laura and Almanzo filled the barn and the bins and the cellar with the harvest of the season, she also saw a need "to reckon up the invisible, more important harvest." "As a child," she said, "I learned my Bible lessons by heart, in the good old-fashioned way, and once won the prize for repeating correctly more verses from the Bible than any other person in the Sunday school. But always my mind had a trick of picking a text here and a text there and connecting them together in meaning. In this way there came to me a thought that makes the stores from my invisible harvest important to me. These texts are familiar to everyone. It is their sequence that gives the thought."

Laura's texts were these:

Lay not up for yourselves treasures upon earth, where moth and rust doth corrupt, and where thieves break through and steal. But lay up for yourselves treasures in Heaven, where neither moth nor rust doth corrupt, and where thieves do not break through nor steal.

And then:

Why say ye, Lo here and lo there. Know ye not that the kingdom of Heaven is within you?

By this she meant to say that it is in the heart and character of every person that the most important harvest of the year is to be measured. "Right seems to be obscured and truth is difficult to find," Laura said. "But if the difficulty of finding the truth has increased our appreciation of its value, if the beauty of truth is plainer to us and more desired, then we have gathered treasure for the future.

"We lay away the gleanings of our years in the edifice of our character, where nothing is ever lost. What have we stored away in this safe place during the season that is past? Is it something that will keep sound and pure and sweet or something that is faulty and not worth storing?" The treasure Laura gathered poured forth in both her books and her life.

All these years of sunshine and work at Rocky Ridge, Laura wrote for newspapers. First it was the Missouri *State Farmer*, and then the Saint Louis papers, and finally for the

longest time the Missouri *Ruralist,* a farm paper. She reported on neighboring farms, and on people who'd made a successful fight against the briar-covered hills and the uncertainties of life and weather. For some time her little articles appeared in a column called "The Farm Home." But as the editors saw more of what she could do, and as her own skills were sharpened, they made a new department for her and called it "As a Farm Woman Thinks."

For Laura it was an opportunity to both write and think, and to bring together her thoughts in small bouquets of essays—sometimes short, sometimes long—that had the fresh fragrance of the fields and the beauty of a mind at peace. Some were homilies—on motherhood, on home, on the haste of life—and might today seem archaic and old-fashioned. Yet they were touchstones to her character, and the vestments in which she clothed her thoughts were those of her own particular experience. She had found by then, and insisted ever after, that no matter how simple they seemed or how old-fashioned they appeared, there were some thoughts and values worth preserving and passing on. She didn't lean on the past as much as she used it to force herself and her readers into a more fruitful, coherent vision of life.

One day Laura and Almanzo sat by a cozy fire in the parlor at Rocky Ridge and complained good-naturedly to each other that there was not time for anything in life except work. They thought back on the days when people always seemed joyful and happy. "I was wishing," Laura remarked, "that I had lived altogether in those good old days when people had time for the things they wanted to do."

For a long time Almanzo was silent. Then he spoke up, remembering aloud all the work Father Wilder had had to do on the farm and all the work Mother Wilder had had to do in the house. There was so much work it didn't stop at supper or sundown, but carried over into darkness. Laura thought back to the way Ma so often sat rocking by the fire, sewing or knitting long into the evening, when the world outside had fallen into silence and darkness—not because she wanted to, but because the work was there to be done.

"Surely," Laura thought, "the days and nights are as long as they ever were. Why should we need extra time in which to enjoy ourselves? If we expect to enjoy our life we will have to learn to be joyful in all of it, not just at stated intervals, when we can get time, or when we have nothing else

to do. . . . A feeling of pleasure in a task seems to shorten
it wonderfully and it makes a great difference with the day's
work if we get enjoyment from it instead of looking for all
our pleasure altogether apart from it, as seems to be the
habit of mind we are more and more growing into."

In the summer before Ma died, Laura found herself walk-
ing alone in the meadow at Rocky Ridge. "I picked a wild
sunflower," she said, "and as I looked into its golden heart
such a wave of homesickness came over me that I almost
wept. I wanted mother, with her gentle voice and quiet firm-
ness; I longed to hear father's jolly songs and to see his
twinkling blue eyes; I was lonesome for the sister with whom
I used to play in the meadow picking daisies and wild sun-
flowers.

"Across the years, the old home and its love called to me
and memories of sweet words of counsel came flooding back.

"I realized that all my life the teachings of those early days
have influenced me and the example set by my mother and
father has been something I have tried to follow, with fail-
ures here and there, with rebellion at times, but always com-
ing back to it as the compass needle to the star."

Memories came flooding back. For the newspaper, Laura
had sometimes written about her life as a pioneer girl—going
to school in the Big Woods, wandering home after the cows
in Minnesota, walking to Sunday school with Pa along the
flowered path by Plum Creek, teaching at the Bouchie school
on the blizzard prairies of Dakota. These years seemed so
distant, for Laura was already nearing sixty. But with each
passing year, they rose more fresh than ever in her memory.

Death soon deepened her dependence on them. Ma died
at DeSmet on Easter Sunday in 1924, in her eighty-fifth year.
Like a moth around the candle flame of necessity, her life
for many years had centered upon Mary, because Mary was
blind. In those years since Pa's death, Ma and Mary had
lived alone in the little house on Third Street.

Carrie's career as a printer had taken her all across
Dakota, managing newspapers in small towns, and in the
Black Hills she had met and married David Swanzey, the
owner of a gold mine and a widower with two small children
to look after. Grace had married even earlier, in the fall
before Pa died. Her husband was Nathan Dow, the son of
early Dakota homesteaders. Carrie and Mr. Swanzey lived

in the Black Hills, but Grace and Mr. Dow lived on a farm only seven miles from DeSmet, and when Ma began to fail they moved into the house in town with Ma and Mary. They were there when Ma died that Easter Sunday, although Laura doesn't seem to have gone up to DeSmet for the funeral.

Caroline Ingalls had been above all else a steadfast woman. She was ingenious and independent, quick-witted and firm in her insistence that her daughters have the advantage of a good home. As devoted as she was to Pa—her devotion carried her through hardships and wandering a lesser woman would not have endured—it was she who did the most to provide that home she always sought. Ma's life was one long devotion, to Pa, to the establishment of a home secure from the storms and tempests of the world, to her children. Pa was the poetry of life to Laura, and he made her heart sing. Ma was constancy and enduring love, and Laura owed more to her than perhaps even she could acknowledge.

Without the familiar anchor of her constant presence, Mary died little more than four years after Ma did, on October 17, 1928, following a succession of strokes and sicknesses. Thus came to an end a life that had been lived in quiet courage and acceptance. Mary was in the Black Hills when she fell sick, and she died at Carrie's home in Keystone. But she was brought home to DeSmet, and was buried in the little prairie graveyard where the endless prairie winds already blew over the graves of Ma and Pa.

These winds carried whispered songs for Laura, and memories of auld lang syne. More than ever she knew the truth of her feeling when Mary had first gone away to the School for the Blind so many years before: everything changes, nothing ever stays the same. More than ever in her quiet moments, the memories and lessons of her life as a prairie girl played upon her thoughts.

In the world around her, the gaiety and the gilded hopes of the 1920s were giving way to economic depression and collapse. In the cities there were bread lines, on the farms there was hunger, and everywhere people were asking, What is America? Is this the promised land? In her own family, only Laura and Carrie and Grace were left, and they were separated by great distances from one another. Laura herself was growing gray.

When Ma died, and then Mary, Laura began to slow down her own busy schedule. She stopped writing for the newspaper. For many years she had helped to organize women's clubs, giving farm women a chance to stretch their minds and learn new things and enjoy some respite from their hard round of chores and housework. These activities she had long since given up, although she continued as a member of several Mansfield clubs. For twelve years she had been the secretary and treasurer of the local branch of the Federal Loan Bank, handling millions of dollars in loans to Ozark farmers. This too was behind her now. Soon she and Almanzo would begin to sell off parcels from their farm at Rocky Ridge.

In 1930, Laura was sixty-three years old; Almanzo was ten years older. Laura helped with the chores and cooked and swept and baked and kneaded bread, and stood for a long time at the window in her kitchen, lost in thought. Whatever had become of Clarence Huleatt and his shoes with copper toes? And Soldat du Chene—what trails did his sons ride beneath the hard western sun? Did blue flags still grow in the meadow at Burr Oak, and was another girl there now, going after the cows and turning her toes in the cool, lush grass? What of the dugout on Plum Creek? Had spring floods carried it away? Or did cattle live there now? And Cap Garland, with his crooked smile and his golden hair—where had he gone?

Cap Garland was dead. Uncle Henry was dead, and so was Uncle Peter. Grandma Ingalls was dead, and Grandpa too. And Pa. And Ma. And Mary. Somehow, Laura thought, the things they did, the dreams they had, the lives they lived should not die. They should be remembered.

So one day Laura went into her little corner study, where the sunlight streamed in the south window and the exquisite little desk stood in the corner, open. She put her back to the window and on a thick tablet of school paper she began to write. She wrote in pencil, from one side of the paper to the other, without a margin. She wrote because Rose asked her to. And there in the quiet corner study Cap Garland came to life, and a ball sailed through the schoolyard air. And Pa, with his hair woozled up and a ferocious growl in his voice; and Ma, standing in a lonely little house with two Indians and the smell of skunk all around; and Mary, boasting of her golden hair—they were alive again.

Laura was about to reap the last, rich, and unexpected reward of a life well-lived: her *Little House* books, with their enduring stories of her prairie girlhood.

"When I began writing children's stories, I had in mind only one book," Laura once said. "For years I had thought that the stories my father told me should be passed on to other children. I felt they were much too good to be lost. And so I wrote the *Little House in the Big Woods*.

"That book was a labor of love and is really a memorial to my father."

It was 1931 when Virginia Kirkus, an editor at Harper's in New York, received the manuscript of *The Little House in the Big Woods*. She read it in a hurry as the train carried her home to Connecticut, and Laura's story carried her back to pioneer days of long ago. She rode right past her station. But she realized with a flush of excitement that she held in her hands "the book that no depression could stop." It was published the following year and just as quickly was acclaimed by critics the country over. Almost overnight, Laura found herself famous as an author.

"I thought that would end it," Laura said, when her book was published. "But what do you think? Children who read it wrote to me begging for more. I was amazed because I didn't know how to write. I went to little red schoolhouses all over the west and I was never graduated from anything."

If Laura did indeed believe that one book would end it, she was woefully wrong. The publisher wanted more, and so did her readers. Alone in her little study at Rocky Ridge, Laura's mind wandered back among the most happy memories. "I have learned in this work," she said, "that when I went as far back in my memory as I could and left my mind there awhile it would go farther back and still farther, bringing out of the dimness of the past things that were beyond my ordinary remembrance. Also, to my surprise, I have discovered that I have led a very interesting life." Her pencil moved slowly from edge to edge of the tablets of lined paper, and book by book came the stories of Ma and Pa and Mary and Laura in the pioneer days of America.

Her next book was *Farmer Boy*, but when Laura submitted it to the publisher in the fall of 1932 it was rejected and returned to her with a request for a complete revision. The revision was accepted the following spring, and later the same year readers learned about Almanzo's boyhood long

ago. Then in a steady succession came *Little House on the Prairie* in 1935, *On the Banks of Plum Creek* in 1937, *By the Shores of Silver Lake* in 1939, *The Long Winter* in 1940, *Little Town on the Prairie* in 1941, and *These Happy Golden Years* in 1943.

"There is a fascination in writing," Laura said in a talk she prepared while she was writing about her life on Plum Creek. "The use of words is of itself an interesting study. You will hardly believe the difference the use of one word rather than another will make until you begin to hunt for a word with just the right shade of meaning, just the right color for the picture you are painting with words. Had you thought that words have color? The only stupid thing about words is the spelling of them."

She may have had gray hair, but she was still the same old Laura.

So many letters from the children who read her books touched Laura's heart, and she tried to answer them all. Her stories carried such a ring of reality and truth that those who read them felt they knew her, and they wrote to Laura as though she were an old friend.

When Laura had finished the manuscript of *By the Shores of Silver Lake* in 1939, the first of her Dakota books, Almanzo suggested that they go home to DeSmet for Old Settler's Day. Laura liked the idea, and they soon set off for the little town on the prairie. Laura's account of their visit was later published in the *Christian Science Monitor*—a delightful portrait of Laura in her seventies and Almanzo in his eighties, going home to the happy golden years:

It was the first of June. The days were lovely, warm, going-somewhere days, and one morning, when the blue haze hung over the Ozark Hills, Almanzo said, "Let's go back to DeSmet, for the Old Settlers Day Celebration. I would like to see the old place and folks we used to know."

"Let's do," I agreed eagerly, for I had just finished writing "By the Shores of Silver Lake." "We could see the homestead Pa took so long ago and Carrie and Grace."

Friends thought we should not take such a trip by ourselves. We ought anyway to have a driver. They

were very tactful, but their idea was that we were too old to go so far from home alone.

We don't think that seventy-three or eighty-two is old and we object to being taken care of.

Almanzo said, "I have driven horses all over that country and the roads to it, and I can drive a car there."

"I rode behind those horses with you and I can still ride wherever you can drive," I answered.

So we told the man, who lives on our farm, that we were leaving and didn't know when we would be back. He was very kind and promised to take care of everything while we were away.

Then, one early morning, we packed our bags, put them in the trunk of the Chrysler, said goodbye to our pet bulldog and started for South Dakota and the Land of Used-to-be.

It was still early in the morning when we came to Springfield, fifty miles away.

Going into Springfield we took the wrong turn and were some time finding the street leading to the highway we must take. A little way and the street detoured. We took the detour and went on and on.

"Haven't we gone far enough to come to the highway?" Almanzo asked at last.

"It seems like it," I said, "but going east we are bound to find the highway running North." Instead we found ourselves on a country road.

A friendly stranger directed us and soon we saw the highway signs and were on our way.

"This is a good start," I grouched, "lost twice this early in the morning the first day out. Do you suppose we will get lost coming and going in every city on our way?"

"It wasn't we were lost. It was the highway," Almanzo said earnestly.

We stopped for lunch at a little eating place beside the road, then went on again in the pleasant afternoon.

When we came to a junction of our highway with one crossing it, we took the wrong end of the new highway. After going a few miles we discovered our mistake, retraced our way and followed the highway on in the right direction.

"That is three times lost in one day," Almanzo said.

"I think it is the limit," I added.

"We will make it the limit," Almanzo declared. "Three times is enough to be lost in one day."

We drove happily on across the level land of North Missouri and southwestern Iowa. Then out on the Dakota prairie where meadow larks sang beside the road. The sun shone into the car and the soft spring wind blew in my face. Almost I seemed to hear Mary say,

"Laura! Put your sunbonnet on! You'll look like an Indian." So I tilted my wide hat-brim to shield my face from sun and wind.

Late one afternoon, we came to DeSmet.

The little town, we used to know, was gone. In its place was a town that spread north beyond the railroad tracks, east to the lake shore, south where the Big Slough used to be, and far to the west. The old school-house was gone. Its place was taken by a large, brick school building.

Along Main Street were fine business houses in place of the one-story, with a two-story false front, stores of the old days.

A large brick bank, wih offices above, stood on the corner where Pa had built his small office building. We took rooms in a hotel a little way from it.

Next morning, at breakfast, two men looked sharply at us as they passed our table, then came back and stopped.

"Hello, Laura!" one of them said.

I looked up, in surprise, into the laughing black eyes of a tall man.

"I am Laura, but who are you?" I answered him.

"I am Sam," he said. "I would know you anywhere." And then I remembered him for an old schoolmate, one of the younger boys in our crowd.

The other man had known Almanzo well. They joined us at the table and we recalled old times together.

Main street was full of street-fair and it rained. It rained all day, but nobody cared. After so many dry years, people were happy to be rained on. When a hard shower came, they ducked under awnings and into doorways. Between showers they splashed smilingly up and down and across the street where water was running.

Almanzo and I were crossing the street when I heard
someone calling, "Oh, Laura!" I looked back. Running
after us, was a little woman.

"I knew you!" she exclaimed. "I knew you!"

"You are Maggie," I said. We stood in the middle of
the street—we who had last seen each other as girls in
school—and the rain poured down.

Wherever I went, someone called, "Laura." It made
me feel quite young again. Then I met an old school-
mate with her grandchildren.

We drove out to see Pa's old homestead. There is a
nice farmhouse in place of the little claim-shanty, but
the cottonwood trees we set that long ago day, when
Grace was lost among the violets, are still growing, big
trees now.

We drove to a nearby town to see Grace and her
husband. From there we drove across the plains to the
Black Hills.

Sister Carrie lives in the Black Hills at the foot of
Mt. Rushmore, where the great stone faces are carved
in the living granite of the mountain top. As we drove
the winding roads, these stone likenesses of Washing-
ton, Jefferson, Lincoln, and Theodore Roosevelt looked
calmly down upon us.

Carrie and Grace who used to be my little sisters are
now taller than I am. We talked together of childhood
days and of Pa and Ma and Mary.

When we talked of our return journey, we decided
not to go back the way we came. Instead we drove on
to further adventures. But that is another story for, as
we drove away from sister Carrie's home, our visit to
the Land of Used-to-be was ended.

Laura and Almanzo drove on into Wyoming and then
turned south along the Rocky Mountains, following the
snow-clad peaks to Colorado Springs. Then they headed
east across the Colorado plains and through the burned-out
fields of Kansas, where yellow dust storms choked the sky
and the temperatures reached 102 degrees, until at last they
reached the cool blue hills of home.

All the while, Laura thought of the little town on the
prairie and the old familiar faces she had seen. "Everywhere
we went we recognized faces," she said, "but we were always

surprised to find them old and gray like ourselves, instead of being young as in our memories."

The long trail of Laura's life had led back at last to Rocky Ridge, and there she and Almanzo settled down to their last years together. They were years of quietude and peace, of gentle memories. They flew by quickly, too quickly, and could not be arrested. The gathered folds of life's curtain had begun to move.

Laura still got up to cook breakfast for Almanzo at seven o'clock, while he went out to care for the goats and the calves. "Then he works in the garden or the shop where he loves to tinker," Laura said, "while I do up the housework and go down the hill to the mail-box for the mail." Old Ben, her spotted bulldog, always followed her, and they would walk together down the road a ways before coming back home to the cooking and the baking and the churning. "When the day is over and evening comes," Laura said, "we read our papers and magazines or play a game of cribbage. If we want music we turn on the radio."

Two years after Laura's last visit to DeSmet, Grace died. Two years after that, the last of the *Little House* books was published, and Laura's work as a writer was over.

"She's the serious, wide-eyed girl now," Rose wrote in this same year, "almost shyly hidden under a surface quickness and sparkle. She's little, about five feet tall; has very small hands and feet, and large violet-blue eyes. I have seen them purple. Baby-fine, pure white hair. She wears it short and well-groomed, and moves and speaks quickly, sometimes vivaciously. But her character is Scotch; she holds a purpose or opinion like granite. . . . She has a charming voice, with changing tones and colors in it, and is sometimes witty or fanciful, but this is always a little startling; she is never talkative and usually speaks in a matter-of-fact way. Often she is silent nearly all day long."

Looking back on her books, Laura herself tried to say what they had shown her. "Running through all the stories," she said, "like a golden thread, is the same thought of the values of life. They were courage, self reliance, independence, integrity and helpfulness. Cheerfulness and humor were handmaids to courage."

Each of these things Laura had put not only into her books but into her life. They sustained her when Carrie died

in 1946 far off in Dakota, leaving Laura as the last surviving member of her pioneer family. They helped her through the hard times to come three years later, when Almanzo had a heart attack.

Almanzo was ninety-two then, but full of fight. He was lean and strong from his years as a homesteader and a farmer. He was full of courage from his life-long fight against the effects of the stroke he had suffered in their first dark years together. He battled on. Through July and August and September, Laura nursed him alone, and on into the first hazy days of fall—harvest time. Then, on a Sunday in October, Almanzo closed his eyes and died, with Laura sitting at his side.

The long years together, the years of "sunshine and shadow," at last were over. Laura was left lonely in the rambling house on Rocky Ridge.

There she spent her own last years, looked after by her friends and buoyed in spirit by the affection that came to her from boys and girls she didn't know but who knew her well. Always the letters came. Always Laura found it a "continual delight" to think her stories of so long ago should be loved by so many children. Always she remembered.

With each year that passed, with each letter that came, with each honor—for libraries were named after her, and even a special book award was created in her name—with each of these, Laura remembered.

The breeze made her remember, and the turning of the seasons, and the smell of rain, and the meadow full of flowers. Now was now.

It was harvest time in 1956. White clouds sailed over Kansas. Leaves turned color in the Big Woods, and were veiled with frost. In Dakota the prairie was gold, and the sun set red behind it. At Rocky Ridge, Laura's heart hurt. She was eighty-nine years old. Now was now. It could never be a long time ago. But she remembered.

She remembered Pa walking down Third Street, his body bent, his carpentry kit in hand. Geese and brants boomed southward. She remembered Almanzo in the wagon, upright, against the prairie wind. She remembered Silver Lake, and the smell of the hot sun on the prairie grasses. She remembered golden years.

The doctor said that Laura must go to the hospital, fifty miles away. So she went.

She remembered Walnut Grove and Reverend Alden and spelldowns in the schoolhouse. The shadows danced upon the walls, the winds of winter sighed outside. She remembered Burr Oak and the pasture and the green grass between her toes. She remembered the graveyard on the hill: "Gone home!" She remembered the dugout, and the silence of the prairie. She remembered the wagon. And the wagon was moving.

Laura was alone. It was winter, and the hospital was silent. Oh, she could not stand the city water. Neta brought her water from the well at Rocky Ridge. It was so good, so cold and clear. Imagine such a simple thing: water from the well at Rocky Ridge.

She remembered George George. That was so long ago. The campfire glowed like a red jewel on the darkening land. The cry of the train in the evening light, calling me! Mary, sweet Mary. And the wagon was moving, and the way the hooves of the horses sounded on the ice, hollow in her heart.

Christmas came. New Year's came. The doctor came to see her. He said Laura could go home, so she went home to Rocky Ridge.

She remembered daisies and broken glass and Uncle George. She remembered deer and bear and firelight, Ma rocking, Pa's fiddle gleaming, songs of auld lang syne. Now is now. There were tears in her eyes, and snow flew in the night. The wagon moved on.

The house at Rocky Ridge was quiet. Soon it would be her birthday. Laura lay in the silence, surrounded by darkness. It was February. In her mind was half the history of America. Where had they gone, the Indians Ma told about? Single-file, sadly west, silent. Fleeting years have borne away the voice of Alfarata. The sky was so high and wide that the wagon seemed to stand at rest. But the wagon was moving.

Through the front of the wagon Laura could see a circle of sky and Pa hunched over the reins. The smell of blue smoke drifted back through the wagon from his pipe. He was whistling. But now is now. It was Laura's birthday: February 7, 1957. She was ninety years old.

Somewhere snow gleamed and glistened in giant drifts. Somewhere a campfire glowed in the night. The wagon moved. Across the wide prairie the sound of a fiddle drifted and faded and drifted again. What was it? Captain Jinks? The Blue Juniata? Oh, carry me back, carry me back!

One day passed. Only one. And then another. Only one other. Now is now: February tenth. Laura was tired. The sides of the canvas were rolled up, and the breeze came softly across the prairie. She looked at Mary; Mary was asleep. The wagon rocked like a lullaby, back and forth, back and forth.

Laura closed her eyes. Now is now. She wished they could go on and on, forever.

Appendix 1:
Important Dates

January 10	1836	Charles Philip Ingalls born.
December 12	1839	Caroline Lake Quiner born.
February 13	1857	Almanzo James Wilder born.
February 1	1860	Charles Ingalls marries Caroline Quiner, Concord, Wisconsin.
January 10	1865	Mary Amelia Ingalls born.
February 7	1867	Laura Elizabeth Ingalls born.
April 28	1868	Charles Ingalls sells land in Wisconsin.
May 28	1868	Charles Ingalls buys land in Missouri.
August 6	1869	Charles Ingalls signs power of attorney, Chariton County, Missouri.
February 25	1870	Charles Ingalls approves sale of Missouri land, Montgomery County, Kansas.
August 3	1870	Caroline Celestia Ingalls born.
May 30	1871	Charles Ingalls revokes power of attorney, Durand, Wisconsin.
October 21	1871	Laura and Mary Ingalls attend Barry School, Pepin Township, Wisconsin.
October 28	1873	Charles and Caroline Ingalls sell land in Wisconsin.
August 23	1874	Charles and Caroline Ingalls join Union Congregational Church, Walnut Grove, Minnesota.

December 20 1874 Christmas party at Union Congrega-
 tional Church.

November 1 1875 Charles Frederick Ingalls born.

July 10 1876 Charles Ingalls sells land on Plum
 Creek.

August 27 1876 Charles Frederick Ingalls dies, South
 Troy, Minnesota.

May 23 1877 Grace Pearl Ingalls born, Burr Oak,
 Iowa.

January 26 1878 Charles and Caroline Ingalls readmit-
 ted to Union Congregational Church,
 Walnut Grove.

August 25 1885 Almanzo Wilder and Laura Ingalls
 married, DeSmet, Dakota Territory.

December 5 1886 Rose Wilder born.

August 1889 Baby son born to Laura Ingalls
 Wilder, dies twelve days later.

June 8 1902 Charles Ingalls dies.

April 20 1924 Caroline Ingalls dies.

October 17 1928 Mary Ingalls dies.

November 10 1941 Grace Ingalls Dow dies.

June 2 1946 Carrie Ingalls Swanzey dies.

October 23 1949 Almanzo Wilder dies.

February 10 1957 Laura Ingalls Wilder dies.

October 30 1968 Rose Wilder Lane dies.

Appendix 2:
The Truth of the *Little House* Books

Many readers consider the *Little House* books historical fiction; others, deeply impressed with their air of reality, take their factuality as an article of faith. In my search for Laura's traces I so often encountered an almost fevered insistence upon the factuality of the *Little House* books—and thus a denial of their art—that perhaps a few observations on the subject are in order.

What may with some liberality be styled academic attention has with a single exception managed to ignore the essential art of the *Little House* books by leaving unexamined the way in which they were created, although the means have long been at hand by which to do so. Evelyn Wenzel has written perceptively of the psychological insights of the *Little House* books. Bernice Cooper has shown in painstaking detail the solid grounds of their historicity—that is to say, their historical context. Many others have come forward with wreaths of affection rather than a critical eye, praising the delicate balance of the books, their graduated complexity and consistent point of view, the decency, courage, and sense of security which they represent, their "depth of reality," the restraint of their language, their "dramatic truth." These bouquets are well deserved, touching as they do upon the literary virtues of the books. But at the same time they let stand unchallenged the assumption that the *Little House* books are unadorned autobiographical remembrance.

About this, Laura herself had something very interesting to say. Long after the series was completed, she received a gentle rebuke from a reader who complained that she had failed to mention the name of the town near which she lived as a little girl, on the banks of Plum Creek. "I should have,"

Laura responded, "but at the time I had no idea I was writing history." She meant, of course, that she wasn't.

Curiously, the most strident voice raised in behalf of the strict factuality of the *Little House* books was that of Laura's daughter, Rose Wilder Lane. When an editor of a teachers' journal—trying to reconcile Carrie's presence in *Little House in the Big Woods* with the fact of her birth in Kansas—observed that Laura "knew she could achieve a more artistic effect by altering the true facts occasionally," Rose took vigorous exception.

"This is important," Rose wrote, "because it has been charged that my mother's books are fiction. They are the truth, and only the truth; every detail in them is written as my mother remembered it." The year the family spent in Iowa was omitted, Rose conceded, and Laura's age in the Big Woods was ostensibly advanced two years at the insistence of the publisher. "But she added nothing and 'fictionized' nothing that she wrote. . . . A fiction writer myself, I agree that my mother could have added to artistic effects by altering facts, but she did not write fiction."

This in itself is a delightful fiction, and the careful reader of the *Little House* books and this biography will already have noticed how far from the mark it rests. It should not be necessary to enumerate here all of the instances in the *Little House* books in which art masters memory or even fact, although one could no doubt compile a small volume to this effect. Whatever the motives behind Rose's spirited apologia, it is true that the stories of the *Little House* books carry an overwhelming sense of reality. What more could we ask of literature than that it grab us by the heart and strike us as real? Yet even this is another measure of the artfulness of the stories.

Laura's memory, as rich as it was, serves only as the basis upon which the delicate structure of art is built in the *Little House* books. Many of the stories are true in the sense that they really happened and they really happened that way. So much else is art, most particularly in nuance and characterization and dramatization, but also on very many occasions in point of fact. Even in Laura's memoir I find instances in which memory failed her or art overruled memory, and although I have depended heavily upon the memoir as essentially autobiographical and without artifice, I have done so with appropriate care.

Laura began to work her memory in her occasional articles for the *Missouri Ruralist*. The memoir followed, at Rose's suggestion and, by Laura's testimony, for Rose's use in her own writing. Although Rose did indeed publish two historical novels based very loosely on her mother's stories, I suspect that Rose sensed the way in which the deaths of Ma and Mary had haunted Laura with memories and thus urged her to commit them to paper, not only to satisfy her itch to write but as a sort of therapy.

From the memoir, the creation of the *Little House* books proceeded through at least two additional stages, over each of which Rose stood ready with advice and assistance. The first of these was a draft manuscript of each particular book—no small jump from the memoir, because the attempt to achieve an appropriate form for the stories began to impose artistic considerations. The second of these two stages is missing.

The artistic gulf between the draft manuscript, such as those which Laura donated to the Detroit Public Library, and the final version as it was submitted to the publisher, clean and without requiring any editing, is too large to allow for anything less than an intermediate manuscript in which "some grace beyond the reach of art" has been imposed. These intermediate drafts, as I say, are missing; should they ever come to light they will measurably illuminate the process by which a true children's classic was created.

Laura donated two draft manuscripts to Detroit—*The Long Winter* and *These Happy Golden Years*. Rosa Ann Moore of the Department of English, University of Tennessee at Chattanooga, has examined these for the first time not as talismans or reliquaries but as literary objects, and has defined with persuasive insight the transformation that took place between draft manuscript and published book in terms of language, form, mood, characterization, and dramatization. The metamorphosis of a caterpillar into a butterfly is no more remarkable. Her work is all the more extraordinary in light of the fact that she did not have the advantage of consulting Laura's memoir. Her essay, which appears in Volume 4 (1975) of the journal *Children's Literature*, should be required reading for all who wish to puzzle over the magical art of the *Little House* books.

It strikes me that the truth of the *Little House* books is the truth of art, that they hold a treasurable truth that tran-

scends fact, and that their essential achievement lies in a co-
herent vision not merely of pioneer life but of life itself. The
books were of a piece with the life Laura lived.

"The *Little House* books are stories of long ago," Laura
herself said in an open letter to the children who adored
them. "The way we live and your schools are much different
now, so many changes have made living and learning easier.
But the real things haven't changed. It is still best to be honest
and truthful; to make the most of what we have; to be happy
with simple pleasures and to be cheerful and have courage
when things go wrong."

This is the truth of the *Little House* books: the real things.

Appendix 3:
All the Little Houses

Over the years, thousands and thousands of people from around the world have made a grand tour to see all the places where Laura lived and where the stories in her books took place. None of the little houses has survived the passage of time, although there is still much to see. In many of these places, the land itself seems to breathe with the spirit of Pa's fiddle and Laura's happy songs.

The following directory of sites connected with Laura Ingalls Wilder is not intended to be exhaustive. But it will give some idea of what is to be seen and to whom the interested traveler can write for additional information.

In writing to the people or organizations in these places, enclose a stamped, self-addressed envelope.

Pepin, Wisconsin. Pepin is situated on the Mississippi River in west central Wisconsin, about midway between Eau Claire, Wisconsin, and Rochester, Minnesota. The little house in the Big Woods is gone, and so are the Big Woods themselves, but the land remains. Lost Creek is there, and the village of Pepin, and the shining waters of Lake Pepin. The site of the little house is marked, back in the bluffs north of town. A special Laura Ingalls Wilder Society is in the process of being formed, and plans are under way to reconstruct the little house in the Big Woods.

Independence, Kansas. Independence is located on the prairies of southeastern Kansas. The site of the little house on the prairie is southwest of town, near Wayside, and is marked. For information write to Chamber of Commerce, 108 Myrtle Street, Independence, KS 67301.

Burr Oak, Iowa. Burr Oak lies in northeastern Iowa, north of Decorah and three miles south of the Minnesota state

line. It was here that Ma and Pa came with the girls to run the Burr Oak House or old Masters' Hotel. Grace Ingalls was born here. Silver Creek still runs behind the hotel, which is being restored, and the graveyard on the hill still bears the stones that Laura wandered among on long-ago afternoons: "Gone Home." For information write to David DeCou, Box 44, Burr Oak, IA 52131.

Walnut Grove, Minnesota. Walnut Grove lies in southwestern Minnesota, east of Tracy and west of New Ulm. The town has grown very little since Laura's day, and the church bell Pa's money helped buy rings now from the belfry of the English Lutheran Church. North of town across the prairie is Plum Creek, and on the farm of Harold and Della Gordon the dugout can still be seen. When I was there I found this the most haunting of the Laura sites—a place of beauty and silence—and it took no imagination at all to see it as Laura saw it. I have been told by later visitors, however, that it has since been supplied with a "grave" for the dog Jack and other gimmickry. For information write to Harold and Della Gordon, Walnut Grove, MN 56180. The site of the dugout is accessible only in season.

DeSmet, South Dakota. DeSmet is situated in eastern South Dakota, west of Brookings. This is the little town on the prairie, and there are many things here in remembrance of Laura. The cottonwoods still grow on the north line of Pa's claim, and in the prairie graveyard southwest of town Pa and Ma and Mary and Carrie and Grace are buried; so are Rob Boast and Mr. Loftus and the wife of Reverend Brown and other characters from the *Little House* books. Silver Lake is gone and the Big Slough has been drained, but much remains to be seen, including the Surveyor's House and the house Pa built on Third Street, both of which are open to the public in season. In the summer a special pageant, based upon Laura's books, is staged. For information write to the Laura Ingalls Wilder Memorial Society, DeSmet, SD 57231.

Mansfield, Missouri. Mansfield is in southwestern Missouri, east of Springfield; here Laura spent most of her long life. The house she and Almanzo built has been turned into a museum, with a modern addition that houses many of her belongings. Here visitors can see Pa's fiddle and Laura's china jewel box, and the Bible she won for reciting the most Golden Texts and Central Truths. Tours are given through

the house, and the house and museum are open in season. If you can find your way to Mansfield you can find your way to Rocky Ridge; it's a mile east of town. Laura and Almanzo are buried in the cemetery at Mansfield. For information write to Irene Lichty, Laura Ingalls Wilder Home and Museum, Mansfield, MO 65704.

Malone, New York. Malone is in northern New York, eleven miles from the Canadian border. The Wilder home is still standing but is privately owned and not open to the public. The site may be visited, however; so also can the Fairground, the Three Cornered Park, the graves of Almanzo's grandparents, and the site of the Academy. There is a permanent display of Wilder Family material in the Franklin County House of History, 51 Milwaukee Street, Malone, NY 12953.

Index